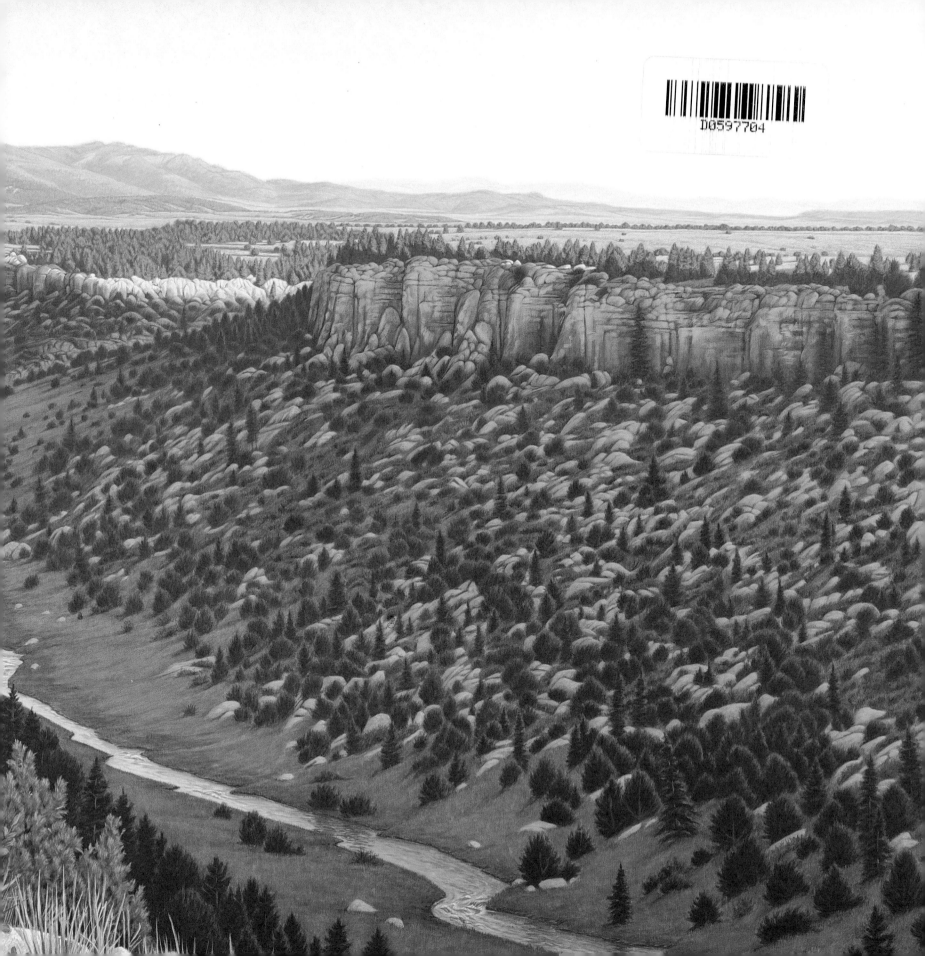

# Enduring Cowboys
## Life in the New Mexico Saddle

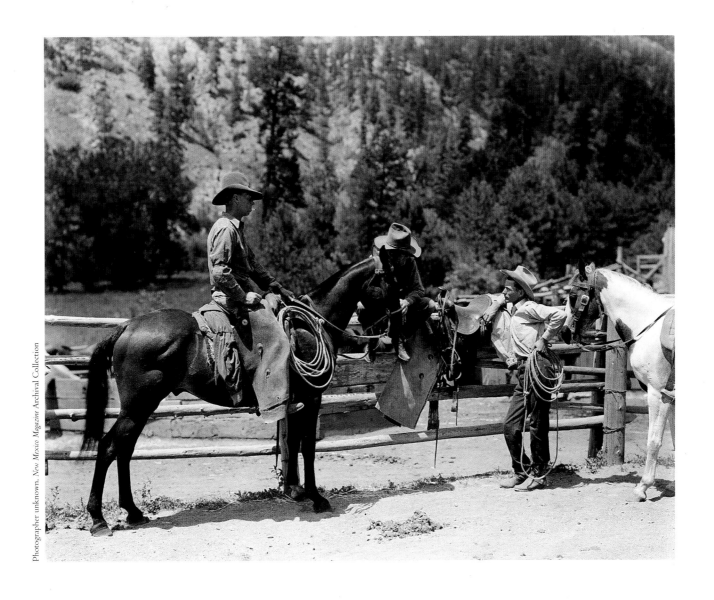

EDITED BY ARNOLD VIGIL

Cathy Nelson

**NEW MEXICO**
MAGAZINE

# Enduring Cowboys

# Life in the New Mexico Saddle

# Acknowledgments

*This book is dedicated to little Diego and baby Justin, who hopefully will continue their* vaquero *lineage despite a one-generation hiatus.*

Dr. George Agogino, retired archaeologist, Portales, N.M.; Leah Arroyo, Alex Gordon, James H. Nottage, Autry Museum of Western Heritage, Los Angeles, Calif.; Charles Bennett, assistant director, Tom Chávez, director, Palace of the Governors, Museum of New Mexico, Santa Fe, N.M.; Jon Bowman, *New Mexico Magazine*; Terry Bumpass, curator, Governor's Gallery, Santa Fe, N.M.; Ralph and Priscilla Duran, Santa Rosa, N.M.; Max Evans, author, Albuquerque, N.M.; Paul Andrew Hutton, historian, Rio Rancho, N.M.; Bill and Panzy Jones, Alamogordo, N.M.; Leslie Kedelty, N.M. Department of Tourism, Santa Fe, N.M.; Stanley and Theresa Kedelty, Navajo Reservation, Crystal, N.M.; Lorentino Lalio, director, Indian Tourism, N.M. Department of Tourism, Santa Fe, N.M.; Johnnie Luevanos, Universal Studios, Universal City, Calif.; Pedro Marquez, Santa Fe, N.M., and Alcario Marquez, Marquez Ranch, Antonito, Colo.; National Cowboy Hall of Fame, Oklahoma City, Okla.; N.M. Archives and Records Division; Jane O'Cain, Robert L. Hart, curators, N.M. Farm and Ranch Heritage Museum, Las Cruces, N.M.; Art Olivas, Photo Archives Division, Museum of New Mexico, Santa Fe, N.M.; Reynaldo "Sonny" Rivera, sculptor, Albuquerque, N.M.; Gretchen Sammis, Ruby Gobble, Chase Ranch, Cimarrón, N.M.; Cynthia Sanchez, N.M. Capitol Arts Foundation, Santa Fe, N.M.; LeRoy N. Sanchez, Santa Fe, N.M.; Linda J. Sanchez, *New Mexico Magazine*; Terrell Shelley, 916 Ranch, Cliff, N.M.; Ray and Beth Silva, Grants, N.M.; Betty Sims Solt, Roswell, N.M.; Joy Stickney, Cathy Fresquez, *New Mexico Magazine*; James Vance, ranch manager, WM. J. "Dub" Waldrip, general manager, Chappell-Spade Ranch, Tucumcari, N.M.; John Vaughan, art/production director, *New Mexico Magazine*; Gilbert Vigil, Rodarte, N.M.; Dr. Edson Way, director, N.M. Office of Cultural Affairs, Santa Fe, N.M.; Jim Wood, *New Mexico Magazine.*

**Editor:** Arnold Vigil
**Book Design:** Bette Brodsky
**Copy Editors:** Jon Bowman, Steve Larese
**Publisher:** John McMahon
**Associate Publisher:** Ethel Hess

Library of Congress
Catalog Card Number: 99-074035
ISBN: 0-937206-58-X

of

Introduction

*Arnold Vigil*                                                          8

Bowlegs

*John L. Sinclair*                                                      12

*Vaquero*: The Original Cowboy

*Michael Miller*                                                       34

The Legendary Cowboy

*Steve Terrell*                                                        60

Cowboys Under Fire

*Steve Larese*                                                        84

Cowboys as Indians

*Conroy Chino*                                                       106

The Techno Cowboy

*Joel H. Bernstein*                                                  130

Contributors

150

# COWBOY GLIMPSES

Bob Lee, *Datil*; Carlos Ortiz, *San Jon*; Stanley Kedelty, *Crystal*; Fawna Lee Speer, *Clovis*;
Bill Jones, *Alamogordo*; Tom Brown, *Capitán*.      22-33

Randal Gates, *San Jon*; Pedro Marquez, *Santa Fe*; Benny Pacheco, *Laguna Pueblo*;
Betty Sims Solt, *Roswell*; Art Evans, *Cuchillo*; John Begay, *Naschitti*.      48-59

George McJunkin, *Folsom*; Gretchen Sammis, *Cimarrón*; the Shelley Brothers, *Cliff*;
James and Joanie Vance, *Tucumcari*; Tony Trujillo, *Magdalena*; Jarrod and Justin Johnson, *Tatum*.      72-83

Tom Kelly, *Water Canyon*; Laurie Kincaid, *Carlsbad*; Jenny Vance, *Tucumcari*;
Ross Begay Jr., *Crystal*; Robert Zamora, *Magdalena*; Julie Gates, *San Jon*.      94-105

Ross Begay Sr., *Crystal*; Rob Chappell, *San Jon*; Charles Good, *Elida*;
Bronco Martinez, *Gallup*; Randall Jones, *Roswell*; Michelle Kedelty, *Crystal*.      118-129

Peg Pfingsten, *Capitán*; Alcario Marquez, *Antonito, Colo.*; James Woolley, *Roswell*;
Fletcher Hall Jr., *Capitán*; Lorenzo Vigil, *Nambé*; Bruce King, *Stanley*.      138-149

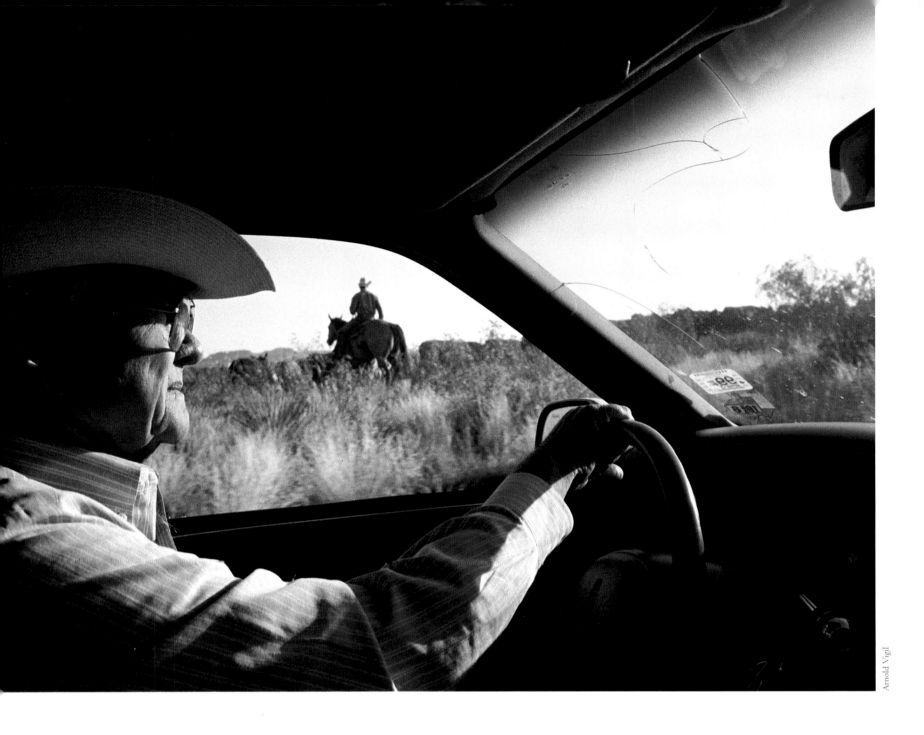

Above — Wm. J. "Dub" Waldrip, general manager of the Chappell-Spade Ranch near Tucumcari, rides roundup on the range alongside working cowboys in his Lincoln Town Car. Although technology has changed the way cowboys do some of their work in the last century, Waldrip says nothing will replace the versatility of the horse. "There's a lot of things that have changed," he says, "but there's a lot that's still the same." The invention of the gooseneck trailer probably has affected ranching the most because it enables horses to be trucked to places that cowboys rode horseback to in the past, Waldrip says.

COUNTRY-MUSIC SINGER ONCE SAID THAT HER DADDY WARNED HER WHEN SHE WAS YOUNG TO NEVER DATE COW-BOYS BECAUSE "THEY AREN'T STABLE AND THEY'LL ALWAYS BREAK YOUR HEART BEFORE THEY LEAVE YOU." TYPICAL OF MOST REBELLIOUS TEENAGERS, THE SINGER SAID THE FIRST THING SHE WANTED TO DO WAS GO OUT AND FIND HERSELF A COWBOY.

This singer isn't alone. For centuries, people across the globe have been fascinated with cowboys, their perceived saddle-tramp tendencies and the mystique of their lifestyle. Hell, even cowboys are intrigued with other cowboys and most of them wouldn't trade their feast-or-famine profession for anything else.

But it's getting harder with each passing day to be one. No, the work isn't any more tough and thankless than it's always been, and the pay is probably even a little better now than in the past. What's getting tougher is that the cowboy's "office," the ranching institution, is under fire from many fronts. Couple that with low wages compared with other professions and the rising costs of stock, horses, tack, feed and land, and you wonder what makes anyone want to be a cowboy.

Environmentalists pose a serious threat to the cowboy lifestyle today as well as a declining price of beef, foreign competition, reduced government subsidies and other economic factors. Many ranchers conclude that it's always a constant struggle just to make ends meet. They feel the barrage of legal battles waged against them by organized and amply financed environmental groups that question their use of public and private lands isn't worth the aggravation or the money.

Introduction

by Arnold Vigil

Most cowboys swear that no one loves the land more than they do and that they should know because they're out there every day, rain or shine, taking care of it. They certainly have a point because abused land doesn't benefit them either, especially in the long haul. Despite all of the forces at work against cowboys today, there are still plenty of them around in New Mexico, where the very concept of cowboy culture was spawned centuries ago. Today, we have landless cowboys who work for everybody else — and love it — and we have cowboys with their own ranches, some totaling a half-acre and others that spread out at more than 100,000 acres.

While compiling this book, however, we found out mighty fast not to automatically call ranchers cowboys or to call cowboys ranchers. There are subtle and not-so-subtle differences — the main one being that the rancher is the businessman and the cowboy is the laborer — and some don't take too kindly to the wrong reference. Others shrug it off, like WM. J. "Dub" Waldrip, general manager of the 40,000-acre Chappell-Spade Ranch near Tucumcari and another larger Chappell-Spade outfit in Texas. Waldrip looks, dresses and talks like a cowboy, and he's even got an insightful anecdote for almost any given occasion, just like those likable cowboys in the movies. But don't call him a cowboy. "I'm a so-called ecologist," he says, "but I consider myself a rancher. I have cowboyed, but now I just make sure things go right on these ranches."

In fact, Waldrip makes his rounds across the Tucumcari ranch's grazing pastures in an air-conditioned Lincoln Town Car, driving cross-county alongside his horse-riding cowboys through weeds, bumps, arroyos and dirt roads. It's probably the most comfortable roundup routine that any cowboy (oops, I mean rancher) has ridden since ranching day one. "I told them it says Town Car, but it's really a Country Car," he says in his wry, down-home style.

Even the advent of versatile all-terrain vehicles (ATVs) and cross-country motorcycles hasn't changed the way cowboys use horses on the larger ranches, Waldrip says. "You still have to round 'em up with horses, there's no other way. The terrain's too rough."

But one weekend rancher, who works in Santa Fe during the week and high-tails it in his pickup to his small place near Abiquiú Lake on weekends, sheepishly declined to be interviewed for this book. His reason: "I'm a truck cowboy." This simple statement poses a compelling question that makes many contemporary cowboys uneasy: Can you still be a cowboy without a horse? The answer is probably yes, but no *real* cowboy worth his grit is ever going to admit to that, at least while he's sober. Many cowboys are downright sensitive about their image and Hollywood might have a little something to do with that.

In reality, however, not all bona fide cowboys wear cowboy hats, pointed boots and ride a horse all the time. Times have long changed and Hollywood still hasn't caught up. Sometimes ball caps take the place of the

classic wide-brimmed Stetsons and comfortable Nikes every so often replace the familiar Tony Lamas in the stirrup. And need we open that horse-vs.-pickup can of worms again? But identity crisis aside, New Mexico cowboys have always known who they are even though Hollywood and the rest of the world might not. Our cowboys come in all different shapes and sizes and represent a diverse range of terrains and ethnic groups – even Native Americans. And more often than you think, they're not cowboys at all, they're cowgirls!

According to the *1997 New Mexico Brand Book* by the New Mexico Livestock Board, there were more than 26,000 different brands registered for cattle and sheep in the state, while a 1997 New Mexico State University statistic listed the number of cattle chomping and stomping on the Land of Enchantment at 1,430,000. Obviously, there has to be plenty of cowboys out there, too, taking care of them. But the overall number of cowboys is declining, according to ranchers in the know who lament that finding enough good wranglers today is getting almost as hard as finding a witness who will testify in New York City.

Most of New Mexico's young men and women who consider themselves aspiring cowpokes each strive to settle down, raise a family and have the inherent goal of owning his or her own ranch. They are unflinchingly determined to realize the western version of the American Dream, despite the added economic and environmental obstacles of modern ranching that their forebears never had to face. It's the only lifestyle most of them have ever known and ever care to know. The most practical of these ambitious cowboys, however, realize that ranching alone will not provide the necessary means for them to achieve their goal. Many have gone on to college or work at other trades to make ends meet so that they can return home to the cows when the traditional workday's done. Come weekends and free time, it's not the television nor the trip to the mall in Albuquerque that take priority – it's the hard, unrelenting work of the ranch that occupies their precious available hours.

*Enduring Cowboys: Life in the New Mexico Saddle* celebrates our diverse mix of cowboys. We offer a variety of essays and photographs that merely scratches the surface of the lives of New Mexico's historical and contemporary cowboys and the issues facing them. We also present an interesting mix of biographical vignettes about working cowboys, some just starting out and others long established ranchers. Many individual accounts of these authentic cowboys' lives could each fill a book in their own right.

Since its first decade of publishing in the 1920s, *New Mexico Magazine* has regularly paid homage to cowboys and the ranching industry in the state. They're an important part of our heritage. We've documented how the cowboy lifestyle has evolved through the technological advancements of the four centuries prior that have led us into the 21st century.

Astonishingly, the enduring cowboy has kept his mystique.

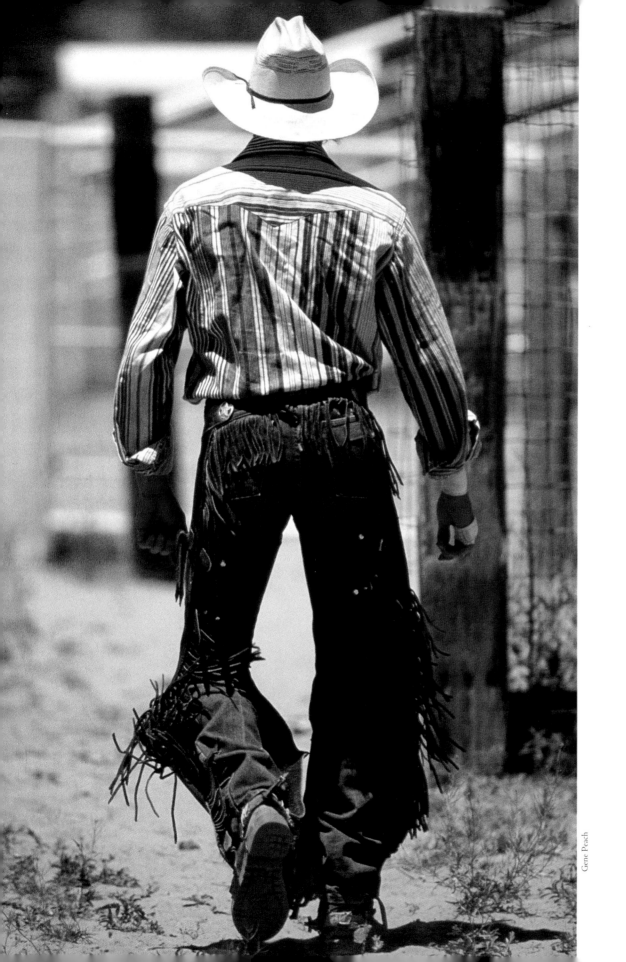

WHEN MY FOOT IS IN THE STIRRUP

AND MY HORSE IS ON THE BUST

WITH HIS HOOFS A'FLASHIN' LIGHTNIN'

FROM A CLOUD OF GOLDEN DUST,

AND THE BAWLIN' OF THE CATTLE

COME ADRIFTIN' DOWN THE WIND

THEN A FINER LIFE THAN RIDIN'

WOULD BE MIGHTY HARD TO FIND.

– Badger Clark

*(Editor's note: The late John L. Sinclair's "Bowlegs" first appeared as a feature article in New Mexico Magazine in September 1938. For the most part, the timeless qualities of his piece apply to cowboys today just as they did in Sinclair's time. The former cowboy contributed articles to the magazine for more than 50 years, his first appearing in 1937.)*

When you walk down the street of a New Mexico town, particularly real cow country towns such as Roswell, Deming, Carrizozo, Las Vegas and Magdalena, and you note that the cowpuncher walking ahead of you has more spread between his knees than his ankles – you know he didn't get that way on foot. It took a horse to do it; years in the saddle put that bow in his legs – long days astraddle horses of all sizes and dispositions.

Abundant sunshine put that slight squint into his eyes, prairie winds tanned his face and wide open spaces gave him the freedom of action peculiar to men of his kind. What are the characteristics of the real cowboy that will distinguish him from the synthetic? Well, it isn't the ten-gallon hat or the fancy boots anyone can buy; it's the mark the elements, horseflesh, corral dust, cowcamp chuck and a man-sized job has branded on him. Dress him in a dinner jacket and white tie, comb

# Bowlegs

by John L. Sinclair

the kinks out of his hair, swap the boots for dancing shoes and take him far from the range – if he's the real article, 'cowboy' will be stamped on that physiognomy no matter how eastern the apparel.

Cowboys are not born, they are made; if a man has the nerve to throw his leg over a horse and stay with him (or do his best, anyway) regardless of his mount's contortions; if he has enough interest in the job to get to know cattle, hoof, horns, and hide; if he can learn to read brands from the simple 'bar' to the intricate "squabble Os" and the "maps of Mexico"; if he can make his lariat rope come alive by the twist of his wrist and have the same ease and patience as a 'cutting horse' when he works stock; if he can take the bruises, falls, discomforts of long hours of hard work in zero weather or blistering heat, all for the meager wage of 35 dollars a month and chuck, and still love his job and never want to do anything else – he's a top-hand cowboy whether he was born on a New Mexico ranch or Weehawken, N.J.

One of the best cowhands and rodeo contestants in the Roswell district arrived in New Mexico from the East about 12 years ago, and didn't know the first thing about saddling a horse. He landed a job with a cowman known all over the state as one of New Mexico's top cowboys. He had a good instructor and the will to make a top hand.

Pulp magazines and horse operas have fired the ambitions of certain eastern lads to come West and be cowboy heroes. Cowboys are stockmen and haven't time to be heroes. They have windmills and fences to keep in repair; they ride horses because they are paid for it and cattle can't be worked on foot; they do chores around the ranch such as feeding the chickens and slopping the hogs. They leave the girls for someone more romantic to rescue.

There are instances of gunplay in the West now and again, but 10-to-1 the badman, when caught, proves to be a hitch-hiker from the East; and, as it is well known, banditry is less prevalent in Rocky Mountain fastnesses than in large cities. A cowboy may have a six-shooter somewhere within the folds of his "thirty years' gatherin'," as he calls his bedroll, but it is too unhandy to carry on his person now that he has no use for it. Drouths and dust storms, the fall of Kansas City prices, taxes, blackleg, winter feed-ing and the doings of the boys in Washington occupy the cattleman's mind these days rather than gun-packing badmen or frail damsels in distress.

A cowboy has to be a jack-of-all-trades. He must not only know how to handle the jobs directly con-nected with the working of cattle, but should be able to cook a meal, drive a truck, repair windmills, be familiar with the anatomy of a gasoline engine, shoe horses and do a neat job of carpentry. Not so pic-turesque as riding gaily over the wide prairie in fancy regalia, but these jobs have to be done about the

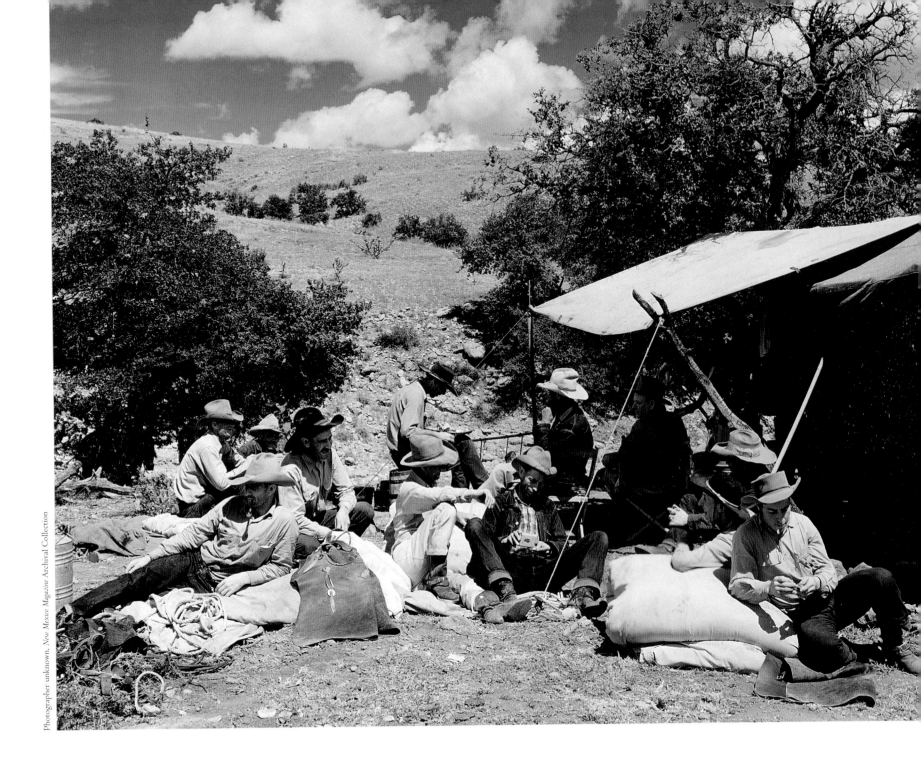

ABOVE — WORKING COWBOYS ON THE SPRAWLING LADDER RANCH IN SOUTHWESTERN NEW MEXICO CHEW THE FAT AT THE CHUCKWAGON TENT DURING A LUNCH BREAK FROM ROUNDUP SOMETIME IN THE LATE 1930S. CHUCKWAGONS ON THE RANGE AREN'T AS COMMON TODAY AS THEY WERE DURING THIS ERA, MAINLY BECAUSE MOTORIZED VEHICLES ALLOW COWBOYS MORE MOBILITY AND MAKE VAST TERRITORIES LESS ISOLATED BECAUSE THEY DON'T HAVE TO BE TRAVELED BY HORSE. COWBOYS ARE ABLE TO DRIVE HOME AFTER A HARD DAY'S WORK RATHER THAN HAVING TO CAMP OUT FOR DAYS AT THE WORKSITE.

ranch and the cowboy attends to them.

There are bow-legged and bronzed governors, senators, bankers, editors, writers and artists, who have risen from the rank of a "forty-a-month waddie" and are proud to speak of their cowboy days. For example there are ex-governors Dick Dillon and Jim Hinkle of New Mexico, the late Sen. John B. Kendrick of Wyoming, Will James and the immortal Will Rogers. There are sons of wealthy eastern and western families who have graduated from universities and are now working as cowhands – just because they love the job.

The dress of the cowboy is the badge of his vocation and the only costume typical of America. The smart wear of the man about town is governed by London and Paris fashion, but the man of the range loyally clings to the stove-pipe-legged frontier trousers and broad brimmed *sombreros* of the pioneer west. They are smart; tailored to suit horseback men with weatherbeaten complexions – and only that type of men.

Fussy is the cowboy when it comes down to a matter of footwear. He is just as particular about his high-heeled boots as the town man is about his oxfords. The handmade article is the choice of the cowboy who lives in boots. They are made to measure, as a tailor-made suit, and do not run in sizes. The high heel and steel instep featured in cowboy boots are essential to the comfort and safety of the rider. High heels and stock saddle stirrups are made for one another. The cowboy, unlike the polo player, never knows what his horse is going to do next. A bronc can't be trusted. A good stirrup hold is necessary for the rider to stay aboard when his mount "hides his head and kicks the lid off," and for safety's sake a stirrup hold that will come loose is necessary when there is too much bronc and not enough cowboy.

Cowboy boots are made to suit western riders, western saddles, western spurs – and above all,

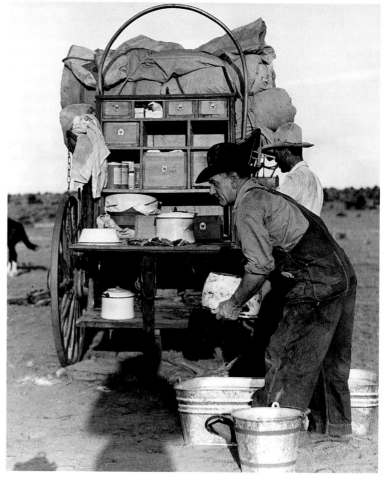

Photographer unknown, *New Mexico Magazine* Archival Collection

ABOVE – A CHUCKWAGON COOK PREPARES TO "SLING SOME BEANS" FOR HUNGRY COWBOYS WORKING THE RANGE IN THIS 1930S-ERA PHOTOGRAPH. THE CHUCKWAGON COOKS OF THE PAST WERE NOTORIOUSLY TEMPERAMENTAL AND MANY COWBOYS WERE CAREFUL NOT TO ANGER THEM, LEST THEY GO HUNGRY. BUT THAT DIDN'T STOP COWBOYS, HOWEVER, FROM REFERRING TO THE COOK AS "COOSIE" (FROM *COCINERO*, THE SPANISH WORD FOR COOK), "COOKIE DOUGH WRANGLER," "BISCUIT SHOOTER," "BELLY CHEATER," "SALLY," "THE OLD WOMAN," "GREASE PUNCHER" OR "POT-SLINGER."

western horses. To quote J.R. Williams:

"We've heard folks often askin'

Why cowboys all wear boots.

But it seems a bit like askin'

Why balloons have parachutes.

Men who put their foot in trouble

Every day or just about,

Are bound to see a moment

When they want to get it out."

Hospitality, in the West, is offered with a capital H. A lonely ranch house, corral and windmill, set in a world of grassy plains and blue sky is lonely indeed. Modern conveniences, radio and automobiles have taken the monotony out of ranch life to a great extent, but the company of human beings to afford conversation and to swap "big windies" is what the lonely cowboy craves most.

On the remoter ranches the wayfarer will be received with open arms. No matter how ragged the apparel or unshaven the chin he will be the guest of honor. The unkindest insult that can be hurled at the host is an offer to pay him for his hospitality. There is the wife of a foreman of a large ranch in southeastern New Mexico, who before going away for the day, never fails to leave the dinner table well-laden with cold meat, bread, fruit and cake; as well as a pot of coffee on the stove — so her mind will be at ease if some hungry person should stop by and even if she is not at home he will nevertheless find plenty to eat.

There is a story told by old-timers of Lincoln County about a cow outfit operating in that part of the state. At sundown of an evening several years ago two cowboys rode up to the house and requested to stay all night. They were received and fed accordingly to western custom and in the morning decided to go on their way. While they were saddling their horses the foreman told them that the supper and breakfast they had received would cost them 50 cents apiece as the ranch charged 25 cents a meal. The boys paid, mounted their ponies and rode away. They were astounded; never had they met with such a lack of generosity. The underwritten law of western hospitality had been defied.

They rode to a watering on the range. The tank was surrounded by a strong picket corral and inside, resting in the sunlight were a dozen or so cows with young calves at their sides. Not a mark or brand marred the sleek hides of the calves. The boys closed the gate and imprisoned the animals until they had

satisfied their revenge on the "two-bit outfit."

They built a branding fire and heated their "running irons." One cowboy "heeled" the calves while the other "flanked" them and held them to the ground. Soon all were neatly branded and turned loose in the pasture. The boys mounted their ponies and resumed their journey. The company's foreman and cowboys were surprised when they rode on to a few of their calves already branded — and under the company's registered mark was indelibly branded: "Meals 25 cents."

When seeking shelter for the night avoid the palatial ranch homes of the cattle kings, with their long galleries and spacious guest rooms. Rather, go down the draw to the lone shack of the "batch" or the "one-horse outfit" where there seemingly isn't room to spare — there they will make room and you will be truly welcomed. I speak only of the remote ranches away from oiled highways and the hardening influence of close settlement.

In the winter of 1929 I rode horseback from Encino to the Capitán Mountains. The ride was long and the weather cold and cloudy. Not having a change of horse I took the journey slowly and spent two uncomfortable nights with my pony hobbled out and my own bed composed of a saddle blanket for a mattress and my sheepskin coat and a slicker for a blanket. I would doze off to sleep only to wake shortly and build up my campfire to keep from freezing.

The last night out I rode into the camp of a "batching" cowboy. Nowhere have I received a more cordial welcome. Of course, there was plenty of room; there was always room at his camp. His shack measured 10 by 12 feet and was built of rough lumber. He had a very sooty but efficient cook stove and the familiar Arbuckle's coffee and the cans of tomatoes, corn and "lick" were a glad sight after the belt tightening I had the two nights previous. Although hundreds of cows watered at the camp there was not a milk cow in the bunch and the poultry flock consisted of two hens and a rooster. Eggs and milk were the unknown quantity. A sack of flour and a slab of salt pork hung from the ceiling on a baling wire to keep them away from the rats. The walls of the shack were decorated with calendars, bridles, lariats, rodeo posters, steer horns, snapshot of kinfolk and pictures of movie actresses. The walls were literally covered with these artistic gems.

My host's portable phonograph furnished music, and we dined to the rollicking refrains of "The Death of Floyd Collins" and "The Letter Edged in Black." The supply of needles was pretty well exhausted as he had not been to town for well over a month.

The door of his shack was scratched and penciled with notices that numerous wayfarers had scrawled

to inform him that they had appreciated his hospitality during his absence. Often, he said, he returned home to find his supper already prepared — the unknown cook having eaten his share and gone. One note on the door read: "Had plenty to eat and stayed all night. Why the _____ don't you stay at home?" He had gone to headquarters for a couple nights and returned to find the note.

"Who wrote it?" I asked.

"Darned if I know," he said, unconcerned. There are no padlocks in his country.

He had one bed laid out in a canvas tarp greasy with horse sweat; over this, to serve as a fancy bed-

spread, was a Navajo saddle blanket well-matted with the hairs of various colored horses. When bedtime came around he was very apologetic.

"I haven't got any spare beddin'," he said. "But I'll split the blankets with you. My bed's dirty, but it's comfortable."

Cowboy courage is best demonstrated at the rodeo. You sit on the firm and secure tiers of the grandstand. You gaze at the man in the arena striving to stay in the plunging and heaving seat of a contest saddle cinched to a bucking horse educated into doing his meanest. And your pulse quickens as a bull-dogger lands on the horns of a steer, is dragged through the dust across the arena and who is unconscious of the danger he is braving in order to wrestle the brute to the ground. That, onlooker, takes one thing — unpoetically called "guts."

Tex Austin, the famous rodeo promoter, tells of an incident of cowboy courage at one of his numerous rodeos. A contestant received a broken leg and was taken to the hospital. On the operating table he refused to take ether and could not be talked into it.

"Why man, when we set your leg the pain will be terrific. You can't stand it," they told him.

Nevertheless the cowboy would not consent, and the doctor worked on him without administering an anesthetic. He gritted his teeth and agony was expressed on his face as his leg was set.

"What was the matter that you didn't want to take that ether?," he was asked after the operation. "It hurt, didn't it?"

"Well," the cowboy explained, "to tell you the truth I had eaten some blackberry pie for dinner and I figured that if I took ether after eating blackberry pie it would make me sick."

The old-time cowboy is a character who will soon live only in history, and it is up to the modern

cowboy to carry on the work that he pioneered. Strong men go and strong men are here to take their places. Pioneering in the American West has gone forever; modern utilities have penetrated the remotest desert wastes. The range cattle industry has adopted up-to-date methods and the cowboy is in tune with the times.

But there are ranches in New Mexico today that have single pastures as large as 40 sections (40 square miles). It still takes a lot of riding to make a drive in a 40-section pasture. Broncs are still just as "ornery." Some outfits work cattle in a "chute" and others prefer the old method of "cutting out" on horseback. Trail herds graze and chuckwagons still rumble over the long miles of New Mexico's vast grazing area. The West still lingers here — and as long as it lingers so will the cowboy — the modern cowboy.

Young waddies today will be punching cattle when they are gray-haired old-timers; after that, cattle will bellow within earshot of their graves. One old-time cattleman of Lincoln County, an expert stockman, a splendid gentleman and one of the kindest bosses I've known, expressed to his family before he died that he desired his body cremated and his ashes scattered on the pasture of his ranch.

"Because," he said, "I like to meet 'em at the water hole."

Cowpunching is a man-sized job — all the world knows that. It has its joys and woes, but when the woes come along you seldom hear a squawk. A famous cowboy, as he stood night guard over a herd of horses in the pelting rain, preached a sermon to his partner from the pulpit of a rainsoaked saddle.

"What's the use of bellyachin'," he said. "There's only you, me, God and the broncs out here. Our trouble's too small for God to notice, and the broncs just naturally don't give a damn."

Of course there's no use bellyaching, cowboy, because you wouldn't want to do anything else but punch cows even if you got a chance. You're here to ride a tough job when it bucks the hardest, never pull leather, and stay a long time.

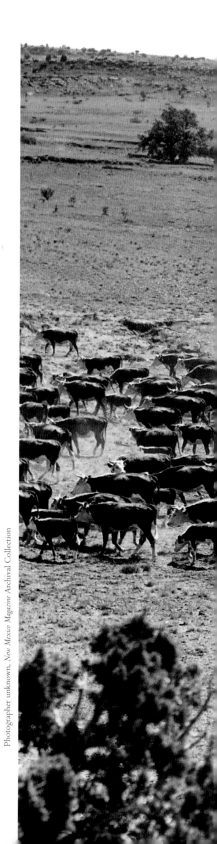

RIGHT — COWBOYS HERD CATTLE ON THE EASTERN PLAINS OF NEW MEXICO TOWARD BRANDING CORRALS, WHERE THE YEAR'S CROP OF CALVES WILL BE CUT OUT, BRANDED AND EARMARKED BEFORE BEING TURNED LOOSE AGAIN TO FATTEN UP ON THE RANGE. THIS PHOTOGRAPH, TAKEN SOMETIME IN THE LATTER 1930S, SYMBOLIZES THE END OF AN ERA WHEN COWBOYS PERFORMED THEIR JOB "THE OLD-FASHIONED WAY" AND DIDN'T HAVE THE OPTION OF TECHNOLOGY TO TRUCK CATTLE FROM ONE FARAWAY RANGE TO ANOTHER OR TO THE MARKET.

Photographer unknown, *New Mexico Magazine* Archival Collection

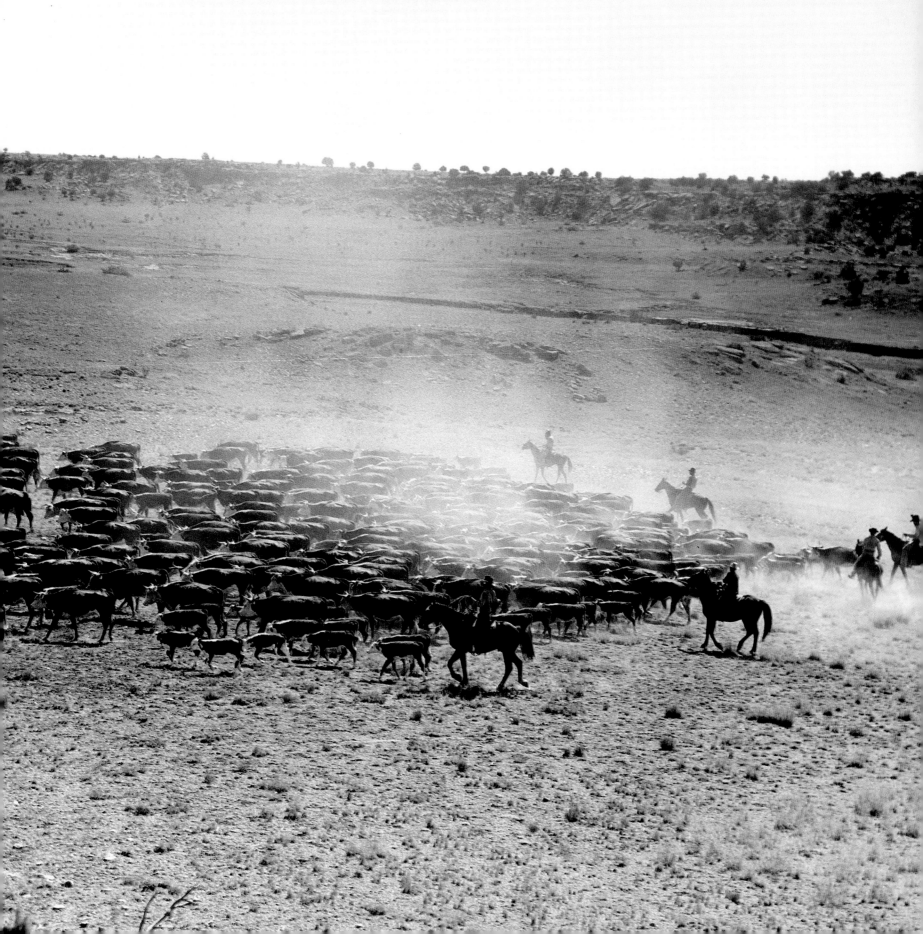

# BOB LEE

Many people think that all cowboys are tall, lanky and move with that certain walk that says, "I'm a cowboy!" Bob Lee of Datil fits that description. But that's all image. When you see Bob working with horses in the round pen or working with a rope and an iron in the branding corral, then you really see a cowboy.

Bob was born in Denton County, Texas. When he was in his early teens during the Depression, Bob began his cowboy career on the C-N Ranch. To this day he still has that Texas cowboy drawl. During World War II, the then-Texas cowboy met his wife Anah while he was in Oregon. They were married in 1945.

After the war Bob did some rodeoing, riding bucking horses. In fact, he was good enough to make it all the way to the Calgary Stampede. But Anah says, "I couldn't take it. It scared me."

By 1947 they were "moving around a lot" and Bob worked on quite a few ranches over the years. For about 40 of those years he worked the Bodenhammer Ranch and the York Ranch, north of Pie Town, near the Continental Divide west of Socorro.

It wasn't until 1992 that the Lees bought their own spread, just east of Datil and far enough off the highway for lots of privacy. It is the first ranch that they've ever owned. Before they settled in they raised seven children – two boys and five girls.

Over the years Bob has formed some pretty strong opinions about modern-day cowboys and ranching. He thinks the lifestyle has surely changed and today, "It's more or less like the movies . . . People only cowboy because it's fun and they never ever learn how," Bob says.

And this tried-and-true cowboy knows the difference between a real rancher and a non-rancher who happens to own lots of cattle. Bob thinks that all you have to do is help someone gather once and you'd sure tell "whether he's a cowman, a city feller or a drugstore cowboy."

Bob remembers that when he was just a kid he learned to cowboy the old-fashioned way. "When I grew up with those old cow people," he says, "they took you around with them and they never said much, but when they told you something, they only told you once and you damn sure better listen."

According to Bob, too many modern cowboys think that "being a cowboy is getting on a horse and loping him to death and then going to town that night and getting drunk and raising hell."

Bob Lee is a cowboy from a different era. In their comfortable home with pictures of horses and the cowboy life, and the ever-present coffee pot in a neat and functional kitchen, Bob and Anah Lee represent a time we should never forget.

– Joel H. Bernstein

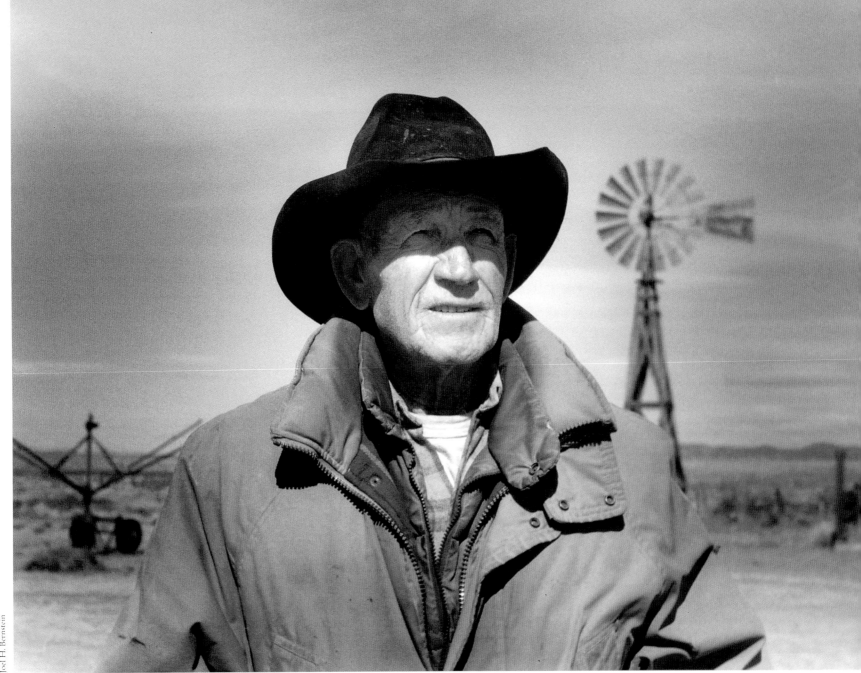

23

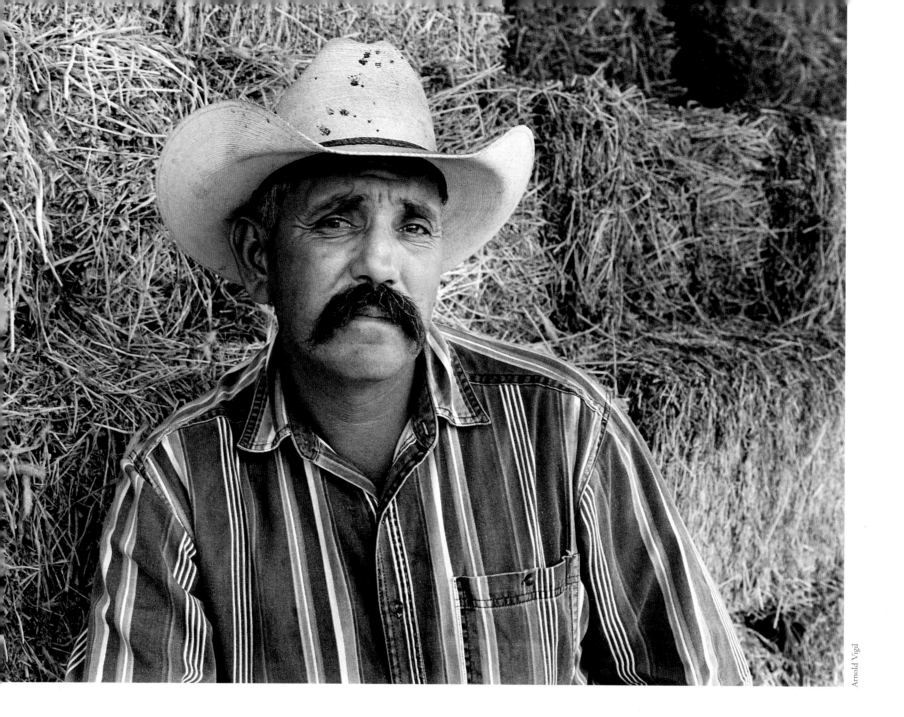

# CARLOS ORTIZ

For Carlos Ortiz, the cowboying and ranching lifestyle is all he's ever known ever since he was thrust into it as a boy. Carlos was just 6 years old when his father died, leaving his mother and her children with a working ranch in Trementina, a small ranching and farming community nestled amongst the plains and mesas between Las Vegas and Tucumcari.

Carlos said he grew up taking care of the place with his mother and he still runs that same ranch today, along with another spread where he lives east of Tucumcari. The cowboy lifestyle seems to suit him the most in his family as his older brothers and sisters prefer to live in the city away from the dogies.

Even just a casual look at Carlos mounted on a horse rounding up cows on the pasture leaves one with a definite impression that this cowboy knows what he's doing.

This seasoned cowpoke is quite in demand as a day worker during the spring and fall, the busy branding and roundup seasons for most of the large and small Tucumcari-area ranches.

The 40-year-old *vaquero* spends the rest of his time taking care of his two ranches. "There's no better life, I'll tell you," Carlos says with conviction.

Carlos hopes his 19-year-old son Joe Dan will also become enamored with the cowboy way in his adult years, especially after the older Ortiz builds up the family ranch. But in the meantime, Carlos jokes, Joe Dan's working in Albuquerque as an apprentice electrician "making the big bucks."

"I think later he'll come back to the ranch," he says hopefully, adding that his 22-year-old daughter, Johnna Lee Voss, is married to a cowboy in the area.

His wife Netta works full time at a local hospital to supplement the feast-or-famine income Carlos makes at ranching. But she spends most of her free time working with Carlos on the ranch.

**– Arnold Vigil**

# STANLEY KEDELTY

Born with the obvious features of his Native American heritage, Stanley Kedelty is proud to be a tried-and-true cowboy as well as a Navajo. Stanley's father instilled the ranching lifestyle and Navajo tradition in him while he was growing up in the Wheatfield area of the Navajo Reservation in eastern Arizona.

Today, the 54-year-old cowboy lives in Crystal, N.M., north of Gallup, with his wife Theresa. Together, and with Theresa's father, 17 of her brothers and sisters and their respective children, they ranch and dry farm a section of land on the Navajo Reservation that her family's been working for at least a century. Adhering to Navajo custom, Stanley left his home to live and work alongside his wife's family in her neck of the woods.

"My dad pretty much had horses around when we were growing up," Stanley says of his childhood. "He taught us the ritual of getting up early in the morning, feeding the animals, looking for the horses. We just continued that."

Both Stanley and Theresa work as principals at schools in eastern Arizona. But come weekends and days off, it's back to Crystal and the ranching responsibilities that continue to be their lifelong love. There was no big change for Stanley when he married Theresa and uprooted to Crystal, where they've raised two bona fide ranching daughters, Michelle, 27, and Leslie, 28.

"I'm pretty convinced that this kind of lifestyle teaches our kids more responsibility," Stanley says. "Our neighbors' kids grew up watching TV. Often they're getting in trouble compared with ranch kids who seem to be better responsible."

Stanley remembers a time in his late 20s when he was chasing a herd of horses with his brothers and the horse he was riding fell on him and trapped his foot in the stirrup. He says his foot swelled up so bad that they had to cut his boot off to treat the limb.

He never considered giving up horseback riding because of the accident, however, and he got right back in the saddle as soon as he could walk again. Today, he rides horses excellently with no lingering fear of repeating his earlier accident.

Today, with plenty of his own and his family's children around to teach the cowboy and Navajo ways of his ancestors, Stanley is determined to keep both traditions alive.

– Arnold Vigil

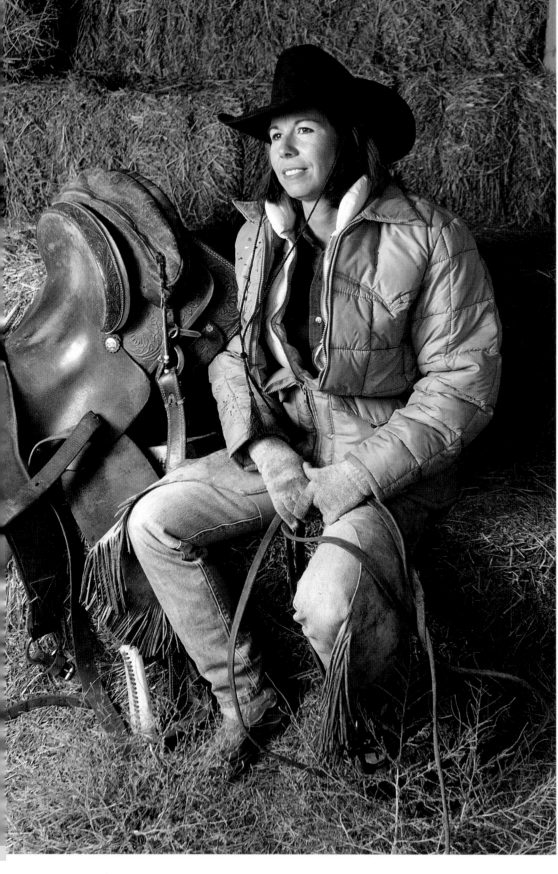

28

# FAWNA LEE SPEER

Fawna Lee Speer raises world-class athletes in Clovis who can race like the wind and turn on a dime, but they're not Olympic sprinters or professional basketball players – they're barrel-racing horses.

Fawna Lee has a knack for turning young animals into champions over the course of a year or two then selling them at high prices, often to young women who can potentially earn thousands of dollars from their investment on the rodeo circuit.

The horse is big business, but Fawna Lee says she's not in it for the money. "I like a challenge, that's what keeps me going all day in the hot or cold." She also works as a Clovis firefighter – 24 hours on and 48 hours off – reaping the steady paycheck and benefits for her family.

Born in El Paso, Texas, in 1958, Fawna Lee was an only child whose mother never rodeoed, yet somehow imparted the knowledge of riding to her daughter. Fawna Lee says she spent "daylight to dark" on a horse, winning her first pair of boots in an all-around category at age 4. She took home two saddles as a 12-year-old, and holds an arena record of 13.4 seconds in a barrel-racing competition in Canada.

During the summer before Fawna Lee graduated from Ruidoso High School, she and her mother logged 30,000 to 40,000 miles on the road in search of their next event. She attended college on four, full-scholarships for rodeo.

The nomadic lifestyle continued after Fawna Lee and her husband, Jerry, were married in 1980. He trains team-roping horses. "We took the kids along branding at night because we couldn't afford a babysitter," Fawna Lee recalls. Their children, Kelly and Coy, are now in their teens.

Fawna Lee says she looks for a certain personality in the horses she trains. "I show them what I want, but I don't overdo it." She and her husband routinely haul young animals to shows even when they're not competing, to get them used to the hustle and bustle of the crowds.

Racing across an arena at top speed is exciting, Fawna Lee says, but she adds, "I always want control. If I'm running that fast, I want to have control."

The 41-year-old compares her riding style to that of her daughter, who goes full-out. "Very few people sit as still and quiet as I do. It's so fluid. I'm always looking two steps ahead."

Fawna Lee thinks of her horses as individuals, and sometimes has a hard time letting them go. "People tell me the horses pine for me after they're sold, and one even throws kisses at me when he sees me."

Now how many coaches can say that?

– Cathy Nelson

# BILL JONES

Bill Jones is a real-deal cowboy. The 84-year-old New Mexico cowpoke was raised on a ranch in southern Otero County and he vividly remembers his first paid cowboy job when he was 12 years old. He worked with a branding crew for the now-defunct Circle Cross Ranch on the western slopes of Sacramento Mountains.

"There was 22 men an' two of 'em Mr. (Oliver) Lee fired before they could get across the first little draw because they were mean to their horses," Bill remembers. "He was sensible enough to know that he couldn't reshape all of those men, but he could damn sure get rid of 'em."

Each member of the wagon crew had a job to do, from the youthful Bill to the cook to the wagon boss to the horse wrangler.

"Sometimes you'll ride 10 miles before you get to the pasture (where) you want (to gather) the cows," Bill says. "Sometimes you start pickin' up cattle as soon as you leave the wagon.

"An' say a thunderstorm came up. One man couldn't hold 'em. If a thunderstorm come up (and) it just rained on the cowboys, that'as all right. They kept workin'," Bill remembers. "If it rained on the remuda (my dad) sent someone right quick to go help 'em. Help him hold his horses. Cause they'da run from a rainstorm you know."

After three months of rounding up and branding, Bill said the work crew prepared themselves for the next round of work without a break.

"It didn't get over with until about the first of September . . . When you went to shipping, you wouldn't need quite as many cowboys on as they did when you branded," Bill recalls. "So, they laid off cowboys accordingly, an' sometimes there'd be enough already fired or quit or somethin'. They'd just go on with the same crew."

Bill later married his sweetheart Panzy Courtney and they bought his parents' Mulberry Ranch in southern Otero County, where they moved and worked full time in 1961. He remembers signing the papers to purchase the small ranch from his mother and father as the happiest day of his life.

The couple retired in 1992 and moved to Alamogordo, where Panzy later passed away in the spring of 1999. Bill no longer rides horses, but the colorful memories of his riding days continue to occupy his thoughts. Although cowboying often was a grueling and tough job, it's certain Bill Jones wouldn't have been as happy doing anything else.

– Jane O'Cain

OPPOSITE – BILL JONES AND HIS SISTER PANSY LEE ON THE B-LEWIS RANCH IN THE SPRING OF 1935.

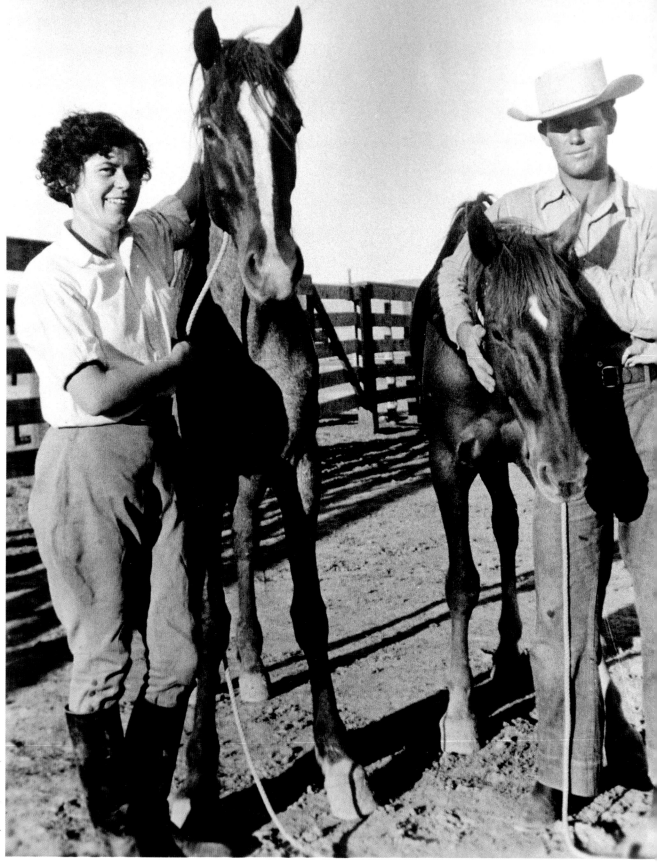

32

# TOM BROWN

Tom Brown is living his dream in the same pine-covered mountains Billy the Kid and Smokey Bear made world-famous near Capitán in south-central New Mexico.

Born the son of a farmer in 1966 in Pine Bluff, Ark., Tom found the prospect of endlessly plowing fields to be too tame and monotonous for his adventurous soul. He abruptly declared to his family at age 5, "This is boring. I'm going to be a cowboy."

Now he is.

"I read all the books as a kid" about being a cowboy, recalls Tom, who says he always had horses as a child. "Everybody wants to be a cowboy. Eighty percent of the population wants the other 20 percent's lifestyle."

After working for Cowboy Hall of Fame cutting-horse trainer Jimmy Orell while in high school, then attending college in Louisiana, Tom worked in Texas for three years, sleeping under the stars, rounding up cattle and branding calves.

"I thought it was all fun," Tom says. "The pay wasn't that good, but the food was great. Those chuckwagon cooks, they sure know how to make those sourdough biscuits."

One time, his horse slipped on a patch of rock. Both horse and rider landed hard, and Tom got knocked out. "When I woke up, I thought, 'That wasn't so tough, I should be at the rodeo.'"

He competed successfully in both cutting horse and saddle bronc events, turning pro in 1992. But an injury suffered in 1998 took him off the circuit for a while.

Tom now buys, sells, trades and breaks cutting horses northwest of Capitán, while leasing part of a ranch in nearby Corona. His wife, Becky Washburn-Brown, is a veterinarian. He often accompanies her on calls, some of which might last all night.

Caring for three-dozen horses, along with two miniature ponies and an endless parade of dogs, doesn't seem to bother Brown. Neither does the prospect of packing in hay on horses during a hard New Mexico winter.

Asked whether he would willingly return to the pioneer days of the late 1800s, he quickly answers, "Oh, yes. I'd own the country!"

— Cathy Nelson

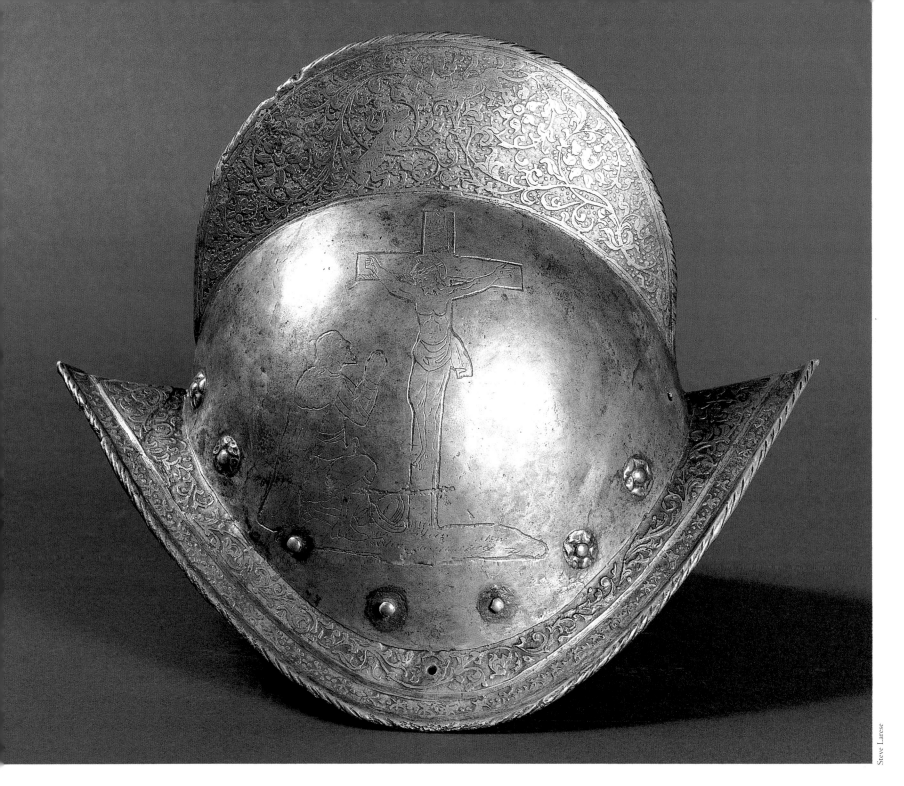

ABOVE – THE FIRST HORSEMEN TO VENTURE INTO NEW MEXICO WERE SPANISH CONQUISTADORES WHO WORE METAL HELMETS SIMILAR TO THIS MORION BELIEVED TO HAVE BEEN BROUGHT TO THE AREA WITH THE DON JUAN DE OÑATE EXPEDITION OF 1598. ACCOMPANYING THE SPANISH SOLDIERS WERE *COLONISTAS* WHO CONTINUED THE OLD AND NEW WORLD *VAQUERO* LIFESTYLE AND BECAME THE FIRST COWBOYS IN WHAT IS NOW THE WESTERN UNITED STATES. (JOINT PURCHASE/COLLECTIONS OF THE PALACE OF THE GOVERNORS; COURTESY OF E. DONALD AND JANET B. KAYE, NATIONAL SOCIETY OF THE COLONIAL DAMES IN THE STATE OF NEW MEXICO, AND THE MUSEUM OF NEW MEXICO FOUNDATION)

**W**HEN THE SPANISH FIRST BROUGHT THE HORSE TO *NUEVO MÉJICO* IT CHANGED LIFE ON THE NORTHERN FRONTIER OF NEW SPAIN — FOREVER. THE APPEARANCE OF MEN ON HORSES WAS A SIGNIFICANT DEVELOPMENT IN THE HISTORY OF THE AMERICAN WEST. IT REVOLUTIONIZED THE LIVES OF THE INDIGENOUS PEOPLE OF THE *LLANO ESTACADO* (STAKED PLAINS) AND ESTABLISHED A SPANISH-INFLUENCED COWBOY CULTURE THAT STILL SURVIVES TODAY.

The Spanish tradition of horsemanship precedes the discovery of the New World. In the spirit of Cervantes and *Don Quixote de la Mancha*, the man on horseback was the very essence of military and political authority in the Spanish world of the 16th and 17th centuries. This enduring philosophy endowed horsemanship and equestrian values and practices with the highest possible status in Iberian society. The Spanish conquistadores brought these beliefs with them to Mexico and to what is now the American Southwest.

When Hernán Cortés landed on the shores of western Mexico in 1519, 16 horses were unloaded from the ships. These horses were the descendants of those brought by Columbus to Hispaniola on his second voyage. Bernal Díaz del Castillo, the chronicler of this historic event and the author of *The Discovery and Conquest of Mexico*, described the breed as "sturdy, short-backed, legs not too long, strong enough to carry a man in armour and a heavy, but comfortable Moorish saddle."

Díaz recorded that the horses had names like *El Rey* (the King),

# *VAQUERO:* The Original Cowboy

by Michael Miller

*Roldanillo* (little Roland) and *Cabeza de Moro* (Moor's head). More importantly, these magnificent animals were considered to be crucial to the Spanish military strategy against the *Azteca* Empire. They were thought to be "the nerves of the wars against the natives" by the Spanish soldiers who rode them.

This strategy proved to be effective. Horses took on divine powers and were often believed to be gods among the native people. Historic documents confirm that in one incident Montezuma, the leader of the Aztecs, was appalled by a report that "the deer" the strangers rode were as "high as the rooftops."

In another report, against Mayan warriors, one Spanish soldier was mistaken for a centaur and even the Castilian soldiers who accompanied him envisioned a miraculous image of Santiago (St. James, the patron saint of horsemen), coming to assist them as he had done so many times in battles in Spain against the Moors. The horse became an important psychological weapon for the Spanish, who used the animals time after time to conquer native groups in the Americas. Following the conquest of Mexico the Spanish moved north. Several expeditions were launched into the frontiers of northern New Spain and the horse continued to play a prominent role on each journey.

The Spanish were fond of their horses. On the Coronado expedition of 1540, Francisco Vázquez de Coronado led his party to *Nuevo Méjico* on a dashing black stallion that was said to be valued at more than 100 gold pesos. This impressive steed became the explorer's favorite. It was loaned to him from Cristóbal Oñate, the father of Juan de Oñate, the future colonizer of *Nuevo Méjico*. Coronado reportedly suffered great distress when the horse died on the return journey to Mexico.

On Jan. 26, 1598, Juan de Oñate led an expedition of 500 people, 82 wagons and more than 7,000 farm animals from Mexico into *Nuevo Méjico*. This event marks the first major trail drive into the region and opened the way for permanent colonization of the province. Ranching quickly became an important part of this settlement pattern and soon large herds of cattle and sheep were common sights on the open range.

With ranching came the centuries-old traditions of horsemanship so cherished by the Spanish as a way of life. On the frontier, conditions demanded that the rancher and his *vaqueros* (cowboys) spend most of the working day in the saddle. The 17th-century rancher depended on his horses to transport both people and supplies. Pack strings supplied the sheepherders on the open range and cattle needed constant attention that only could be handled by men on horseback.

Finally, there were the herds of horses made up of brood mares, the young stock and spare riding horses that needed constant supervision to keep them from wandering away, being stolen by Indians or destroying crops in unfenced fields. In this way the age of the cowboy was born in New Mexico.

Raising, breaking, handling and using horses, and the constant attention given to herding and caring for cattle kept the colonial *vaquero* busy. To finish the work, *rancheros* looked to local Indian populations for help with the stock, especially around the corrals and stables. It was against Spanish law for Indians to ride horses in New Spain, but the sheer isolation of *Nuevo Méjico* encouraged violations of this law. The need for horsemen was great and colonial ranchers encouraged Indian helpers to ride out for livestock and to help with horses on long cross-country trips. Young Pueblo men were eager to cooperate at first until the work became too harsh and abuse by Spanish citizens became excessive.

Some of the Pueblo *vaqueros* rebelled against the constant labor demands and abuse. Because the Spanish had control of most of the Pueblo villages these rebels were forced to steal the strongest and fastest horses in the herd and escape to the camps of the Plains tribes living to the east and north. Many of these fugitives were welcomed by their Plains Indian brothers, and their well-trained horses and experience in handling the animals became an incentive for alliances between the Pueblo and the Plains people. The Pueblo horsemen could teach their new friends much about horses in a very short time. As soon as the Plains tribe became accustomed to handling horses they could go out and steal more from the Spanish to build a herd of their own. In a span of just five to 10 years the entire tribe became skilled horsemen.

Spanish archival records tell of numerous accounts of Pueblo runaways. Sometimes entire families fled from Spanish oppression, also joining Apache and other nomadic tribes. In addition to teaching them about horses, the Pueblos also shared their knowledge of gardens, lodging and pottery. This set of circumstances set up a network of trade and communication among the various tribes. When one Plains tribe had enough horses they would trade them to another tribe and teach them the art of horsemanship. Soon, nearly every tribe on the *llano* had secured horses, dramatically changing the lives of the Plains people.

The Pueblo Revolt of 1680 escalated this process significantly. The Pueblos drove the Spanish out of *Nuevo Méjico* for 12 years and captured most of their livestock in the process. Several Apache bands took large numbers of horses as a share of the booty for helping in the revolt. In two or three years, thousands of horses reached the Indians of the Great Plains and they became great hunters and warriors. This greatly enhanced their lifestyles and increased their potential to thwart further Spanish settlement and expansion.

With the complete reconquest of *Nuevo Méjico* in 1695, the Spanish resumed colonizing the province. However, settlement was often restricted to the security of the Río Grande Valley. Here, military men could protect the established *villas* and *ranchos* from the skilled Plains warriors who now fought and raided both Spanish and Pueblo settlements alike on horseback.

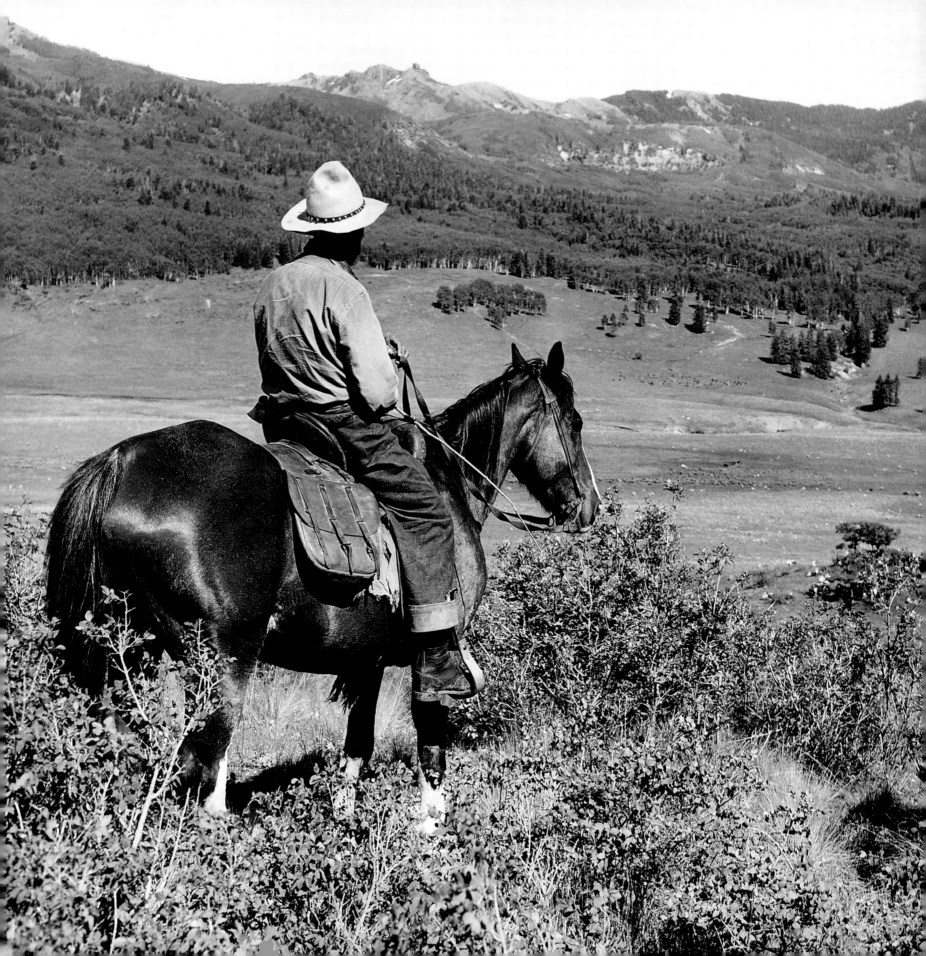

Photographer unknown, *New Mexico Magazine* Archival Collection

Ranching continued to expand after the revolt and became important economically for colonial New Mexico. The Spanish and Pueblos created alliances on the frontier to protect themselves from the raids of the mounted Plains tribes. As a result, the Hispano horse and cowboy culture changed with the times. As ranching became more economically important to the province, new and better equipment to support ranching and cowboys arrived in New Mexico. Horse gear was used for frontier travel and equestrian equipment provided protection and comfort for the horse and rider.

Saddles have always been the essential link between horse and rider. The *silla de montar* (saddle), made for gentleman riders or *charros*, displayed a large horn, heavy housing and rich ornamentation. *La silla vaquera* was a Mexican-designed work saddle made for use on large ranches. This saddle was a skeletal, cowboy type; it had a small horn, light housing and little ornamentation.

The *charro* saddle was used by gentlemen to show off performance skills, their taste in the finer things, and to draw attention to the horse and the rider. The *vaquero* saddle was designed for long days of riding and rounding up livestock. Both pieces of equipment communicated the ideals of the proud heritage of Hispanic horsemanship. Many horse accessories were developed to assist the *vaquero* in his work and to showcase the *charro* in performances. *Estribos* (stirrups) were not essential for riding, but they aided the rider in mounting, provided balance and produced direct force essential for work and combat.

Three types of stirrups were used. The toe stirrup is a loop or peg tied to the end of a rope that runs between the big and first toe. The foot stirrup is more rigid with an arch, sometimes closed in front, and is hung from a wide strip. The cross stirrup (*estribo de cruz*), made of forged iron and so named because of its cross shape, is decorated with cold-chisel stamping and punchwork. *Espuelas* (spurs) were a part of the *vaquero*'s everyday necessities. Their decoration was often of Moorish-Spanish influence, combining geometric inlays, scalloping on the heel arch and hexagonal piercing on the shanks. The design, however, was more 19th-century Mexican, consisting of a straight shank, a tubular section of the heel arch and silvery end attachments. The purpose was to provide force on the horse with a single motion.

*Botas* (leggings) provided protection around the shins of the cowboy and protected him from dust, scratches and kicks. The heavy leather was wrapped around the rider's lower legs and tied with thongs.

LEFT – A *VAQUERO* WATCHES HIS CATTLE GRAZE ON A NORTHERN NEW MEXICO MOUNTAIN PASTURE IN THIS PHOTOGRAPH TAKEN SOMETIME IN THE LATE 1930S. SUCH SIGHTS WERE MORE COMMON DURING THE COLONIAL AND MEXICAN PERIODS OF NEW MEXICO, BUT THE CONCEPT OF COMMUNAL LANDS CHANGED DRASTICALLY AFTER THE U.S. TAKEOVER OF NEW MEXICO IN 1847, WITH MOST OPEN LANDS BEING DECLARED FEDERAL AS WELL AS CHANGING INTO PRIVATE OWNERSHIP.

Some leggings were decorated with elaborate stamping on the leather with designs of vines, trees, blossoms and other motifs. The finer *botas* were reserved for *charro* performances and *charrerias* (riding exhibitions).

The *poncho* and *serape* are mixed cultural textiles from Native American and European influences. They were also essential accessories for every *vaquero* on the range. The *poncho* protected the *vaquero* from rain and snow, dust and wind, and almost any natural element that arose. *Serapes* were equally useful on the range and often served as bedrolls. Professional weavers produced thousands of these textiles for every level of society from central Mexico to the upper Río Grande. Made from wool and silk, they often contained complex weaves and intricate designs with Indian and Hispano-Moorish roots.

Every rider, from *vaquero* to rancher, *charro* to *mayordomo*, needed a *sombrero* (hat) to protect him from the sun and rain, and to display his taste and status. The broad-brimmed, highly ornamented variety became a symbol of *vaqueros* and *charros* alike. Intricate details of embroidery and cordwork were often added by Mexican hatmakers to produce a higher quality. These *sombreros* were mostly associated with *charros* and *rurales* (rural police). American filmmakers of the 1920s adopted this style in early motion pictures and created an international symbol of the well-dressed Western rider.

Many elements of *vaquero* horse gear became standard equipment for American cowboy culture. Bits, boots, rawhide lariats, quirts, bridles and romals were just a handful of the accessories adopted into the horse tradition of the American West. Cowboys everywhere adopted their equipment to the terrain, climate and work at hand. Hispanic influence in ropes, saddles and cowboy technique can be found everywhere in the United States and Canada.

It is interesting to note that *vaquero* vocabulary transcended into the American cowboy culture, creating a unique mixture of words and phrases. Many Spanish terms and anglicized Spanish words have become permanently imbedded into classic cowboy lingo. The words *chaparejos* and *chaparreras* were anglicized by American cowboys into chaps, the leather leggings worn by cowboys to protect their legs. Dally, a term used by American cowboys that means to wrap the end of a rope around the saddle horn when roping a cow, comes from the Spanish phrase *"dar la vuelta."*

A rope placed over a horse's head in Spanish is called *jaquima*. The anglicized version used by American cowboys is hackamore. A *reata* is a rawhide rope in Spanish. Anglo cowboys call it a lariat. A *cuarta de cordón* is a riding whip in Spanish, while American cowboys call it a quirt; and a fine hair rope known to the *vaquero* as a *mecate* is called a McCarty by Anglo cowboys.

Mustangs were wild Spanish cattle (*mesteños*) in New Spain and a wrangler was the man in charge of

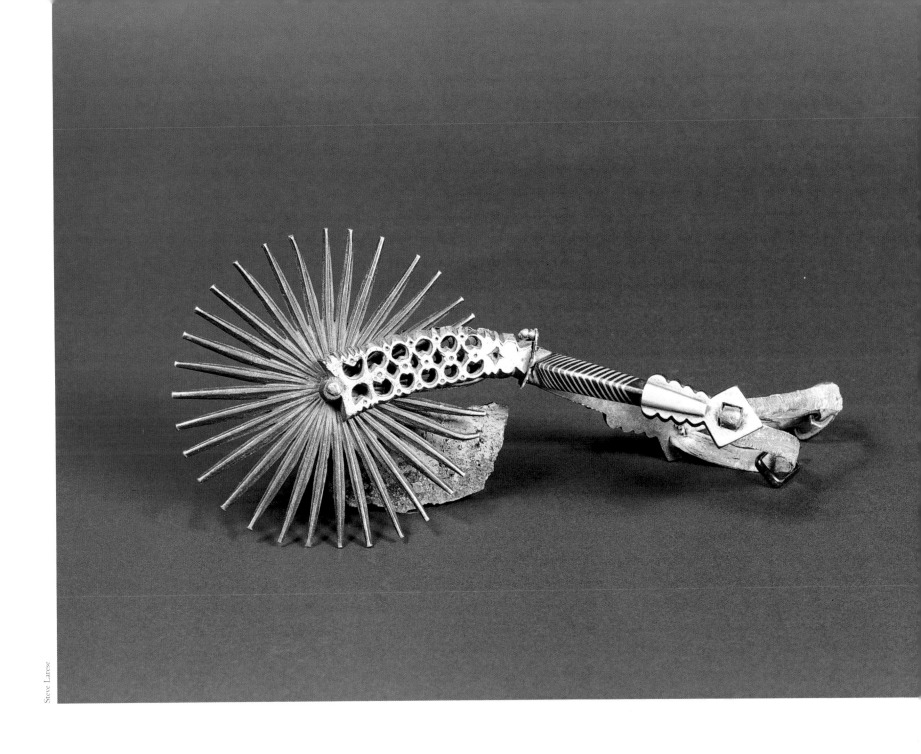

ABOVE – THIS ORNATE, "WHEEL" OR "ROSE-ROWEL" *ESPUELA* (SPUR) BECAME POPULAR WITH *VAQUEROS* IN MEXICO AS WELL AS NEW MEXICO IN THE 18TH AND 19TH CENTURIES. SUCH SPURS WERE OFTEN DECORATED WITH SILVER INLAY AND MADE OUT OF IRON. MUCH OF THE EQUESTRIAN EQUIPMENT INTRODUCED BY SPANISH AND MEXICAN HORSEMEN HAS BEEN INCORPORATED INTO MANY OF THE RANCHING TOOLS USED IN THE WEST TODAY. (COLLECTIONS OF THE PALACE OF THE GOVERNORS, MUSEUM OF NEW MEXICO, SANTA FE, N.M.)

extra mounts on a trail drive. The *mayordomo* was the ranch manager in Spanish America and the *patrón* was the boss or ranch owner in most cowboy lingo. Perhaps, the best known Spanish term still used in cowboy talk and one that has been assimilated into everyday American language is the word rodeo.

The all-American sport of rodeo has distinct Hispanic influences. From Mexico, equestrian games and contests moved into the American Southwest, but the influences on early rodeo were a combination of pre-existing Indian cultures and a Spanish heritage brought to the New World by the conquistadores. *La sortija* (the ring race) was a popular Moorish-influenced horse game that dates back to the 16th century and lasted well into the 20th century. Riders with wooden lances galloped at full speed toward a small gold ring attached to a slender thread tied to a tree branch or a lance in a large field. The rider who skewered the ring with his spear won it as a prize. In most cases, the winner rode into the audience and presented the ring to a woman he wanted to impress, much to the delight of the cheering crowd.

*El juego de canas* (jousting with canes) was an Arabian horse competition that the Spanish brought to the New World. In this game, each horseman threw a cane at his opponent while riding full speed at him. The object was to catch the competitor's cane in midair and to avoid being hit by the flying cane.

The rooster race, known as el *corrido del gallo*, was a popular horse game in *Nuevo Méjico*. A rooster was buried in the ground up to its neck. The *vaqueros* took turns galloping at full speed toward the bird, culminating in a dangerous effort to lean down from the charging horse and grab it by the head. The winner crossed the finish line with the unfortunate rooster in hand. This game became popular with the Pueblos as well, and was often played on *Día de San Juan* (St. John's Day), a popular saint's feast day in New Mexico. Recently, attempts to re-enact the game at Pueblo feast days have been protested by animal-activist groups outside of the state.

These games were the predecessors of the modern rodeo, but the line between work and play wasn't always as clear-cut on the frontier. *Nuevo Mejicano vaqueros* enjoyed showing off their riding and roping skills in a variety of games and contests. Many contests pitted *vaqueros* against cattle and horses in recreational versions of everyday ranch work. These early *vaqueros* participated in equestrian contests decades before the American cowboy arrived in the Southwest. In those days, the contests were known as *charrerias* and includ-

Arnold Vigil

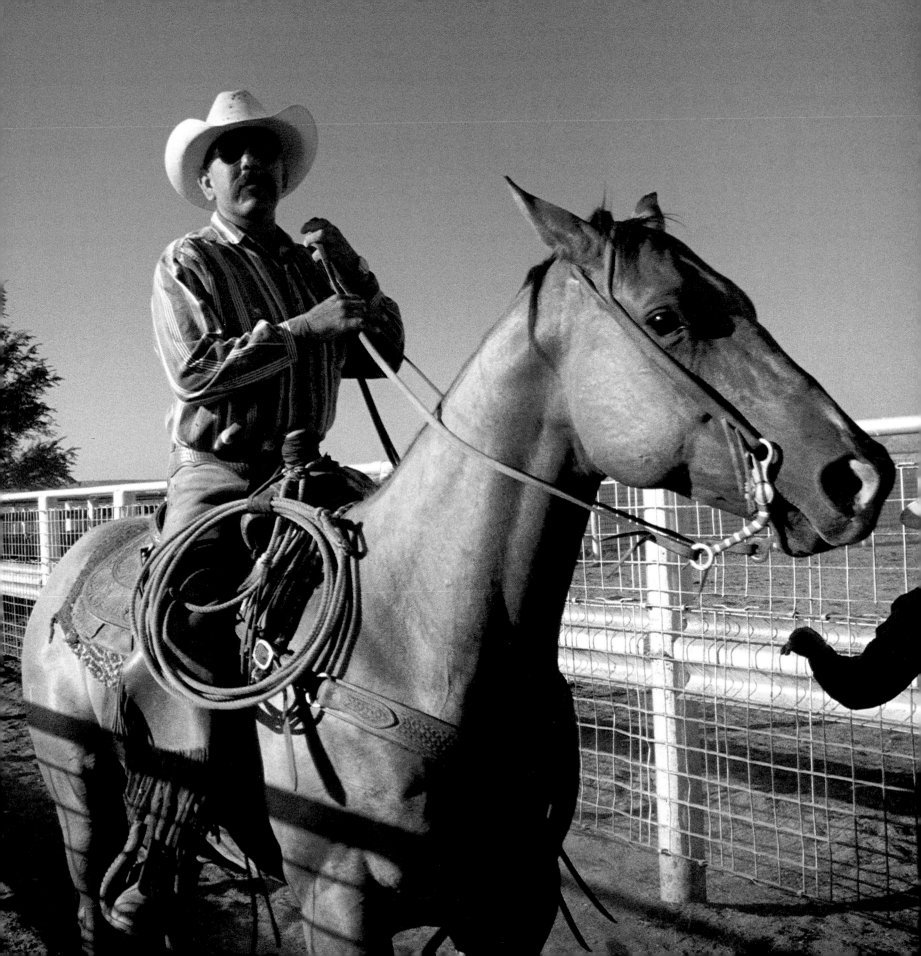

ed competitions in steer and horse roping, riding wild bulls and horses, and bull wrestling.

The skills, courage and showmanship of the early *vaqueros* were combined at their most extravagant during the roundups (*rodeos*) on the large *ranchos* located in New Mexico and throughout the Southwest. These roundups were first organized for the very practical purpose of branding livestock, but soon attracted visitors from hundreds of miles around because of the exciting competition among the *vaqueros*. Rodeos became festive occasions where *charros* dressed in their finest outfits and *vaqueros* demonstrated their skills in branding and horsemanship. Elaborate meals were served, music played throughout the day and dancing frequently lasted into the night. In addition to the actual ranch work, there were contests in *jaripeo* (bull riding), *colear* (steer wrestling), bucking-horse riding and roping.

One of the best descriptions of these early rodeos in New Mexico was written by Fabiola Cabeza de Baca in her classic work, *We Fed Them Cactus*. Cabeza de Baca grew up on the *llano estacado* in an era before American influences dominated the ranching industry. The purpose of her writing is to tell "the story of the struggle of New Mexican Hispanos for existence on the *llano*," she explains in the introduction. This exceptional book was selected by the University of New Mexico Press as a Zia Classic because of its vivid detail and authenticity. It is must reading for anyone interested in the real history of ranching and cowboys in New Mexico.

Since there are no *vaqueros* alive today who can describe these exciting events prior to the American occupation of 1847, we must rely on other sources of information. Spanish and Mexican documents often describe these early rodeos and contribute to the collective knowledge of this important American legacy. Oral history, diaries, and published and unpublished interviews from this era have also preserved this often-ignored chapter in the history of American rodeo. The evolution of the rodeo as it is known today began in Deer Tail, Colo., in 1869. According to rodeo historian Jimmy Walker, this event was "the first organized, public cowboy contest in America." Held on the Fourth of July, this rodeo gathered the best horsemen in the area for a riding contest, in which "slick saddles were used with stirrups not tied under the horses and spurs were prohibited," Walker explained in an interview.

OPPOSITE – THE SPANISH WORDS *CHAPAREJOS* AND *CHAPARRERAS* WERE ANGLICIZED BY AMERICAN COWBOYS INTO CHAPS, THE LEATHER LEGGINGS WORN BY COWBOYS TO PROTECT THEIR LEGS. MANY OTHER SPANISH NAMES WERE INCORPORATED INTO THE FAMILIAR AMERICAN COWBOY LINGO WITH SLIGHT VARIATION, INCLUDING RODEO; LARIAT FROM *REATA*; DALLY FROM THE SPANISH PHRASE "*DAR LA VUELTA*;" MCCARTY FROM *MECATE*; BUCKAROO FROM *VAQUERO*; HACKAMORE FROM *JAQUIMA*; AND MANY OTHER NAMES AND PHRASES.

Mary Lou LeCompte, a rodeo historian from Texas, tells us that a British cowhand named "Emilinie Gardenshire won the competition when he succeeded in staying on the notorious 'Montana Blizzard' for 15 minutes. Gardenshire finally subdued the bucking, jumping, pawing horse and rode around the circle in a gentle gallop to claim his prize as the Champion Bronco Buster of the Plains."

These rodeo historians surmise that the Deer Tail event and other similar cowboy contests were the forebears of modern American rodeo. Because these contests were often held on Independence Day, it reinforced the notion that rodeo was invented by American cowboys. Rodeos, *corridas* and *fiestas* featuring *charro* sports occurred throughout the American West more than 60 years before the "all-American" sport of modern rodeo was introduced.

"To acknowledge the Hispanic heritage of rodeo in America does not conflict with the widespread belief that rodeo is truly an American sport," LeCompte contends. "Rather it means that like American society generally, rodeo is a product of diverse cultural and ethnic traditions."

Most historians agree that the days of the authentic rodeos and the cowboys that worked them are gone along with the vast herds of wild cattle they tended. Working cowhands can still be found throughout the American West and some have clung tenaciously to vestiges of old-time cowboy life. Some ranchers continue to work in the saddle and make their own tack in an effort to preserve cowboy traditions.

Rodeo continues to be a popular sport not only in the West, but across the continent. The politics of ranching and interest in cowboy culture remains high in many parts of New Mexico as well as the nation and the world. With threatened loss of public grazing rights and the reduction of federal subsidies to ranchers, new challenges confront the working cowboy. Faced with the dilemma of these modern realities, many people continue to reach back for the security of a simpler life.

A good dose of cowboy mythology and history is good for the soul. And for those *vaqueros* whose bloodlines go back to the time of Cervantes and the golden age of horsemanship in Spain, always remember the wisdom of this old New Mexico *dicho* (saying), "*Caballo que vuela no quiere espuela*" (A fast horse does not need a spur).

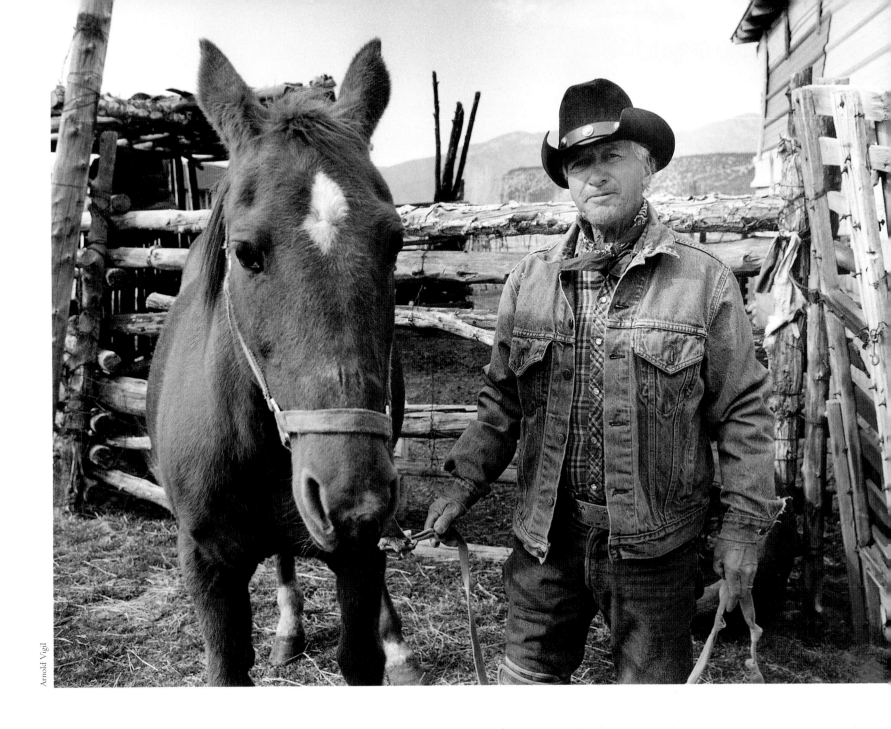

Arnold Vigil

**ABOVE** – GILBERT VIGIL OF RODARTE IN TAOS COUNTY GETS HIS HORSE READY FOR NEW SPRINGTIME SHOES. VIGIL COMES FROM A LEGACY OF *VAQUEROS* THAT DATES BACK TO THE DAYS OF DON DIEGO DE VARGAS AND THE RECOLONIZATION OF NEW MEXICO IN THE 1690S AFTER THE PUEBLO REVOLT OF 1680. GILBERT IS ONE OF THE LATEST IN A LINE OF VIGIL HORSEMEN WHO LIVED IN CUNDIYÓ, A SMALL SANTA FE COUNTY *MESTIZO* VILLAGE THAT WAS HISTORICALLY SETTLED IN THE 1700S TO ACT AS A BUFFER COMMUNITY BETWEEN HOSTILE INDIAN TRIBES AND THE MORE POPULATED SPANISH CAPITAL OF SANTA FE.

# RANDAL GATES

"Everything's BIG in Texas."

Well, that ol' cowboy saying doesn't hold a drop of water when it comes to Randal Gates, a 7-foot-tall cowboy born in Clovis and currently living with his new bride in San Jon near Tucumcari.

Randal is as New Mexico as they come and he's worked on ranches in the eastern parts of the state ever since he was a 3-footer. This friendly cowboy is quick with a smile and learned the wrangling way from his father, who Randal says has temporarily forgone the ranch life to serve as a policeman.

But the young Randal says he intends to keep the cowboy lifestyle in his blood for the rest of his life. The 24-year-old wants to save his money and eventually buy his own ranch, starting off small, maybe five or 10 acres, and adding on from there.

"It's the only life I want to live," he says. "It's a good life for a family."

Other cowboys are always quick to rib Randal about his size, but many of them admit they don't take it too far — mostly because of his size. He's the first to admit that he doesn't play basketball, but anyone who sees him will attest that he could if he wanted. Besides, who's going to tell him he can't do whatever he wants.

On an autumn day in 1998, Randal was picked up as a day worker on the Chappell-Spade Ranch near Tucumcari. The ranch manager had to provide him with the tallest horse on the spread, otherwise "he'd a been draggin' his feet on the ground."

The 265-pound cowboy was married in the summer of 1998 to Julie Pound, who hails from an entrenched Socorro ranching family. But it seems the news still hadn't soaked into his head that sunny day on the Chappell-Spade. After a half-day of helping to round up, weigh and load 500 head of cattle into stock trucks bound for Texas, he high-tailed it in the pickup back to the Chappell Spade headquarters where all the working cowboys were to be served lunch.

Randal walked in, took off his cowboy hat, sat down and was ready to dig into a well-deserved lunch of red chile casserole, tossed salad, beans, homemade bread, cheesecake and iced tea. When the ranch foreman asked him where everybody else was, he shrugged, grinned, then put on his hat and quickly left out the door — without saying a word. Randal realized that he left his new cowgirl bride and another cowboy several miles away at the worksite with no ride.

Later, while all the rest of the cowboys were already seated, swappin' stories and waitin' to eat, in walks the other cowboy, Randal and Julie, who didn't appear mad. After all, they were still newlyweds.

– **Arnold Vigil**

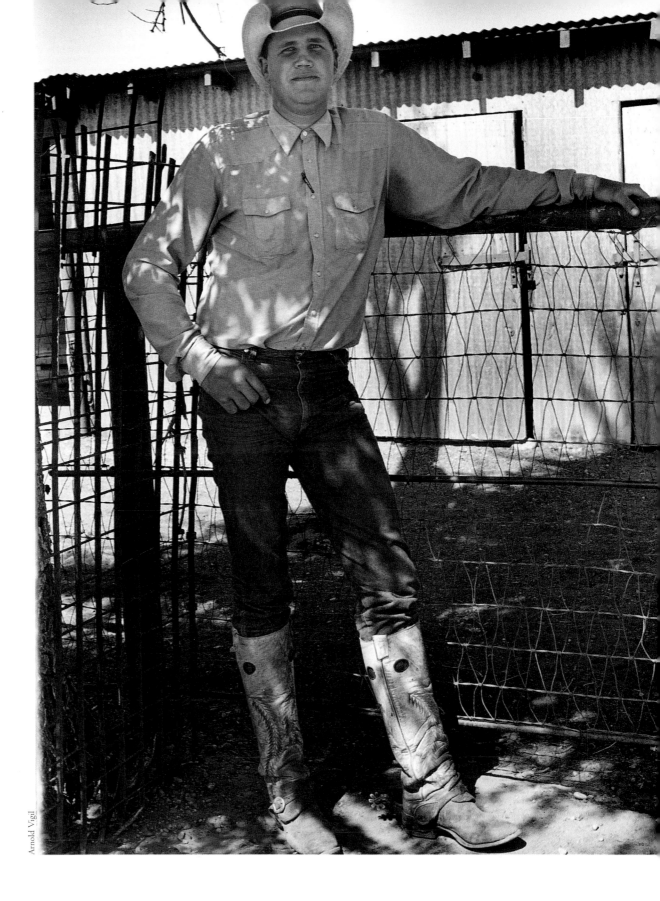

Arnold Vigil

49

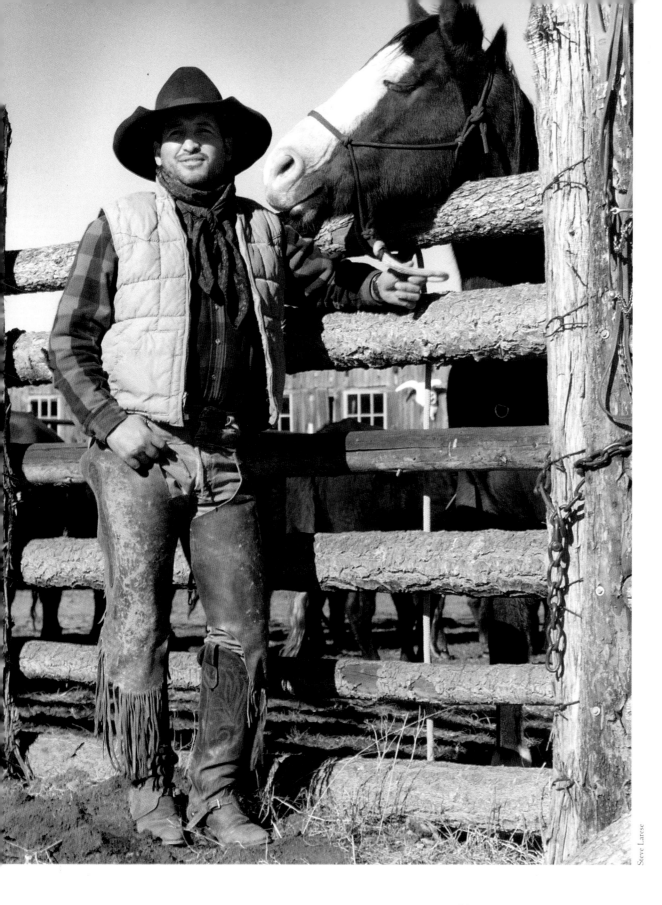

Steve Larese

# PEDRO MARQUEZ

Pedro Marquez has plenty of reasons not to desire the feast-or-famine lifestyle of a cowboy. Growing up under the city lights of Santa Fe and Española influenced Pedro to pursue and obtain a master's degree in architecture, a profession in which he currently owns and operates a successful business.

But despite the concrete and asphalt surroundings of Pedro's childhood and current profession, he was heavily influenced by his *vaquero* father Alcario, who maintained a professional career in Santa Fe and Los Alamos to provide the means to own a ranch and cattle the family worked on weekends and days off.

In fact, the 39-year-old Pedro learned how to ride a horse before a bicycle. While his schoolmates in Santa Fe and Española were chasing women and raising hell, he was chasing dogies and raising champion lambs, steers and horses. (Okay, he might've partook in just a "little" of what his classmates were doing.) Pedro twice won grand-champion awards for livestock in Río Arriba County during his teens.

Today, Pedro's success at architecture has enabled him to buy his own ranch near his father's in the border area of northern New Mexico and southern Colorado near Antonito. He plans to build up his herd and restore several historic adobe buildings that came with the property.

Eventually, Pedro will move his wife Sarah and their three children Camilla, 12, Antonio, 9, and Anna, 6, to the ranch from their home near Santa Fe. All of the kids are interested in ranching and undoubtedly will continue the Marquez tradition.

Pedro is keenly aware of the fact that he comes from a long line of Hispanic *vaqueros* who were the first cowboys in the Southwest. Thus, it is only fitting that his architecture company is currently designing the new state Hispanic Heritage Cultural Center in Albuquerque.

"Hispanic ranchers (of northern New Mexico and southern Colorado), in general, have smaller places and are more family-oriented compared with the southern (Anglo) ranchers who have larger places and are more business-oriented," Pedro says. "With us, cattle and land passes from family member to family member. That's why you often see the narrow, rectangular strips of land in many areas."

Besides hundreds of acres owned by Pedro and his father, the family also grazes land on many public allotments, including a summer section above the Brazos Peaks east of Tierra Amarilla. Pedro says they drive their cattle cross-country from the border area south to the Brazos through mostly private land and common areas of the Tierra Amarilla Land Grant — just like it's been done for hundreds of years.

Pedro says he knows that the issue of environmentalism might spell a drastic reduction or even an end to public grazing rights in his lifetime. But he says the concerns are not exclusive to one end of the argument and he is taking measures to naturally regenerate his own pastures and waterways.

"Who knows what will happen with public land. Eventually they might knock us all out," he says. "But we enjoy a beautiful Earth, too."
— **Arnold Vigil**

# BENNY PACHECO

The late Benny Pacheco was heavily influenced in his youth by working his family's small herd of cattle near Laguna Pueblo. He soon relied on those open spaces and the sense of freedom that came with that lifestyle, which also entailed never committing to marriage.

For that reason, Benny decided later in his life that being a single cowboy appealed to him the most, and he made it his goal in life to own his own ranch and herd. Benny's later experiences with sheep made him come to the conclusion that cowboying and shepherding offered him the same rewards.

Benny also worked odd jobs at construction and tanning hides for the R.L. Cox Fur & Hide Co. in Albuquerque. Later, he met Herbert Allen of Mesita, a small village on the Laguna Reservation, and agreed to shepherd Allen's herd of sheep.

In the meantime, Benny remained close with his own family and often lived with his sister Emma at San Felipe Pueblo. His strong feelings of independence, however, would never have allowed him to be a burden to anyone. Emma's daughter Marie encouraged Benny's ambition to get his own sheep camp and she and her husband Lawrence helped him locate a billy goat and ram to begin his herd.

For his campsite, Benny chose a place off the highway between Laguna and Acoma Pueblo. He gave it the Keresan name of *Shroo Wee* (the Turquoise Spring Camp in English) and it sits out of sight, behind a small mesa. Benny quickly built on his herd and ultimately left it behind for his family.

Before her Uncle Benny died in 1990, Marie promised him she would continue his legacy. Although many people in Laguna thought she would sell the animals after the death of "Grandpa Benny," as the family called him, Marie, Lawrence and their children and grandchildren (Megan, Haley, Nicole, Benjamin and Jeffrey Jr.), maintained the herd instead. She kept her promise.

Ray Abeyta, a shepherd out of nearby Cañoncito, showed up after Benny died, looking for work. He currently lives at *Shroo Wee* and helps out the family.

Marie always keeps in mind some advice Benny had given her before he died at age 73. He told her to do what he always did — talk to the sheep.

"If you listen to them, they talk back to you," Benny told her. "You might think they are stupid . . . but they're not." So Marie and Lawrence talk to them. They wonder if the sheep are having a good day and how they are feeling in the mornings.

They say it seems to work.

— **Kathryn Marmon**

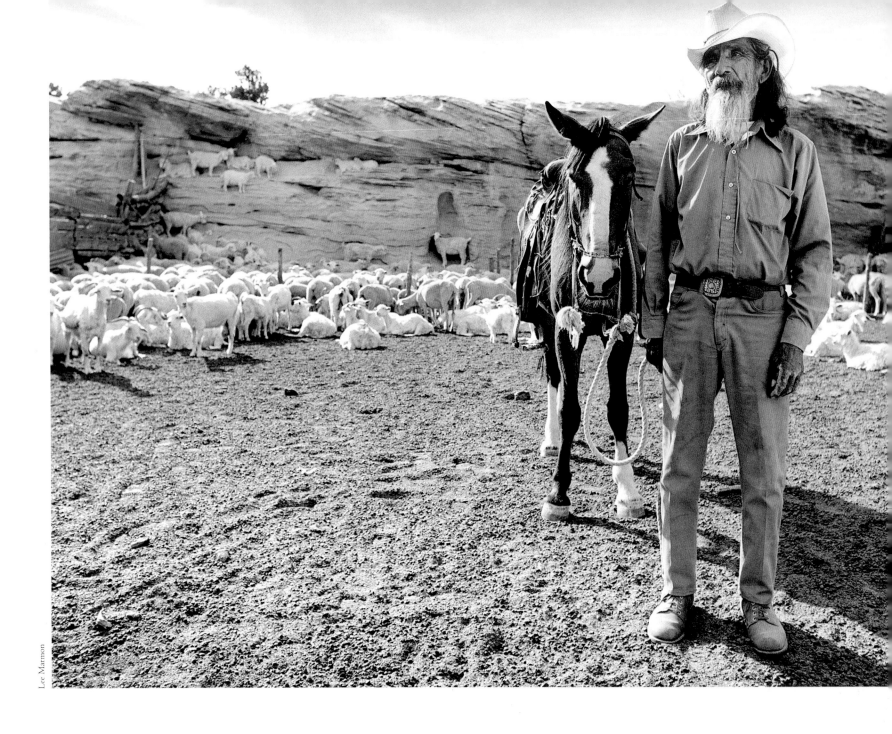

Lee Marmon

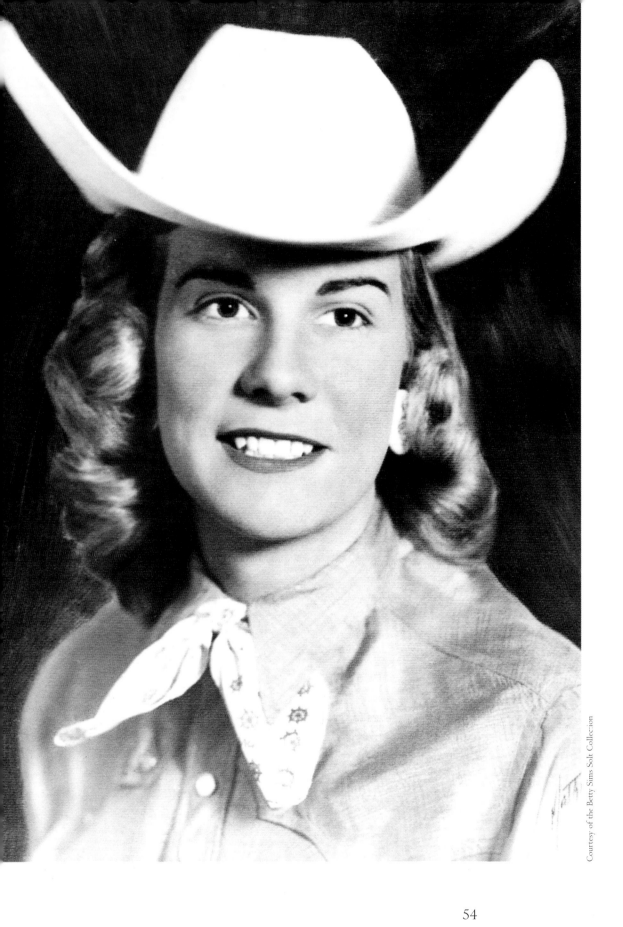

# BETTY SIMS SOLT

There's nothing like watching a horsebacked cowgirl racing across a rodeo arena as fast as her horse can run, controlling him with the reins and her spurs. A young Betty Sims Solt made quite a name for herself doing just that and she holds a place in the National Cowgirl Hall of Fame for her exploits.

Betty, a tall, graceful woman, rancher and poet, grew up living the ranch life. Her father owned a ranch west of Santa Rosa, and she entered her first competition on horseback when she was just a seventh-grader in the late 1940s. She won one of her first barrel races while her brother Richard won at bronc riding.

"I won $10 and my brother won a big bottle of hair oil, and he tried to trade me out of my $10," she remembers, fondly.

Later, throughout her high school years in the early 1950s, she participated in the annual New Mexico State High School Rodeo Association, competing in barrel racing, cutting-horse contests, the boot-and-cigar race, breakaway roping and the queen contest. She qualified for the National High School Rodeo finals all four of her school years.

In the cigar race, she remembers the girls had to pile their boots at a spot in the arena. When the race started, they'd run back to the pile, put their boots back on, then ride their horses to the opposite end, where someone waited with cigars and matches.

"You had to get off, light your cigar, and have it going, get back on your horse, and race to the other end of the arena," Betty laughs. "Whoever crossed the line first won, and you had to have your cigar going. If it was out, it didn't count.

"You would have your reins in one hand and your whip in the other, so your cigar was just in your mouth and you were swallowing that smoke, you know, and puffing. There were a lot of green girls!"

Betty, who retired from teaching and currently owns a ranch near Roswell where she still rides several times a week, continued to compete in rodeo throughout her agricultural-college years in Las Cruces. She qualified for the national college finals each year she competed and won much praise and prizes, but no cash.

"They wouldn't let us have cash because that would make you professional and you couldn't compete," Betty recalls. "But you got saddles and buckles, and boots, spurs, and hats and things like that.

"Even in college they didn't give the women the same as men. One year, I won the All-Around Cowgirl. The All-Around Cowboy got this beautiful hand-tooled saddle and I got a $10 watch. I'll never forget that one."

– Jane O'Cain

# ART EVANS

Art Evans is known as a rancher's rancher, a cowboy's cowboy. He surely is a champion chuckwagon cook and definitely one of the most universally liked and respected men in New Mexico ranching. Art Evans, although primarily a cowman, was also named New Mexico "Sheepman of the Year" by a statewide sheep-raiser organization in 1992.

Born in 1922, he grew up on a cattle ranch at New River, north of Phoenix, Ariz. Art and his wife Wanda (they were married in April, 1943 and have three children) came to the Land of Enchantment in 1953 to manage the Ladder Ranch in Sierra County, then owned by the Tovreas family, large cattle operators in Arizona and New Mexico.

In 1958, J.P. White bought the ranch and in 1960 Robert O. Anderson became the new owner. Art stayed on through all the changes until 1981, when Anderson put him in charge of the Diamond A Cattle Co.'s Sheep Division and he moved his family to Roswell.

Today Art is retired, but for a few years starting in 1992 he was rehired as a consultant by cable-television giant Ted Turner, who had bought the Ladder. No one knew that ranch better than Art Evans. During his years on the historic ranch, he's seen the range stocked with cattle, sheep and buffalo, plus some pretty fine horses. Somehow, this third-generation stockman always made a major contribution to the ranch each time it's been restocked with new diverse lines of animals.

As a chuckwagon cook, Art has been credited with cookin' up the best biscuits on the entire chuckwagon circuit. He says that he started cooking while in high school in Peoria, Ariz.

"The first bread that I ever made was without baking powder," Art vividly remembers. "We made it with graham flour, a course wheat. I was at a cow camp . . . We didn't run a wagon, but we cooked with Dutch ovens . . . We stayed 30 days at one camp and then moved on."

When Art retired from the Diamond A in 1992, they presented him a classic chuckwagon restored by John Wolfe at Crossroads, N.M., as a retirement gift. That same year Art took the wagon to Ruidoso and won prizes for the overall and most authentic wagon and camp at the Lincoln County Cowboy Symposium. In 1994 it was also named the Best Trail Wagon at the Cowboy Symposium in Lubbock, Texas.

Today, Art and Wanda live north of Truth or Consequences at Cuchillo on their Knife Creek Cattle Co., just about a stone's throw from the Ladder Ranch fence.

He still enters chuckwagon competitions while eager cowboys and non-cowboys await a chance to sample his good cowboy food, hear a tale or two from a wonderful storyteller and maybe even pick up a few pointers from a helluva stockman.

— **Joel H. Bernstein**

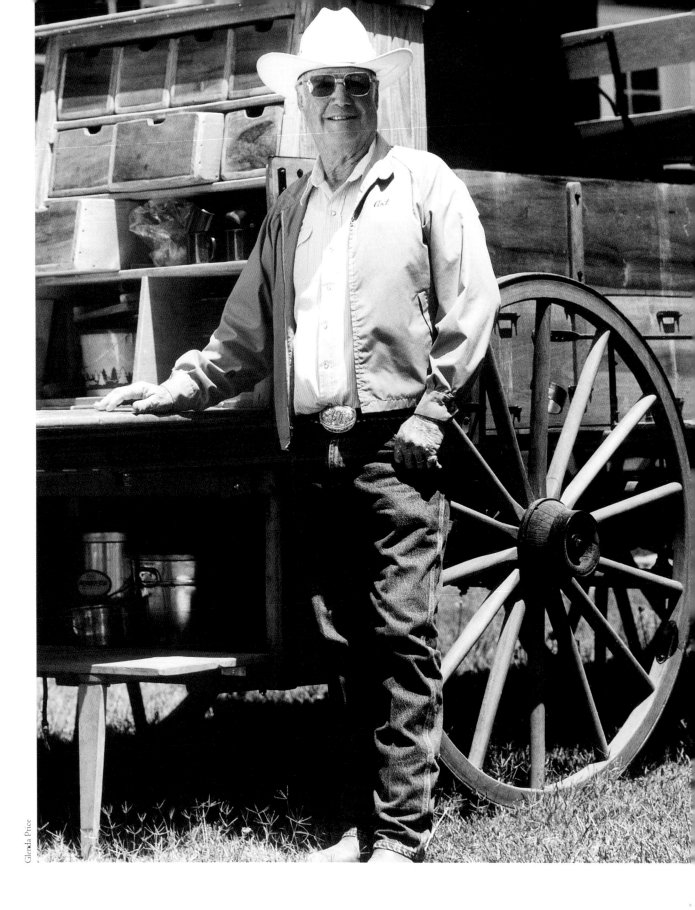

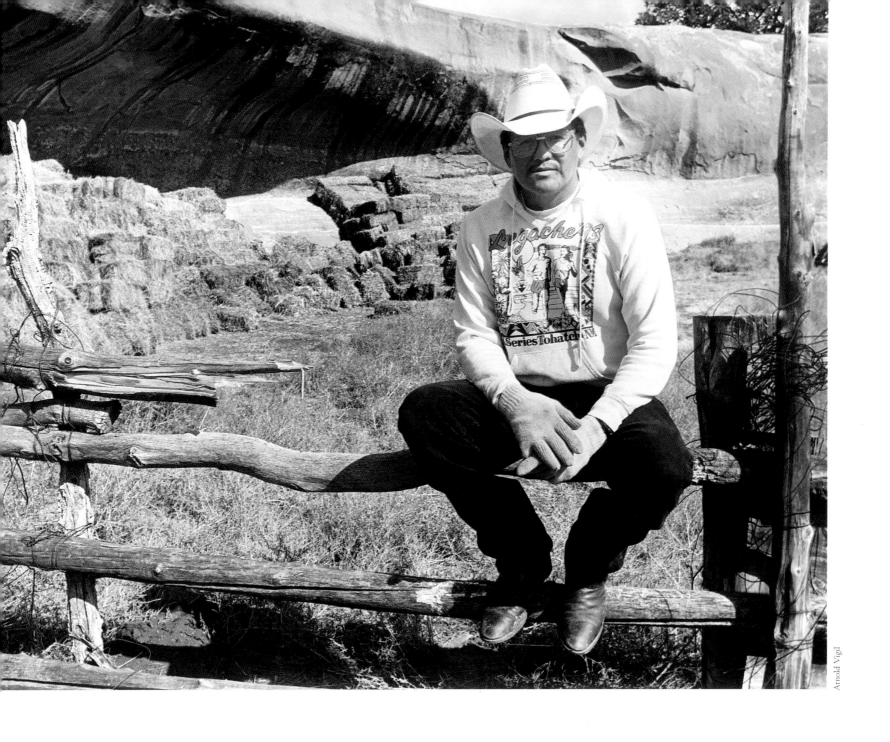

# JOHN BEGAY

Although John Begay works full time in construction and renovation for the Navajo Reservation Housing Authority, being a cowboy in his free time occupies most of his thoughts. John's father, Ross Begay Sr., had him working on the family ranch in Crystal, N.M., north of Gallup, since as far back as he can remember. The Begay family has been working the ranch allotment for more than a century.

"I've never thought of anything else except being a cowboy," John points out, adding that he's never really left the Navajo Reservation. "I like to stay in the country and keep the tradition going."

John lives with his own nuclear family in Naschitti, N.M., a small community in the eastern foothills of the Chuska Mountains on the Navajo Reservation between Gallup and Shiprock. Three of his younger children, Jamie Lynn, 14, Jasmine, 6, and Jaylene, 5, are already active in ranch life, willingly tending to cattle and horses and participating in youth rodeo.

Two other sons, Joshua Lance, 16, and Jeremy Lane, 14, currently live in Phoenix, Ariz., and John says he's tries to teach the boys both cowboy and Navajo tradition when he sees them. The 36-year-old cowboy said he hopes both of his sons will return to the reservation when they get older.

"I think it's very important for them to learn the customs," John says.

John says his three younger children each have a horse to ride and they are required to do the typical country chores that any other kids growing up on a ranch must perform. John says that although his main connection to the land is through the ranch allotment that his paternal family's been working for more than a century, that's good enough for him.

"It's not important for me to have my own place as long as I can come and help on the family ranch," John says. "I hope the kids keep it going."

– Arnold Vigil

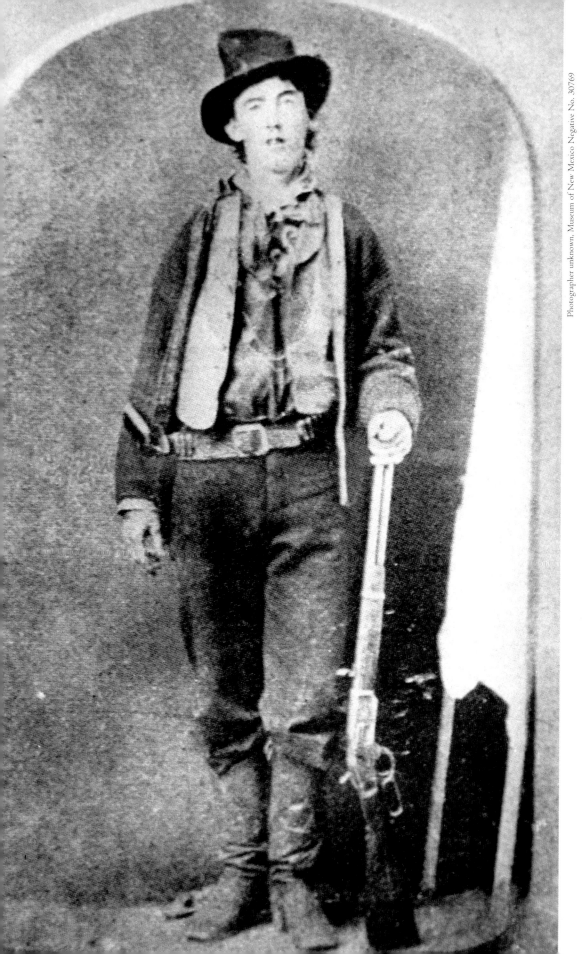

Photographer unknown, Museum of New Mexico Negative No. 30769

LEFT — THE AUTHENTIC BILLY THE KID'S LIFE AND EXPLOITS
SERVED AS GRIST FOR MANY JOURNALISTS AND PULP FICTION
WRITERS OF HIS ERA. SENSATIONALIZED HOLLYWOOD MOVIES
MADE LONG AFTER HE WAS KILLED BY SHERIFF PAT GARRETT IN
1881 TOOK THE EMBELLISHED LEGEND OF BILLY A STEP FUR-
THER. WHILE THIS COWBOY'S PERSONA HAS REACHED MYTHIC
PROPORTIONS WORLDWIDE, MANY HISTORIANS AGREE THAT
NUMEROUS DETAILS OF HIS LIFE HAVE BEEN EXAGGERATED AND
CANNOT BE CONFIRMED. ONE WELL-KNOWN BUT UNSUBSTANTI-
ATED DETAIL IS THAT THE NUMBER OF MEN HE KILLED EQUALS
THE NUMBER OF YEARS HE LIVED — 21. PEOPLE IN HICO,
TEXAS, ALSO CLAIM THAT BILLY'S GRAVESITE IN FORT SUMNER,
N.M., DOESN'T CONTAIN THE REAL KID'S BODY AND THAT
THEIR "BRUSHY BILL" ROBERTS, WHO DIED IN 1950, WAS THE
REAL KID. MOST KNOWLEDGEABLE SCHOLARS, HOWEVER, DIS-
PUTE THIS CLAIM.

"Y OU'RE NOT LIKE THE BOOKS! YOU DON'T WEAR SILVER STUDS. YOU DON'T STAND UP TO GLORY. YOU'RE NOT HIM! YOU'RE NOT HIM! YOU'RE NOT HIM!" – "Moultrie" (Hurd Hatfield) to Billy the Kid (Paul Newman) in *The Left-Handed Gun* (1958)

Moultrie was right, in more ways than he knew. The real Billy the Kid – that Lincoln County cowhand-turned-famous outlaw – was not the romantic, silver-studded gunslinger of dimestore Westerns that were popping up even in the Kid's own era. Moultrie in *The Left-Handed Gun* made money by selling fantastic versions of Billy's adventures to the pulp press back East, presumably magazines like *National Police Gazette*, while the real-life Billy enjoyed his youth in Silver City. In this movie, Moultrie was so disappointed because Billy didn't match the Legendary Billy, that he ratted out his clay-footed hero to authorities, leading to The Kid's death by the gun of Sheriff Pat Garrett.

A moving little story – except Moultrie himself was a creation of fiction. Billy probably is the most famous ex-cowpuncher to have his life twisted into larger-than-life mythology. But he's certainly not the only one.

You could argue that with all the books, movies, music and television that have been devoted to the subject, the Legendary Cowboy must be a major, perhaps the major force in the entertainment industry in at least the first three-quarters of the 20th century.

But the Legendary Cowboy is more than that. While he sprang from popular entertainment he quickly grew into a full-blown myth, a myth through which America looks at its history, and through which we look at ourselves. If Hollywood or Buffalo Bill or Owen Wister or

# The Legendary Cowboy

by Steve Terrell

whoever hadn't created the myth of the American West, we would have had to create it ourselves. What was it about the cowboys, whose work was definitely demanding, but not in itself that romantic, that inspired the Legendary Cowboy to grow?

In her book *West of Everything: The Inner Life of Westerns*, Jane Tompkins writes, "This West functions as a symbol of freedom, and of the opportunity for conquest. It seems to offer escape from the conditions of life in modern industrial society; from a mechanized existence, economic dead ends, social entanglements, unhappy personal relations, political injustice."

It's not just a knee-jerk aversion to technology. Instead, the Legendary Cowboy appeals to those who know in their hearts that pushing paper or crunching numbers doesn't have the same kind of spiritual rewards as branding a calf or busting a bronco or pursuing a band of rustlers. Westerns, Tompkins argues, do not satisfy a hunger for "adventure," but a deeper hunger for meaning in your labors.

In his book *The American West*, historian Dee Brown speaks of an early (1906) silent Western film, *The Life of a Cowboy*. The movie had "four standard scenes — a bar, a stagecoach, a hold-up and a chase." For many decades, the pattern remained the same.

"Real cowboys, of course, rarely ever saw a stagecoach, and when they did the chances of it being held up were remote. They visited saloons much less frequently than New Yorkers and seldom chased anything more villainous than a bad-tempered steer," Brown writes.

Indeed, there are major differences between the historical cowboy — who first came into this country as a *vaquero* in the Spanish colonization wave in the late 1500s, then again after the Civil War when giant cattle empires were built in the West — and the chivalrous, stone-jawed, strong-and-silent knights in ten-gallon hats of Old West lore.

Some estimate that as many as a quarter of working cowboys in the 1800s were Black. And there were Hispanic and Indian cowboys, too. But with rare exception in Westerns, the Mexicans were either simple townsfolk or sometimes evil *banditos*, Indians were the enemy and Blacks were invisible. You might say the

"dark side" of the Legendary Cowboy is that he and all his legendary bunkmates were always lily-white.

In the world of Western myth, some cowboys went bad, becoming cold-blooded murderers like Billy the Kid, or, less extreme, cattle rustlers who used their skills to steal from honest cattlemen – or dishonest cattlemen who hired professional killers to prey upon others. It was up to the good, decent law-abiding cowboy heroes to stop them.

In historic reality, there were periods of great unemployment among cowboys, especially toward the end of the 1800s when the huge ranches were forced to "downsize" drastically. Indeed, many cowboys did turn to rustling. And often detective agencies such as Pinkerton would hire other out-of-work cowboys to catch the cowboys-turned-rustlers. Sometimes the methods of these "good guys" were just as violent and illegal as the rustlers they pursued.

But these dirty little historical facts aside, there is evidence that the Legendary Cowboy and the mythology he embodies have been around before the Old West was even "old." The cowboys of yore reveled in and willingly promoted the myths of the Old West. Decades before the concept of "theme park" was ever born, in the early days of the railroad, there are known cases in which local cowboys would stage fake shootouts for the benefit of train passengers.

Of course, some desperate folk didn't fake it when it came to violence destined to be glorified. Case in point, New Mexico's major contribution to Old West lore: a media-conscious youth born Henry McCarty but better known as Billy the Kid, a cowboy/gunman for John Tunstall and Alexander McSween during the Lincoln County War. Moultrie of *The Left-Handed Gun* might have been fictitious, but some real live people were cashing in on stories about Billy. His real exploits – the five-day shoot-out at McSween's house and his daring escape from the Lincoln County jail – seemingly would be sensational enough. But even in those days tales about Billy were exaggerated into legend. By the end of 1881, the year of his death,

OPPOSITE – COWBOY CROONER GENE AUTRY POSES WITH HIS HORSE "CHAMPION," CA. 1946. BESIDES MAKING A NAME FOR HIMSELF ON THE MOVIE SCREEN, AUTRY ALSO PERFORMED THE MOST IDENTIFIABLE RENDITIONS OF SUCH CLASSIC SONGS AS "BACK IN THE SADDLE AGAIN," "RUDOLPH THE RED-NOSED REINDEER," "PETER COTTONTAIL" AND "HERE COMES SANTA CLAUS." AUTRY, WHO DIED IN 1998, ALSO WROTE THE *COWBOY CODE*: THE COWBOY MUST NEVER SHOOT FIRST, HIT A SMALLER MAN OR TAKE UNFAIR ADVANTAGE./HE MUST NEVER GO BACK ON HIS WORD OR A TRUST CONFIDED IN HIM./HE MUST ALWAYS TELL THE TRUTH./HE MUST ALWAYS BE GENTLE WITH CHILDREN, THE ELDERLY AND ANIMALS./HE MUST NOT ADVOCATE OR POSSESS RACIALLY OR RELIGIOUS INTOLERANT IDEAS./HE MUST HELP PEOPLE IN DISTRESS./HE MUST BE A GOOD WORKER./HE MUST KEEP HIMSELF CLEAN IN THOUGHT, SPEECH, ACTION AND PERSONAL HABITS./HE MUST RESPECT WOMEN, PARENTS AND HIS NATION'S LAWS./THE COWBOY IS A PATRIOT.

there were at least eight pulp novels either based upon or purporting to be true accounts of the life of Billy the Kid. In 1882, Pat Garrett himself got in on the act, with the help of writer Ashmun Upson, by releasing *The Authentic Life of Billy the Kid*. Garrett's version, according to many historians, was as fanciful as it was self-serving.

The "dime novels" that featured fantastic tales of the West existed as many as two decades before Billy's death. In 1869, *Buffalo Bill, the King of the Bordermen* — the first Buffalo Bill dime novel — was published. There would be at least 80 more before the turn of the century.

William Cody, born in 1846, was an army scout, an Indian fighter, Pony Express rider and a cowboy in real life. But his greatest talent was his showmanship. In the 1880s Cody began his most famous endeavor, a part-circus, part-rodeo, part-melodrama extravaganza called "Buffalo Bill's Wild West and Congress of Rough Riders." Annie Oakley was part of this show as a sharpshooter. In 1885, Sitting Bull himself toured with the Wild West show. Cody's production toured all over the United States and Europe, spreading word of the Legendary Cowboy.

Meanwhile, on the literary front, the lowbrow dime novels continued propagating their wild-and-woolly version of the West. But by 1902 the first "serious," respectable, cloth-covered cowboy novel appeared, *The Virginian* by Owen Wister. The author, a Harvard graduate and a lawyer in Philadelphia, made his first visit to the West in 1885. *The Virginian's* tough but soft-spoken protagonist embodied virtually every aspect of the Legendary Cowboy.

"When you call me that, smile," he drawls to the bad guy Trampas. The book immediately became a bestseller and paved the way for two of America's most popular novelists — Zane Grey, who published his most famous book, *Riders of The Purple Sage* in 1913, and Louis L'Amour, who between 1950 and his death in 1988 published more than 100 novels.

But it wouldn't be books alone that would ensure the survival of Old West legend. By the turn of the

OPPOSITE — KID LEGEND SPANS ACROSS OCEANS AND MULTIPLE MEDIUMS, INCLUDING MOVIES, COMIC BOOKS, PAPERBACK NOVELS AND GENERAL PARAPHERNALIA. SHOWN CLOCKWISE FROM UPPER LEFT: PULP MAGAZINE, BASTEI-VERLAG GUSTAV H. LUBBE, 1963, GERMANY. COLLAGE INCLUDES BOURBON DECANTER, CA. 1976, FROM McCORMICK DISTLLING CO., WESTON, MO.; 1933 GUM CARD FROM "INDIAN GUM" SERIES, GOUDY GUM CO., BOSTON, MASS.; *BILLY THE KID ADVENTURE MAGAZINE*, JUNE 1952, TOBY PRESS, INC., NEW YORK, N.Y.; BUSTER CRABBE AS BILLY THE KID ON DIXIE ICE CREAM LID, CA. 1942, PHILADELPHIA DAIRY PRODUCTS; AND DUST JACKET FROM *BILLY THE KID: A SHORT AND VIOLENT LIFE* BY ROBERT M. UTLEY, 1989, UNIVERSITY OF NEBRASKA PRESS. COMIC BOOK, ATLAS PUBLICATION, CA. 1950, AUSTRALIA. RE-PRINT OF PAT GARRETT'S *AUTHENTIC LIFE OF BILLY THE KID*, ATOMIC BOOKS, 1946. (ITEMS COURTESY OF THE PAUL ANDREW HUTTON COLLECTION)

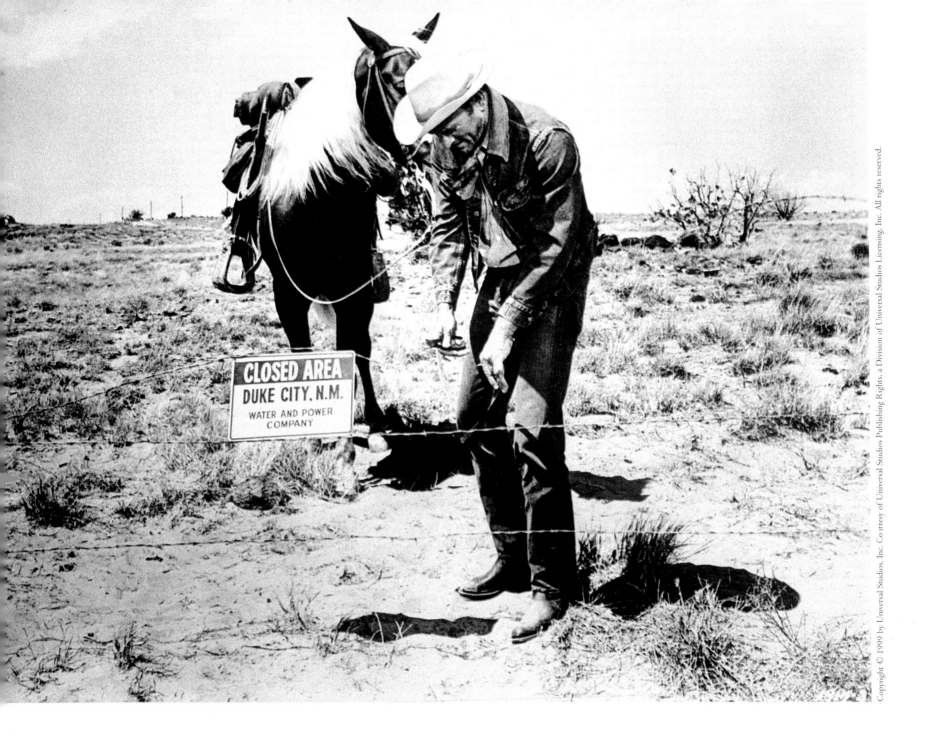

**ABOVE** – ACTOR KIRK DOUGLAS PORTRAYS JACK BURNS IN THE MOVIE *LONELY ARE THE BRAVE*, THE STORY OF AN OLD-TIME ROMANTIC COWBOY WHO IS SEEMINGLY LOST AND CONFUSED IN A MODERN WORLD OF AUTOMOBILES, HIGHWAYS, THE HEAVY HAND OF THE LAW AND, MOST OF ALL, LESS FREEDOM. THIS MOVIE, BASED ON EDWARD ABBEY'S BOOK, *THE BRAVE COWBOY*, WAS FILMED IN ALBUQUERQUE IN 1962 AND SHOWS FASCINATING SCENES OF THE BURGEONING CITY AND THE UNSCATHED LANDSCAPE OF THE SANDÍA MOUNTAINS. ITS SENSITIVE AND VISUAL PORTRAYAL OF A COLD TECHNOLOGICAL WORLD STEADILY DOMINATING AND HARDENING THE HEARTY PEOPLE OF THE OLD WEST IS A WESTERN CLASSIC.

century, with the golden age of the cowboys rapidly ending, along came the infant film industry.

A 12-minute silent titled *The Great Train Robbery* (1903) was the first wildly popular Western movie, though Thomas Edison's *Brush Between Cowboys and Indians* (1904) was the first actual "cowboy" movie. Toward the end of his life, Buffalo Bill Cody himself took part in the new medium, starring in three silent movies based on his own supposed exploits.

The first huge cowboy star was Tom Mix, a real live cowboy who went to Hollywood, just like countless other unemployed wranglers who found they could make more on a movie set in one day than in a week on a cattle drive. But Mix was not destined to be an anonymous extra. He quickly became the heir apparent of the Buffalo Bill brand of Western flamboyancy.

While previous silent-screen cowboys dressed in relatively simple ranch-hand garb, Mix wore costumes that even seemed colorful on black-and-white film — huge ten-gallon hats (some even credit Mix for introducing this style of headwear), fringe, silver buckles. Like Buffalo Bill, Mix loved to brag about his previous life — chasing outlaws, braving the treacherous elements — and was known to embellish his cowboy career with plot lines from his movies. The film industry was quick to learn about New Mexico as an ideal location to shoot Westerns. In 1915 Mix made more than a dozen films in Las Vegas, N.M., but he wasn't even the first. An obscure cowboy flick called *The Dude* was filmed in Organ, N.M., in 1911.

The New Mexico landscape, rich in history as well as exotic beauty, became the backdrop to many Western movies through the years. Several Billy the Kid thrillers were shot here, including the first full-length feature *Billy the Kid* (shot in Gallup in 1930), *The Left-Handed Gun* (Santa Fe, 1958) and the two *Young Guns* movies (shot in several northern New Mexico locations in 1988 and 1990).

The advent of sound in the late 1920s brought in a whole new era of cowboy movies and gave the Legendary Cowboy two of his best-known faces — Gary Cooper and John Wayne. Wayne and his ideals of individualism, courage and unquestioning patriotism came to symbolize the ideal of American masculinity. While movies like *Stagecoach*, *The Searchers*, *The Ox-Bow Incident*, *High Noon*, *Shane* and *The Magnificent Seven* were feature films that appealed to adults, beginning in the 1930s there also were cowboy films with more simple plots and less-complicated characters geared toward youngsters.

Such films featured heroes like Gene Autry, Roy Rogers and William Boyd as Hopalong Cassidy, the hero of a series of pulp novels beginning in the 1930s. Autry, an accomplished songwriter as well as actor, popularized the concept of the singing cowboy. Though Ken Maynard, a former rodeo star and silent-screen actor, was the movies' first crooning cowpoke, Autry was right behind him, followed by Rogers.

Born Leonard Slye, Rogers was an Ohio native who met his first real cowboy while hitchhiking when his car broke down in 1930 near Magdalena, N.M. Rogers also was a member of the cowboy vocal group The Sons of the Pioneers, whose songs "Tumbling Tumbleweeds" and "Cool Water" became cowboy classics.

But how close to real cowboy music are the smooth barbershop harmonies of the Sons of the Pioneers or the yodeling of Gene Autry? Not too far off, even though real cowboys didn't yodel, according to music writer Nick Tosches, who notes that several real cowboys made records in the 1920s and 1930s. However, Tosches says the Hollywood cowboys ignored the African-American influence present in many real cowboy songs. For instance "Home on the Range" was first discovered in 1908 by folklorist John Lomax, who heard it sung by a Black chuckwagon cook in San Antonio, Texas.

Hearing bluesman Leadbelly's rough and gritty "Out on the Western Plains," you might be tempted to think that it is closer to the songs you might have heard on a real cattle drive. But in fact, Leadbelly, a huge fan of Western movies and an admirer of Autry's voice, aspired to become a singing cowboy himself. The first singing Black cowboy in the movies would be Herb Jeffries, who starred in the all-Black *Harlem On the Prairie* in 1937 and three sequels over the next two years. Jump blues singer Louis Jordan starred in the all-Black Western musical called *Beware* in 1946.

Even before sound came to the movies, Tin Pan Alley was responsible for several cowboy tunes — often by writers who had never set foot in the West. These tunes include "Rag Time Cow Boy Joe" (1912), "My Pony Boy" (1909), both catchy tunes, promoting a carefree view of the cowboy's life as opposed to many real cowboy songs that lyric hardship and mortality. And the Tin Pan Alley and Hollywood cowboy ditties are not nearly as raunchy as some real cowboy songs, such as the notorious "Chisholm Trail," collected by folklorist Lomax, with several verses that are downright dirty.

Cowboy culture became entwined with country music. Even when they weren't singing about little dogies and old paints, country-western singers adopted cowboy-type garb — some with sequined jackets and fancy boots to make Tom Mix look conservative. Hank Williams called his band the Drifting

OPPOSITE – A PORTRAIT OF THE YOUNG ELFEGO BACA, WHOSE TRUE-TO-LIFE EXPLOITS IN SOCORRO COUNTY IN THE 1880S SERVED AS GRIST FOR WALT DISNEY PRODUCTIONS' 1958 TV MINI-SERIES, *THE NINE LIVES OF ELFEGO BACA*. ACCORDING TO TRUTH AND LEGEND, BACA APPOINTED HIMSELF DEPUTY TO PROTECT THE HISPANIC CITIZENS OF FRISCO IN THE WESTERN PART OF THE COUNTY, WHERE TEXAN AND ENGLISH COWBOYS IN THE AREA WERE RELENTLESSLY HARASSING THE FARMERS AND SHEEPHERDERS. THE SELF-APPOINTMENT CULMINATED IN A SOLO BACA BEING HELD SIEGE IN A SMALL CABIN BY 50 HEAVILY ARMED CATTLEMEN, WHO WERE THWARTED BY THE SHARPSHOOTING AND HOLED-UP DEPUTY FOR TWO DAYS. HE WAS LATER ACQUITTED FOR THE DEATHS OF TWO OF THE TEXANS.

Cowboys. In the 1970s, Willie Nelson and Waylon Jennings rebelled against the Nashville establishment, calling themselves "outlaws" and sang tunes to a new generation of cowboys. The song "Mamma Don't Let Your Babies Grow Up to Be Cowboys," performed by both Nelson and Jennings, looks right into the soul of the Legendary Cowboy: "They'll never stay home and they're always alone even with someone they love."

Whether or not their yodels were authentic, Autry and Rogers, as well as the non-musical Hopalong Cassidy, translated well into television. Each of the three had their own shows in the early to mid-1950s, all geared toward children. They also inspired locally produced kiddy show hosts across the country, such as "Foreman Scotty" in Oklahoma City, Lew King in Phoenix, Rex Trailer in Boston, "Cactus Pete" out of Harrisburg, Ill., "Buckaroo Bill" in Grand Rapids, Mich., and "Sheriff Bob" in western Wisconsin.

Then there was Dick Bills, whose *K Circle B Ranch* was a favorite of New Mexico youngsters who faithfully tuned into his show on KOB-TV. Sing the first words of Bill's theme, "Ridin' down to the trail to Albuquerque," to any male baby boomer who grew up in New Mexico and in a virtual Pavlovian response, he will sing back the next line, "Saddlebags all filled with beans and jerky . . ." Then at night, adults across the country tuned into *Gunsmoke*, *Have Gun Will Travel*, *Death Valley Days*, *Rawhide* and *Bonanza* — there were dozens of them back in the 1950s and '60s. The Legendary Cowboy did well on the radio, but he fared even better on the tube. In 1958, eight of the 10 top-rated TV shows were Westerns. But those days are gone.

There hasn't been a major hit Western series on television since *Bonanza* went off the air in the early '70s. And while Hollywood might offer an occasional movie like *Unforgiven* or *Silverado* or the *Lonesome Dove* mini-series every few years, the Legendary Cowboy doesn't show up on the silver screen that much anymore. If you look in his face these days he looks a lot like the Kirk Douglas character Jack Burns in *Lonely Are the Brave*, trying to negotiate his horse Whiskey across the highway, right before he is struck by a truck hauling toilets to Duke City, N.M.

Maybe there were just too many Moultries pointing out that the Legendary Cowboy is not the cowboy of fact and Hollywood lost sight about the importance of mythology. Or maybe we're just too far removed in time from the Old West for it to seem relevant. But rodeos are still strong. Cowboy poetry festivals are sprouting up all over North America. Ian Tyson and Tom Russell still write great cowboy songs, while Taos singer/rancher Michael Martin Murphey has devoted his last several albums to cowboy songs and for the past several years produced the annual WestFest that celebrates cowboy culture. Max Evans, author of *The Hi-Lo Country*, still pens his Western novels in Albuquerque and helps them get made into movies. It's not the same as the days when every kid in America had a Roy Rogers lunch box, but it's something.

At this point in his career, the Legendary Cowboy probably feels like John Wayne in the 1971 movie *Big Jake*, in which an on-going joke is that people keep telling Wayne's character, "I thought you were dead." By the end of the film he proves he most definitely is alive.

**SOURCES AND SUGGESTED READING**

*The American West* by Dee Brown, Charles Scribner's Sons, New York, 1994

*The American Cowboy in Life and Legend* by Bart McDowell, The National Geographic Society,
    Washington, D.C., 1972

*The Old West: The Cowboys* by William H. Forbis, Time-Life Books, New York 1973

*West of Everything, The Inner Life of Westerns* by Jane Tompkins, Oxford University Press, New York, 1992

*The Cowboy, Representations of Labor in an American Work Culture* by Blake Allmendinger,
    Oxford University Press, New York, 1992

*The Life and Times of the Western Movie* by Jay Hyams, Gallery Books, New York, 1983

*Billy the Kid, A Short and Violent Life* by Robert M. Utley, University of Nebraska Press,
    Lincoln and London, 1989

*Billy the Kid, A Handbook* by Jon Tuska, University of Nebraska Press, Lincoln and London, 1983

*Country Living Legends and Dying Metaphors in America's Biggest Music* by Nick Tosches,
    Charles Scribner's Sons, New York, 1977

*Liner notes*, written by Jeff Place for Bourgeois Blues by Leadbelly, Smithsonian Folkways Recordings, 1997

*For a Cowboy Has to Sing* by Jim Bob Tinsley, University of Central Florida Press, 1991

Gene Peach

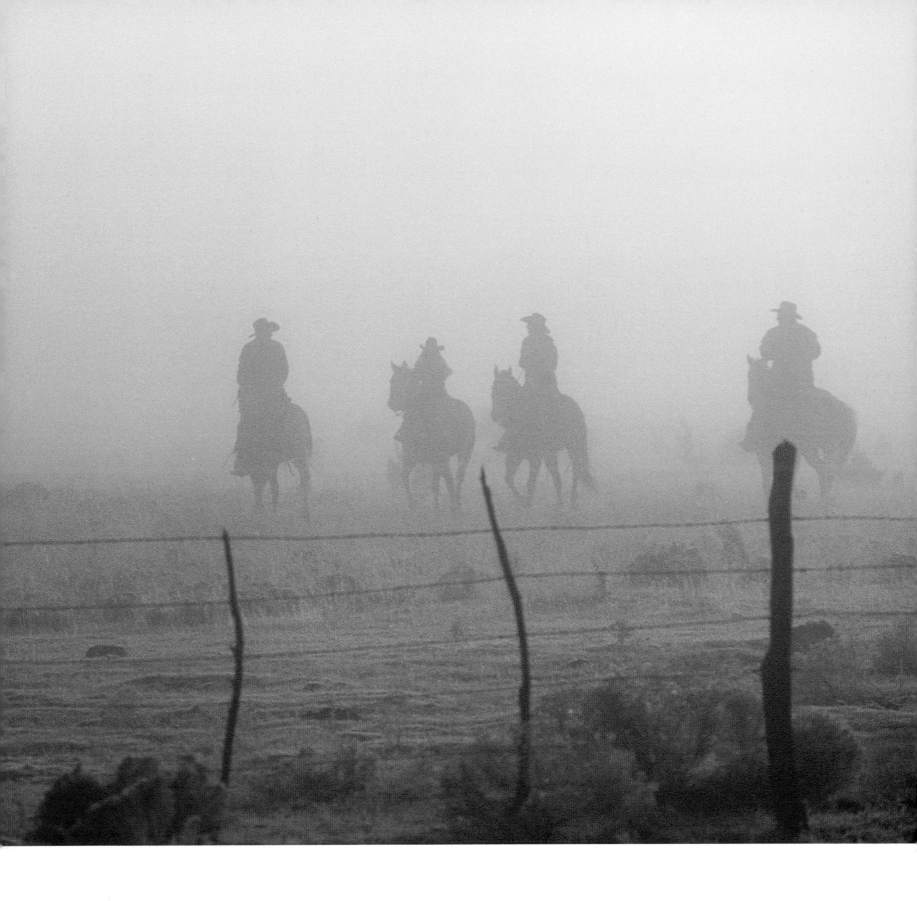

# GEORGE MCJUNKIN

George McJunkin is one of the most interesting historical cowboys of New Mexico. Not only was he one of a very few Blacks in the territory around turn of the 20th century, he also is credited with making one of the most important archaeological discoveries in North America. He discovered Folsom Site, an area south of Ratón that provided evidence of prehistoric man and extinct bison that dates back more than 10,000 years. George found the site while working on the Crowfoot Ranch in 1908, shortly after a major flood devastated the area.

George was described as a true gentleman and intellectual, although he never received any formal education. Many think he acquired his first schooling as a young boy by sitting outside a classroom window and listening to a teacher talk in Rogers Prairie, Texas. Blacks weren't allowed inside the schools at the time. The rest of his education was mostly self-taught, although he learned plenty from others around cowboy campfires.

George McJunkin was born a slave in 1856, but he gained his freedom about six years later, according to Dr. George Agogino, a retired archaeologist who extensively researched the Black cowboy's life. At the age of 16, George resisted his father's trade of blacksmithing and left home. He joined some cowboys herding horses to New Mexico, but a band of Comanches attacked them and stole the animals, Agogino says.

The cowboys recovered some undesirable horses the Comanches turned loose and they rustled more stray horses in the area. They later arrived in New Mexico with the same number (or more, perhaps) of the original herd. Thus began George's cowboy career in New Mexico.

George later took on his former slave owner's last name and worked for many ranches around Ratón. He always knew the Folsom Site contained important historical artifacts, but his pleas to have someone professionally excavate the area fell upon deaf ears. Archaeologists at the time didn't believe Paleo Indians existed in the New World so they didn't think the site would reveal anything.

And George realized that going out there with his own pick and shovel would cause more harm than good. It wasn't until after George's death in 1922 that local amateur archaeologists excavated the site. Professionals then took their turn a year after the site had already been molested and Agogino says that damaged prehistoric spear points were found in sloppy dirt piles, and only one intact point was discovered *in situ* through careful excavation later.

Some believe George fathered children from an Indian woman, but no records exist to confirm this. George experienced much prejudice in his lifetime, but many of his fellow cowboys considered him an equal even though some were former Confederate soldiers. People of his day routinely called him "Nigger McJunkin." Agogino says that one time George was with a group of working cowboys who sat down to eat in a Ratón dining room, but he was told that Blacks had to eat in the kitchen. When George left, the rest of the white cowboys followed in protest and the whole group, including George, was ordered back into the dining room because there wasn't enough room for them all in the kitchen.

– **Arnold Vigil**

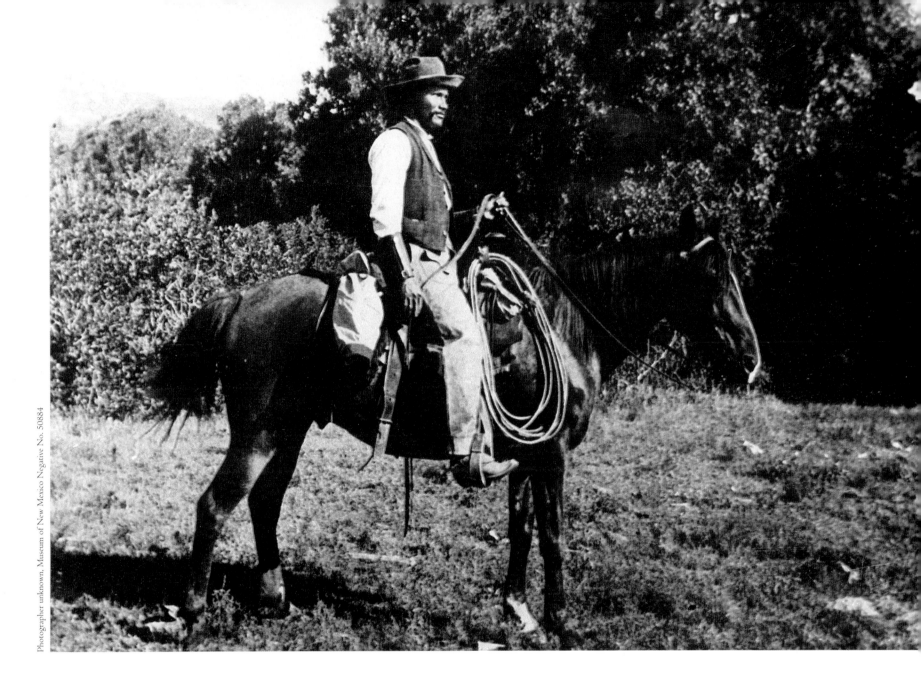

73

Steve Larese

# GRETCHEN SAMMIS

From the very moment Gretchen Sammis was born, she's breathed the mountain air of northeastern New Mexico alongside horses and cattle — on a historic scale. "I still sleep in the same room I was born in," she is quick to proclaim.

Gretchen owns the 11,000-acre Chase Ranch, a historic spread just outside of Cimarrón that dates back to 1867. Her great grandfather Manly Mortimer Chase bought it from Lucien Maxwell (of Maxwell Land Grant fame) on just a handshake and a supply of wild horses, Gretchen says.

At one time boasting more than 100,000 acres, the Chase Ranch today still includes some of the most beautiful terrain that the eastern foothills of the Sangre de Cristo Mountains have to offer. Gretchen's grandparents Stanley and Zeta Chase raised her on the ranch and the handsome cowgirl inherited the place in 1963.

She ran it part time while teaching physical education in Cimarrón, then totally devoted herself to ranching after she retired from educating in 1972. But Gretchen points out that being a cowgirl never left her blood while she attended college or instructed in the classroom.

"I haven't worn a dress in years," Gretchen exclaims. "The last time was years ago for a fancy banquet sponsored by the conservancy district. I remember saying to myself, 'This isn't for me!'"

Gretchen and longtime friend Ruby Gobble operate the Chase Ranch today and by observing them working their daily chores, you literally have to remind yourself they are 73 and 68, respectively. Ruby started working on the ranch in 1963 when she needed a place to keep a herd of mares she owned at the time and Gretchen's stallions were a perfect match. Since then, the all-girl crew has exceeded expectations and continues to perform phenomenally.

Both Gretchen and Ruby are members of the National Cowgirl Hall of Fame, with Gretchen being admitted in the ranching heritage category. Ruby, once a champion roper, went into the hall in the rodeo competition division. Both still avidly ride horses, but mostly for work and not pleasure, Ruby points out.

Stressing that the fluctuating economics of the cattle industry makes it hard for any rancher to earn a profit, Gretchen says she lives the cowgirl lifestyle totally by choice. But she also supplements her income by selling permits to game hunters, who scour the mountains within her ranch's boundaries in search of deer, elk, wild turkey and an occasional bear.

Gretchen says she feels the future of ranching is in jeopardy not only because of economics, but also the threat environmentalists pose to the lifestyle. "I don't think there's a rancher left who abuses his land," she says. "He can't afford to. It has to take care of him next year."

– Arnold Vigil

# the SHELLEY BROTHERS

The story of the four late Shelley brothers and their valiant efforts to help their father Thomas Jefferson Shelley hold on to the family's 916 Ranch north of Cliff during the Great Depression is a remarkable show of perseverance and unity.

Terrell Shelley owns the 916 Ranch near the Gila Wilderness today and he relates how his father Lawrence and uncles Worthington, Will and Vernon worked for years without pay to help their father Thomas keep the ranch back in the mid 1930s.

Thomas Jefferson Shelley inherited the mountain portion of his father P.M. Shelley's ranch in 1935 and it was his responsibility to settle the estate. His first duty was to gather all of the wild cattle out of the mountains to sell them, pay the taxes and get the estate out of debt.

"They worked all through the year. As soon as it went to warmin' up, like in March, they would gather their pack outfits and get all the cowboys ready and they would go to the mountains and stay and camp," Terrell says. "They would stay 25 to 30 days at a time and work cattle . . . And then they would go back to a different area for another 30 days.

"They would do that ever' spring and they would stay and camp all summer up through the fall 'til the cold weather set in, until they couldn't work anymore because of the weather . . . In the later years,

they got to haulin' them to the railroad tracks instead of drivin' 'em. I don't know exactly what year that was, but it was somewhere in the late '30s or early '40s that they started haulin' 'em."

Terrell says his great-grandfather P.M. Shelley also left a daughter some farmland; another daughter inherited interests in the family's Cliff Mercantile; a "lower part of the ranch" went to another son; and Thomas received the ranch's mountain region north of Cliff, located northwest of Silver City.

"Yeah, it was all hard, a lot of places didn't manage to hold on to the ranches," Terrell relates. "And (Granddad) probably wouldn't have, if all the boys hadn't a worked for like two years without any pay . . . They all got paid; they just didn't get paid until the estate was settled. They just furnished them groceries and clothes and whatever they needed, but they didn't draw any wages. And then they all got a lump sum.

"My day said he got his lump sum . . . and there was a section of ground down here that he could have bought for $600 at that time — and he had the money — but he had to have a new car. I've heard him say a million times, 'I wish I had bought that section of land instead of a car.'"

– Jane O'Cain

OPPOSITE – CLOCKWISE FROM TOP LEFT: VERNON, WORTHINGTON, LAWRENCE AND WILL.

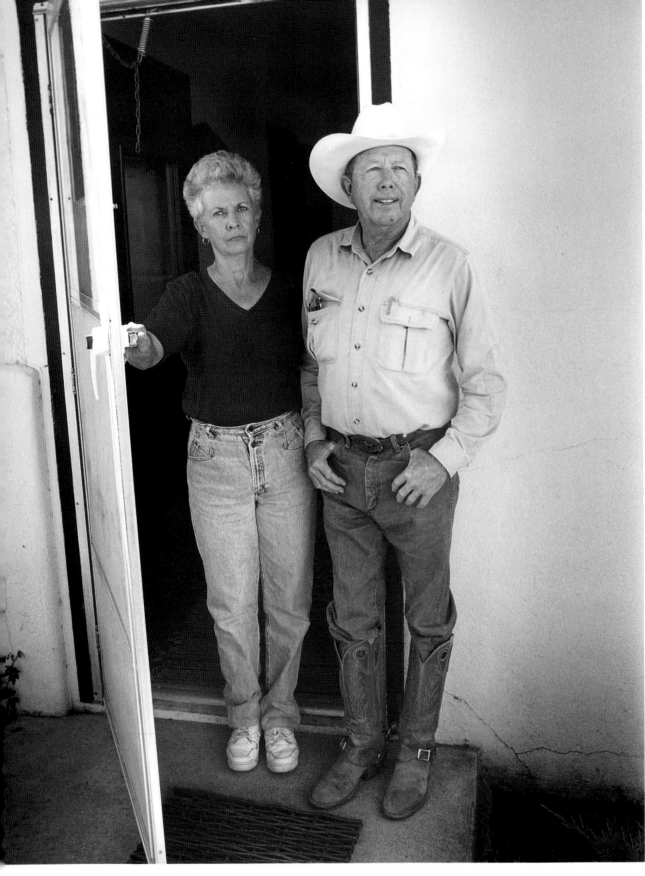

Arnold Vigil

# JAMES & JOANIE VANCE

James and Joanie Vance are quite the hardy cowboy couple. James is quick with a smile, but don't let that fool you. He's damned tough when he needs to be. Joanie is the type to size a fella up first before she'll let her guard down. But once she decides to show you her down-home charm, you'll quickly realize that she can cook up some mighty tasty grub back at the Chappell-Spade ranchhouse, while sharing some of her wry humor in the meantime.

Together, the Vances manage the Chappell-Spade Ranch near Tucumcari, where they've been running the show for 25 years and raising three daughters in the process – Jamie, Joana and Jenny. Only Jenny lives the ranching lifestyle full time as their other two adult daughters chose another honorable profession and became teachers.

James, 62, says he was raised on a small farm in McAlister south of Tucumcari and he "evolved" into ranching. On the other hand, Joanie, 58, grew up in Tucumcari and her father owned a ranch, but she had to give up the city slicker life when she married James about 40 years ago.

But Joanie says she quickly adapted to the rural cowboy lifestyle.

"The only thing that gave me trouble was having to get up early," she laughs. "After that, I got along pretty good."

Although the sprawling 40,000-acre Chappell-Spade Ranch is at their daily disposal, James and Joanie both long to have their own spread some day soon. And when they finally do get their own place, they want it to be in the Tucumcari area, where they've roosted nearly all of their lives together.

There's no doubt that the Vances are set on automatic pilot to ride the cowboy mode well into their retirement years. The lifestyle certainly has benefited them in many ways, especially with their youthful appearance and even-tempered demeanor. Unless they reveal it, you'd probably never guess their age.

"I think an active lifestyle keeps you young," James says. "It's really a great life."

James should know, because when he's not perched on the horse ridin' the range or giving orders to tough cowboys, he likes to strap on skis and swoosh down the slopes at Angel Fire and Red River.

– Arnold Vigil

# TONY TRUJILLO

In the old cowtown of Magdalena, just west of Socorro, there are only a few people as admired, as respected or as knowledgeable about the local history and folklore as Tony Trujillo. But don't be misled by his readily identifiable overalls and baseball cap – Tony Trujillo is all cowboy.

Tony's family arrived in Magdalena around 1915 and his grandfather became village marshal. Now in his late 60s, Tony has lived in the small town all of his life except for a brief period in the 1950s when he served in the military with an anti-aircraft unit stationed in Wiesbaden, Germany.

Raised by his grandparents, Tony explains, "In Spanish families it was the tradition that the oldest daughter send one of her kids to the grandparents for company." In his family, Tony was that child and he readily acknowledges how much he learned about horses and cattle from his grandfather.

Tony is one of nine children – he has five brothers and three sisters – most of whom still live in Magdalena. He married a local girl, Eva, in 1957 and they have five children, three boys and two girls.

When asked how he got started cowboying, he just gives one of his famous smiles and says simply, "I was just born into it." He's held other jobs and civic responsibilities over the years, but cowboying is the real constant in his life.

He headed the local school board for 12 years and worked in the perlite mill in Socorro. Between 1953 and 1982 he was a "house father" at the Bureau of Indian Affairs (BIA) school and dormitory in Magdalena.

"But even then," he quickly points out, "I cowboyed every chance I got."

Longer than anyone else, Tony has been president of the acclaimed Magdalena Old-Timers' Reunion, which was founded in 1972. And he is known far and wide for the mouth-watering barbecue at the annual reunion.

"I learned to cook by just doing it," he explains in his usual modest way. "If they take you out to the ranch and dump you there, you learn how to cook."

Tony also is the cowboy you see driving the ever-familiar Old-Timers' wagon in the parades around the area and in the local festivities every July. It's hard to miss because the proud and pretty queens are usually seated aboard.

Magdalena is famous for cattle drives and the historic Magdalena Stock Driveway. The town was one of the most important cattle-shipping points in the West well into the 20th century. Tony, working for the famous Double H Ranch west of town, cowboyed on several of the drives both as a horse wrangler and as a drover.

Today, he stays active and does day work on at least six ranches in the area. Riding the range with Tony is indeed a treat because he's ridden the country all his life and knows the people so well. His superb storytelling on roundups is essentially a history lesson in itself. Everyone who gets a chance to share his stories and experiences is truly richer for the adventure.

– Joel H. Bernstein

# JARROD & JUSTIN JOHNSON

All of Carl Lane Johnson's memories come in pairs: Jarrod and Justin steering the pickup truck while still in diapers so Carl Lane could feed the animals; Jarrod and Justin breaking horses at age 11; Jarrod and Justin running the Carrizozo ranch alone in their early teens because there wasn't any other help available.

Even though the twins are roundin' 30 now and live on their own, Johnson still shudders at the thought of raising pint-sized cowpokes in the country near Tatum.

"It was a nightmare," he says. "We didn't turn out the lights for two years. And then it got worse."

Fortunately for Carl Lane, Jarrod and Justin turned out to be two of the best cowboys he's ever had. The three of them, along with three other men, operate six ranches in southeastern New Mexico, annually racking up thousands of miles on the road to keep on top of it all.

And that, they say, is the key to success in an industry where it's getting tougher and tougher to make a living. Buy more land, run more cattle, work even harder.

For Jarrod and Justin, who each now live on other ranches flanking the family spread, that means dressing in the dark every morning about 4:30, feeding the horses, saddling one to ride, and going off to do whatever needs to be done — from repairing fences and windmills to breaking horses and building corrals.

"Daddy was 60 before he ever slept in," jokes Justin, "and that was only until 6 a.m."

Humor is a way of life for the Johnson clan. Carl Lane recalls the twins sleeping around the clock "and then some" after a few days of branding, while Jarrod remembers how Justin's colt fell in the drinking tub with Justin mounted on top. "That was one of the best horses I ever broke," Justin is quick to note.

Another time, Jarrod mischievously threw his hat under a horse's feet, causing his twin brother to tumble backwards into the chicken coop. "They fell off their horses regularly," Carl Lane points out dryly.

But Justin got his revenge one winter after he noticed Jarrod horsin' around on thin ice in a frozen water tank. "It was already starting to crack," he says. "I just gave it a whack with the ax to help it." Jarrod's pants froze immediately, Justin laughs wholeheartedly.

Carl Lane didn't spare the rod, as he puts it. "We were broke," he says. "They're just lucky to be alive.

"The worst thing was when I was talking to them, neither one would listen because they both thought the other one was."

Once the elder Johnson came home from a cattle sale to find they hadn't fed the animals "because it was too cold." In a fury, he told the boys, "It's always going to be too hot, too cold, too something."

"That was the last time we let the weather stand in our way," Justin interjects. "We're steady."

Jarrod adds, "Daddy gave us lots of responsibility, but we could handle it."

"We know (the future) is going to be hard, but we're preparing for it now," Justin says.

— Cathy Nelson

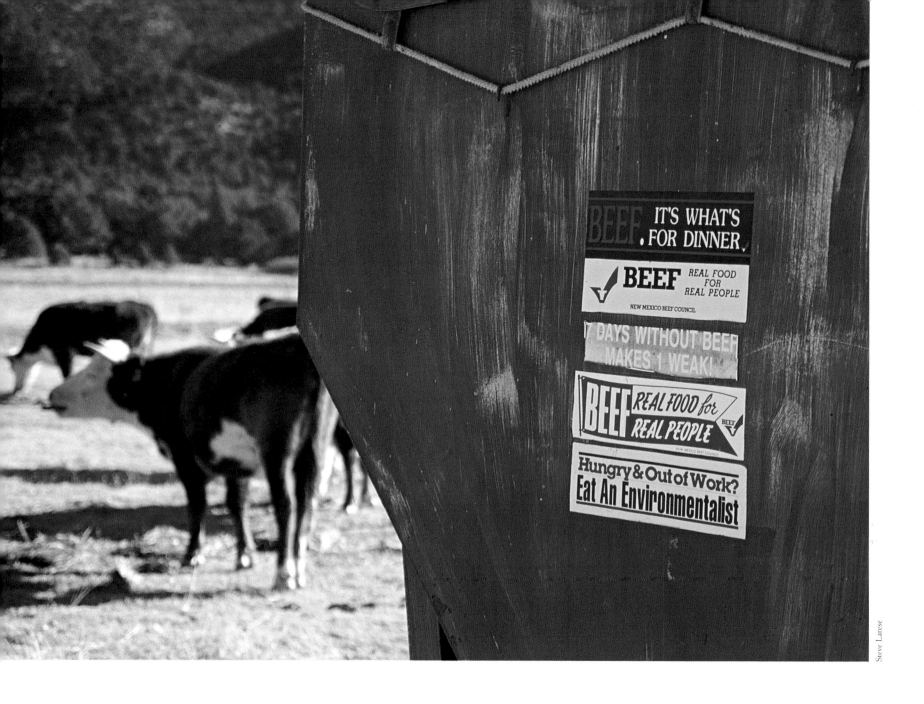

ABOVE – COWBOYS REMAIN TENACIOUSLY COMMITTED TO THEIR CULTURALLY ENTRENCHED LIFESTYLE. THEIR ROCKY RELATIONSHIP WITH ENVIRONMENTALISTS WHO QUESTION THE USE OF PUBLIC LAND FOR CATTLE GRAZING IS HEATING UP. THESE BUMPER STICKERS ON AN AUTOMATIC GRAIN FEEDER ON THE CHASE RANCH NEAR CIMARRÓN ATTEST TO THE SIMMERING ANIMOSITY AND GRAZING DEBATE, WHICH APPEARS TO BE GATHERING MORE ATTENTION FROM THE PUBLIC. IRONICALLY, MOST COWBOYS CONSIDER THEMSELVES ENVIRONMENTALISTS BECAUSE THEY SAY THEY STEWARD THE LAND. ENVIRONMENTALISTS CLAIM THAT CATTLE'S BENEFIT TO SOCIETY DOESN'T JUSTIFY PUBLIC GRAZING AND GOVERNMENT SUBSIDIES.

SED TO BE COWBOYS HAD ONLY TO RELY ON WORK, WITS AND WINCHESTERS TO MAKE A LIVING. TODAY'S CATTLE RANCHERS SAY THIS STILL HOLDS TRUE, BUT IN ORDER TO SURVIVE NOWADAYS, HAVING THE ECONOMIC SAVVY OF ALAN GREENSPAN AND THE LEGAL PROWESS OF PERRY MASON ARE EVERY BIT AS IMPORTANT AS A STRONG BACK AND STEADY HORSE.

Raising cattle has never been an easy business. Drought, floods, disease, blizzards, insects and countless other uncontrollable situations have and always will harass ranchers. But most New Mexican ranchers say today, people are the biggest immediate threat to cattle growers and their way of life in New Mexico.

Three areas of trouble in varying degrees for all ranchers are labor shortages, the beef market, and their much-publicized battles with the government and environmentalists over public land usage. Which problem has the most weight depends on the size and location of the ranch.

"Right now, our main thing is that our market is just shot to hell," says Tatum rancher Carl Lane Johnson, whose Diamond-and-a-Half Ranch was set up in New Mexico by his grandfather in 1914. "Farmers, ranchers, miners – people in the United States of America who are producing stuff that we have to have to live – are taking a whipping like you have never seen."

Johnson says that although he's not getting the price per head he used to, his volume keeps it going.

"But the little fellow is just damn sure out of soap," he says. "He

# Cowboys Under Fire

by Steve Larese

just can't generate enough cash to take care of his cattle. And, we are producing too much meat in this country. That's the long and the short of it."

As for the environmentalists, Johnson says they pretty much leave him alone, but they're "just killing those boys in the West with all the pretty country."

"To be candid, our country here is so ugly they don't bother us," he says. "Flat as your kitchen table with nothing but telephone poles and pump jacks." But what is giving Johnson the most grief is a continuous labor shortage.

"We do not have any cowboys left," he says. "I mean they are just gone. Some boys walk the walk and talk the talk, but when you get them out on these here old ranches and try to get something out of them, it's a joke. Our labor situation is our most long-lasting problem. If it wasn't for my two boys, I'd throw my deal in."

Johnson explains that his definition of a cowboy is a highly skilled laborer who'd work at a ranch a spell and then move on, usually counting his horse, saddle and maybe a good dog as the only constants in his life. Often they'd work with the end goal of settling down and someday buying their own ranch. In fact, calling a rancher a cowboy is considered an insult by some.

"Anybody who could do the work can go to town and make $30,000 to $50,000 a year, Monday through Friday," he says. "I can't pay nearly that, and they'd be working hard seven days a week."

Many of today's would-be cowboys have started their own ranch-support businesses. The hands that were hired separately to perform jobs crucial to maintaining large ranches have banded together and formed their own companies. Some install fences, some break horses and others drill wells.

While the average age of New Mexico's ranchers has gone from 53 in 1992 to 56 in 1997, many don't have the time or energy to perform the tasks they did 10 years ago. And, ranchers lament, these cowboying companies need a little more compensation than a few bucks, a hot meal and a roof over their head for a while. For the most part, smaller ranches rely on sons and daughters to help out, or "neighbor" with nearby ranches. But many ranch children have grown up and gone to college or town, thanks to the success of their parents. And every year, it seems there are fewer neighbors to swap help with.

Bob Jones, whose Slashed Triangle Ltd. Ranch southeast of Alamogordo near the Texas border has been in his family since 1906, agrees finding good ranch help nowadays is a constant struggle. But what could drive him and many other ranchers out of business is what he calls the monopoly of the meat-packing industry.

Ranchers make their money by selling cattle to feedlots, where the cattle are fattened up then sold to meat-packing plants. Here the cattle are killed, processed and wind up neatly wrapped in supermarkets across the country.

"There's really only three big meat packers left in the country, and they are setting the prices," Jones says. "They affect us ranchers by what they pay the feeders. The feeder industry is in really big trouble because they're losing probably up to $200 an animal every time they sell to the packers, and they have to sell these animals because when a cow is ready to go, it has to go, just like a head of lettuce. The feeders have to pass that loss down to us."

"We're a price-taker, not a price-asker," agrees Faye Gaines, who with her husband Pete owns the Point of Rocks Ranch between Springer and Clayton. "The price of beef in this country is controlled by people in the stock market who've never seen a cow."

Jones says some feeders have seen the writing on the wall and have gone into business with the packers. Packers are buying cattle on the hoof, and they make arrangements with these feedlots to maintain the cattle until they're ready for processing, effectively cutting out ranchers and other feedlots. This "captive supply," Jones says, is estimated by some to be up to 80 percent of the beef in the United States.

"For six or seven years this has been going on," Jones says. "We can't get true market value from them. And we can't get our elected officials to enforce the anti-trust legislation that's on the books."

Also, increased international pressure from beef-producing countries such as Argentina, Australia, Canada and Brazil is impacting U.S. ranchers. Some large U.S. food and restaurant corporations are purchasing the less expensive foreign beef, further cutting our ranchers out of the loop. Lawsuits have been filed in federal court by the Cattlemen's Legal Fund against one of the nation's largest "corporate ranches," alleging price-fixing. The United States Department of Agriculture (USDA) is also investigating ranchers' allegations made against meat packers. But like similar investigations involving huge corporations, it's always difficult for the government to reign in successful businesses when the prevailing attitude in the country, especially among ranchers themselves, is "less government interference."

Changing foreign and domestic beef markets and cost or lack of labor might be seriously crippling some New Mexico cattle operations, but these problems haven't captured headlines and emotions as has the issue of cattle grazing on public lands. Many ranchers make sure to use the word "radical" when referring to environmentalists because, they say, ranchers have been environmentalists since day one.

"We are the environmentalists," says Gaines. "We've been here for 55 years and know this land better

Arnold Vigil

than anybody. These other people just see things from the highway and try to tell us what to do."

"We'd be the last people to hurt the land," says David Sanchez, who runs a small herd of cattle on leased land in the Santa Fe National Forest. The land originally was part of the Juan José Lovato Land Grant, which his grandfather inherited under the Treaty of Guadalupe Hildalgo. "We're always out here on the land, and we've been here a long time. We understand that if we damage it, we'll be the first ones to suffer."

Sanchez, who also works for Los Alamos National Laboratory, says he has only praise for the Española Ranger District, which manages his permit. "They really understand our needs, and they manage beyond what the textbooks and computer programs tell them to do," he says. "They have a lot of practical experience and know the land. They know the projects we've done out here have been good for the environment." That being said, however, Sanchez says he often suspects the U.S. Forest Service, which is charged with managing public lands, is actively trying to run all cattle off federally-controlled public lands.

"When the U.S. took over control of the land grants, they told us we were to be stewards of the land, and that as the land prospered, so would we in the form of increased cattle permits," Sanchez says. "We've done our part, but instead we've been hit with stricter guidelines. Washington, D.C., is taking away our right to utilize resources on public lands."

"Our biggest problem right now is the government," says Hugh B. McKeen, a rancher near Reserve whose family owns a ranch and farmland near Mills Creek and also leases public land in the Gila Wilderness area. "They (Forest Service) just have this attitude that they are the absolute authority. They're supposed to be working for the people, and instead they're treating us like slaves."

McKeen says Forest Service rangers make on-the-spot decisions that affect ranching permits and that sometimes contradict existing laws and permit-holder rights.

"Even if they let you appeal the decision in court, the judge just throws it out or comes right out and says, 'This man's a federal officer, so whatever he said stands.' They just look for any way to stick up for the original decision."

LEFT — WHILE PENITENTE PEAK AND LAKE PEAK TOWER IN THE BACKGROUND, A LONE COW GRAZES ON A LUSH MOUNTAIN PASTURE IN THE PUERTO NAMBÉ AREA NORTHEAST OF SANTA FE IN THE PECOS WILDERNESS. ONCE CONSIDERED COMMUNAL LANDS IN THE COLONIAL AND MEXICAN PERIODS, SUCH TERRAIN BECAME HIGHLY REGULATED AFTER THE AMERICAN TAKEOVER IN THE MID-1800S. CITING DAMAGE TO THE LAND BY CATTLE, MANY ENVIRONMENTALISTS SEEK TO HAVE MORE REGULATIONS ON PUBLIC LAND THAT WOULD SEVERELY RESTRICT GRAZING RIGHTS AND DRAMATICALLY INCREASE TRADITIONALLY LOW FEES.

Many times, ranchers' complaints about the Forest Service boils down to a perceived lack of respect for ranchers on the government's part. The stereotype of the independent cowboy who loathes authority and aims to wander where he pleases isn't too far off the mark in many cases, many ranchers admit. Ranchers who graze the same land their family did far before the government stepped in are especially sensitive to being told "what to do and how to do it."

"All the good rangers got fed up and frustrated with the system and quit," McKeen says. "They'd come out here, size the condition of the land up with you, and if something needed changing, you'd work together. Now it's hippies in Washington, D.C., who are managing by computer and rolling over because some environmentalist files a lawsuit. We need more experience and science and less management by litigation."

Steve Libby is the staff officer for the Gila National Forest Ranger District. It's his job to oversee ranching, wildlife, watersheds and forest planning in the Gila. The fact that one of the most beautiful, recreational areas in the state is also located in one of its most conservative, ranch-oriented portions has at times turned the Gila into a battlefield. But it's not bullets whining past ranchers' and rangers' heads — it's lawsuits. And ducking doesn't help.

"There's a lot of money to be made by lawyers, the environmental groups and the meat-processing plants," says Libby, who often gets caught in legal crossfire. "There's a lot of people with agendas, and that makes our job tough. There's a tremendous amount of distrust. This is tough country to make a living, and to couple that with hard economic times for ranching, a lot of people here are frustrated and some sure don't appreciate anybody, especially the government, coming in and telling them what they can't and can do."

Indeed, when the government limits the number of animals a rancher can graze on his permit, many ranchers take it as an environmentalist-backed government attack directed against their families. Less cattle, less money, less food on the table. When a ranger has to tell a rancher he must cut back 10 head because they're negatively impacting the Endangered Species Act-protected Southwest willow flycatcher, all a rancher may care to understand is that some little bird just cost him his daughter's college tuition.

U.S. Forest Service employees like Libby say, ultimately, public land across New Mexico and the rest of country does belong to all people. In doing its job of keeping the land as naturally healthy as possible while accommodating use by human beings, some people are just going to feel the government is giving them the short end of the stick.

Ranching advocates sue the government because they feel like the Forest Service is doing too much; environmentalists sue the government because they feel the Forest Service isn't doing enough. Ranchers say, "Public land is public. The people should be allowed to utilize the country's resources to make an honest living as originally mandated by the government."

Environmentalist say, "Public land is public. One group shouldn't be granted special privileges and negatively impact the quality of land that belongs to all citizens." The rest of us say, "Well, we like hiking and camping in the outdoors and want it to stay beautiful, but gee whiz, America wouldn't be America without our cowboys."

Susan Schock, director of the environmental groups Gila Watch and Public Lands Action Network, is one of those so-called "radical" environmentalists. She says she's received threats of violence from some ranchers, and a photograph of her home was printed on the front page of a rancher-friendly local paper. The reason why, she says, is that she and other organizations such as Forest Guardians support the removal of all cattle from all public land. And with the legal know-how and war chests these groups possess, the environmental movement in New Mexico is a force to be reckoned with.

"Even if the cattle did absolutely no harm to the land and riparian areas, there are many economic reasons why ranching in New Mexico just doesn't work," says Schock, whose grandfather homesteaded a ranch in southeastern Arizona in 1913. "By far, the little money ranching generates is paid to out-of-town banks. Most of their big-ticket purchases are made outside of their communities. Rural ranching communities would make so much more money if they encouraged tourism and outdoor recreation like fly-fishing, which is huge money." Schock and other environmentalists claim that many New Mexico ranchers aren't full time, that they are "hobbyists" who sometimes live out of state.

The granddaddy of all "radical" environmentalists, Edward Abbey, wrote, "Cattle ranching on the public lands is the most sacred form of public welfare in the United States." The very word "welfare" makes ranchers see red. But environmental groups are able to point to many millions of dollars in federal loans, subsidies, aid and tax breaks afforded ranchers. In today's range wars, statistics are cranked off like rifle shots.

And, there's at least one point most of New Mexico's ranchers and environmentalists would have to agree on: You can't make a living based solely on ranching in New Mexico. Says McKeen, "You have to do something else than just run a ranch. There's just no way you can make a decent living on ranching alone."

"You have to have at least 100,000 acres to really make it," says Gaines. "We can't compete with oil

companies and these weekend ranchers from Dallas who can afford all the land, but we'll go down fighting."

According to 1996 figures provided by the U.S. Department of Commerce's Bureau of Economic Analysis, agriculture, timber and fisheries account for only $808 million of New Mexico's $42,698,000,000 Total Gross State Product, or 1.89 percent. Break that down to just cattle ranching, and the number is much lower. Agriculture, timber and fisheries employ 12,329 of New Mexico's 907,098-person strong work force, or 1.36 percent. Again, ranching is just a sliver of that percentage.

Yet, according to New Mexico State University's 1997 agricultural statistics report, there are 1,430,000 head of cattle in New Mexico, which has a population of 1,729,751 people. Environmentalists argue that a profession that negatively impacts so much public land and receives so much federal money while generating so little income for New Mexico is just not viable.

So if ranchers say their future is uncertain, why do they hang on? The answer, they say, is that ranching isn't just a job, it's a treasured, honorable way of life.

"I keep going because of tradition," says Sanchez, summing up the feelings of many New Mexico ranchers. "We've been ranching for 400 years here. I want my kids brought up with the values of hard, honest work and working with the land. They can make their own choices about ranching, but those values will always be there."

"It's just our lifestyle," says Gaines. "We're third-generation ranchers and everything we know is tied up in this ranch. You just don't get up and walk away because things get rough. This beautiful land is on loan from God, and it's our love of the land that keeps us going."

RIGHT — EIGHT-YEAR-OLD JORDAN MUNCY RIDES THE FENCE LINE TO CHECK FOR ANY NEEDED REPAIRS ON HER FATHER BLAINE MUNCY'S O X BAR RANCH IN TORRANCE COUNTY. JORDAN'S FUTURE AS A COWPOKE IN THE 21ST CENTURY IS FULL OF UNKNOWN VARIABLES AS THE RANCHING INDUSTRY CONTINUES TO BE ATTACKED IN THE PUBLIC EYE, COURTROOM AND MANY GOVERNMENTAL LEVELS BY ENVIRONMENTAL GROUPS. THERE SEEMS TO BE LITTLE DOUBT THAT GRITTY CONTEMPORARY RANCHING FAMILIES SUCH AS THE MUNCYS WILL DO WHAT IT TAKES TO CONTINUE THEIR COWBOY TRADITIONS.

Gene Peach

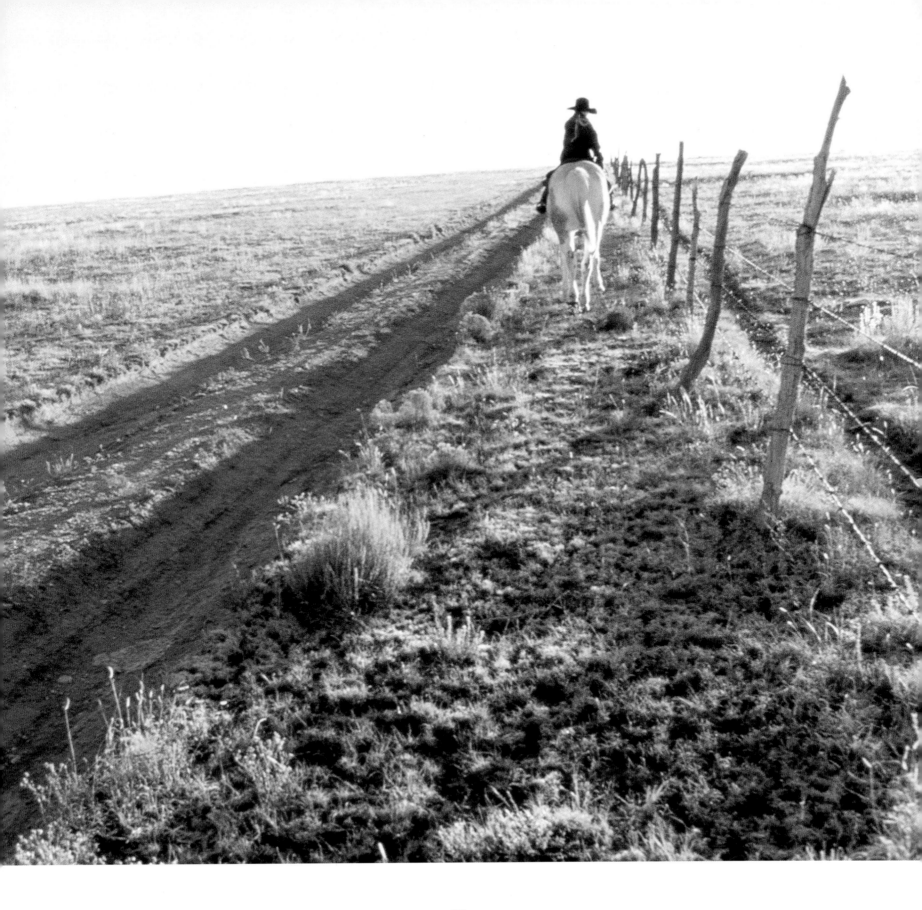

# TOM KELLY

The route through Water Canyon, west of Socorro, is one of the most beautiful drives in central New Mexico. For more than three generations, the Kelly Family has stewarded this mountainous area south from U.S. 60 on FR 235 and it hasn't always been easy.

Tom Kelly has cowboyed on the Water Canyon Ranch all his life except during a military stint in the Pacific during World War II. Tom's grandfather James P. Kelly was born in Virginia then went to Colorado to tend livestock for the Ute Indians. Later, he homesteaded the ranch in 1882. It was good cattle country — abundant water and absolutely glorious views. Tom's dad Frank Kelly was born at the ranch headquarters in 1886.

Tom says that in the old days Water Canyon was bustling with people, mostly prospectors. "Everybody had a hole they were digging in . . . nothing of real value showed up," he says. There were cabins all over the canyon and the miners were mostly Civil War veterans from both the North and the South. Today, there are virtually no people living there.

"I didn't want to be a cowboy," says Tom, who became a cowboy and rancher the long way around. "There was never any money in it that I could see. But I stayed here . . . someone had to care for the cows."

His older brother Jim, realizing that the ranch couldn't support another family, left for college after World War II, then completed a long and distinguished career with the Bureau of Land Management

(BLM). He and his wife Anabel are currently living their retirement years back on the family ranch.

Hilda Kelly, Tom's wife, came from Oklahoma. Her grandfather arrived in New Mexico to ranch in 1913 and when she was old enough, Hilda started visiting. "I always liked New Mexico," she says with a smile. Tom and Hilda met at a dance and were married in 1949.

Today, the Kellys run some cattle on Water Canyon Ranch, but the majority of their stock is grazed at their other spread in Milligan Draw, off I-25 between Socorro and Truth or Consequences. That operation is the southern part of the old S O Ranch, which was owned by Hilda's grandfather.

Tom has had a running "difference of opinion" with the U.S. Forest Service about Water Canyon. He contends that governmental micromanagement of the canyon's environment, particularly wildlife, has radically changed the conditions — and not for the better. He points out that since late 1940s, the year-round creek that flowed through Water Canyon hasn't really had much water and now the tributary is almost permanently dry.

Tom truly loves Water Canyon and says he'll continue fighting to keep it as alive and healthy as it was when it provided a living for hardy prospectors and a pioneer ranching family. The issues are very complex, but Tom and Hilda Kelly are articulate spokesmen for the rancher's point of view.

— **Joel H. Bernstein**

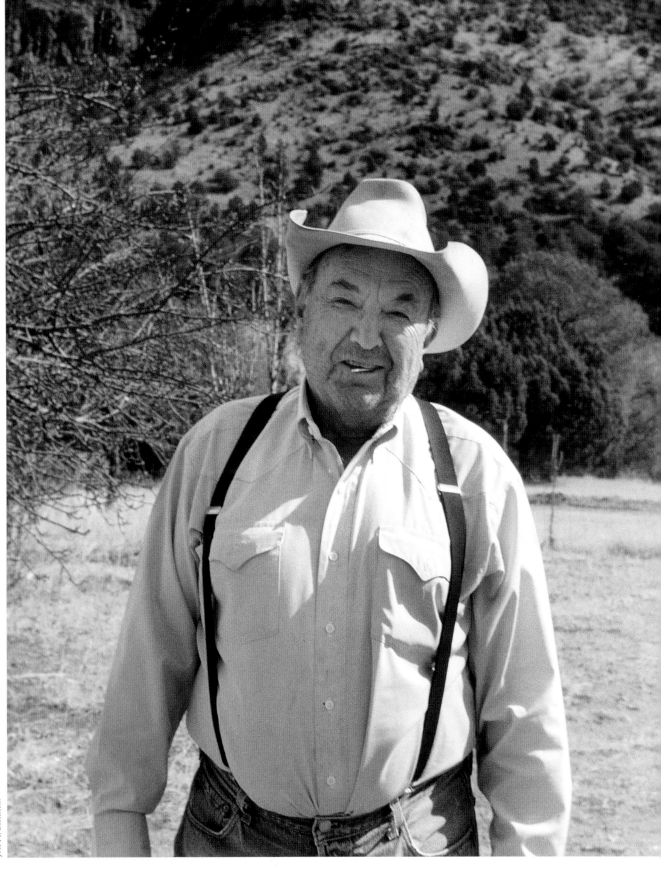

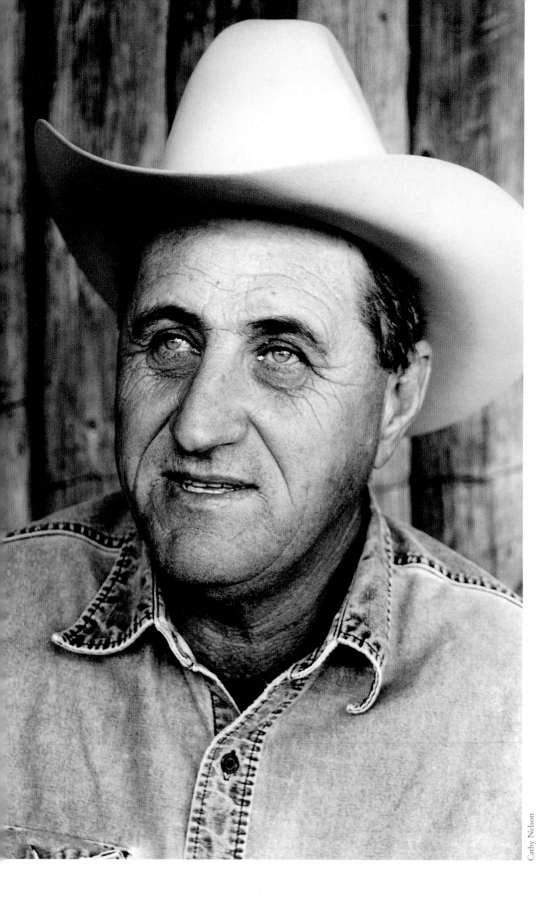

# LAURIE KINCAID

Politics and cowboying generally don't mix, but Laurie Kincaid believes New Mexico ranchers must get involved on every level – local, state and federal – in order to protect their financial interests and way of life.

In addition to running cattle in the hot, dry desert near Carlsbad, Laurie serves as an Eddy County commissioner and on numerous boards and committees. He was named the Cowbelles' "Man of the Year" for 1998 because of his extracurricular efforts.

"It used to be one-third of the (state) Legislature was in boots and hats. Now it's two or three," Laurie says. "We need people in politics that understand the agricultural life and agricultural politics."

Laurie has plenty of experience to back up his opinions. He was born in 1942 on a southern New Mexico ranch that is now part of Guadalupe Mountains National Park, and attended school with some 12 other children spread out through eight grades.

"When I was that boy's age," he says, pointing to his 7-year-old grandson, E.J., "we lived 60 miles from town, with no electricity or running water, no TV. We entertained ourselves with marbles."

He recalls one night spent in a mountain log cabin with no windows. "We woke up to find a porcupine had ate the back end out of Daddy's shoe."

Now Laurie and his wife, Nina, along with E.J. and his mother, are just 15 miles from Carlsbad by gravel road, and enjoy all the modern conveniences of city life.

"We still milk a cow," Laurie notes. "This boy won't even drink store-bought milk. And we take him six miles to the pavement to catch the bus in the morning, and pick him up at the same spot in the afternoon."

Although Laurie's parents moved to town so he could attend high school, he says he didn't like it, and still wanted to be a cowboy when he graduated.

"This is all I've ever known. I never thought about anything else, never had any desire to be anything else."

Laurie and Nina were married in 1961, and bought their own place in 1970. Working with his wife and watching his grandson grow up are his favorite parts of ranching, while raising cattle in dry weather is the worst.

"The main thing is getting water to them," Laurie says. "They can't stand many of these 100-degree days without water."

Environmental concerns such as these are one reason the rancher spends more time in meetings and on the phone than out on the range where he feels most comfortable.

"I think by me being involved, it gives me a chance to get the rancher's perspective across," Laurie says. "Some of us have to devote some time to this, or we won't be in business."

– **Cathy Nelson**

# JENNY VANCE

If you saw pretty Jenny Vance anywhere else but on a ranch, you'd probably think she's as girl as they come — sugar and spice and everything nice.

But Jenny is the first to admit she's always been a tomboy and stepping in horse manure, whether accidentally or not, never bothered her a bit. Today, the 25-year-old raises and trains champion quarter horses on the Chappell-Spade Ranch near Tucumcari, where her father James is the ranch manager.

"I'd rather be outside with the horse than playing with a Barbie doll," proclaims Jenny about her childhood days on the Chappell-Spade. "I will always be involved with horses."

The youngest of three sisters, Jenny plans to become a veterinarian specializing in horses and hopes to lay claim to a ranch of her own someday. In the meantime, she's out there on the eastern New Mexico countryside riding side by side with the other seasoned working cowboys, rounding up strays, branding, loading, weighing and whatever other hard work is required. And, yes, she also helps her mother Joanie dish out chow back at the ranchhouse.

Horses are the love of this cowgirl's life and she admits that some-times she grows overly attached to many of the horses she's raised. Jenny says that once she had to let go of her favorite quarter horse to a cowboy at another Chappell-Spade ranch in Texas.

"The manager wanted my horse and I had to let him have it," she remembers. "But he sent it back after a few weeks and said it was too spirited. You know how Texans are, they're kind of slow. I never had problems with that horse."

Besides growing up on the Chappell Spade Ranch, Jenny was Tucumcari's state 4-H Horse Show rodeo queen in 1989. Her roots and goals are solidly entrenched in the cowboy lifestyle and she has no plans to alter them.

This young, feisty cowgirl is already set in her ranching ways and is ready to start training her own greenhorns. She says she'll probably start with her husband Karl, who she doesn't hesitate to call a "city slicker."

"I like him not knowing anything about it (ranching)," she exclaims, "that way I can teach him my way of doing things and he thinks that's the right way."

– Arnold Vigil

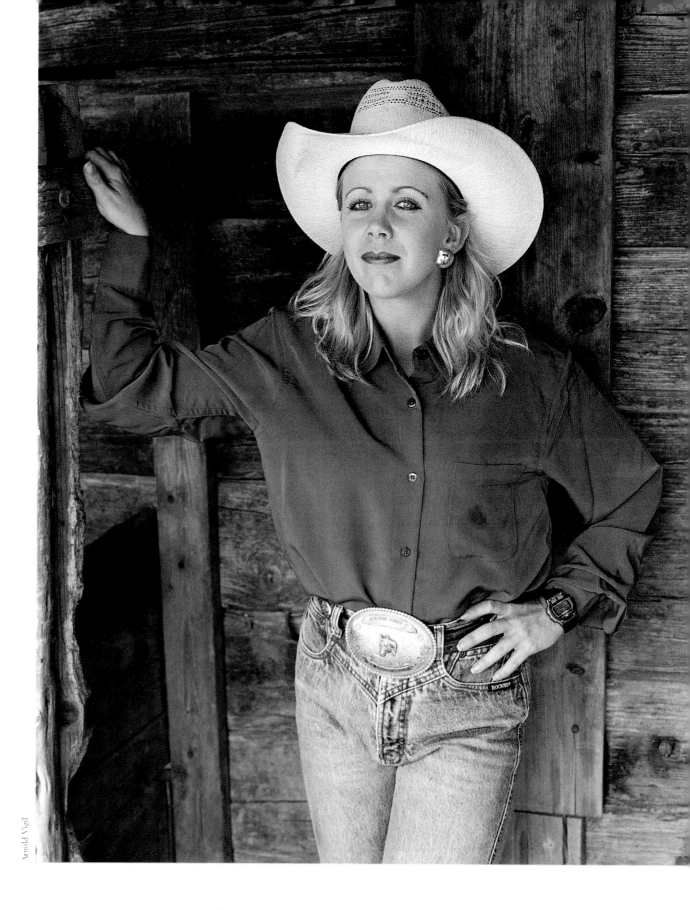

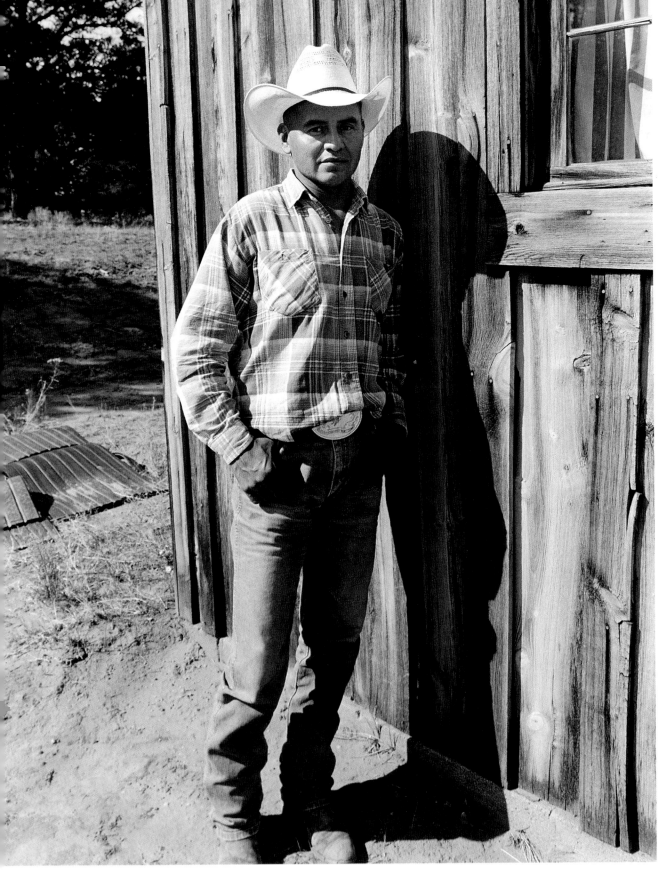

# ROSS BEGAY JR.

Ross Begay Jr. is no different than any other working New Mexico cowboy who's experienced the bumps, bruises, pains and, above all, joys of ranch life. But Ross Jr. says most of the scrapes he's suffered occurred on the rodeo circuit, where he derived his primary pleasure from riding irritated bulls.

"I was damn good at it, too," he proclaims.

Ross Jr. doesn't ride bulls any more, mostly because he snapped his femur bone and broke his hip in 1985. But the incident that ended his rodeoing days wasn't the result of a giant muscular beast, flinging him across a dirt arena like a rag doll.

Rather, the accident happened on the family ranch on the Navajo Reservation in Crystal, N.M., north of Gallup, where his horse suddenly reared up on a hill and fell. His brothers were forced to create a makeshift litter to carry him out of the remote area to a place where an ambulance could pick him up.

A broken leg didn't keep this tough 39-year-old cowboy out of the saddle, however, because he's worked as a full-time cowboy for most of his adult life. Today, he works during the week at the Navajo Tribe Utility Authority in Fort Defiance, Ariz., but nearly all of his free time is spent either on a horse or in his pickup back at the family ranch on the reservation.

His only desire to leave is to go to rodeos or, maybe, to the National Championship Bull Riding Finals in Las Vegas, Nev. But he'll always come back, he says. Ross Jr.'s desire to compete in rodeo still passionately burns in his heart.

Ross Jr. says that up until just recently, his 18-year-old son Lekota has mostly shown a preference toward modern society. But now the teenager is becoming more interested in learning ranch work and traditional Navajo custom.

"Lately, he's been wanting to help me here and there," Ross Jr. says, "harvesting hay, hauling, providing for the winter."

Ross Jr. says it's still too early to tell if his two daughters, Jodonna, 14, and Tanya, 2, will choose the ranch over the city. In the meantime, Ross Jr. says working on the family ranch satisfies him but he still dreams of owning his own place.

"Right now, I'm just a helping hand to everybody else," he says. "I'll get my own place after I win the lottery."

— **Arnold Vigil**

# ROBERT ZAMORA

A lifelong cowboy, Robert Zamora is in the saddle just about every day and he wouldn't have it any other way. There definitely aren't as many men who fit this portrait today as there were even 50 years ago.

Robert was born and raised in Kelly, an old mining town just south of Magdalena. Although his father was a miner, the family raised cattle and a young Robert naturally learned to be a cowboy. Even as a youngster he helped out on neighboring ranches.

"I started mining when I was a kid, but I always wanted to do what I'm doing now — cowboying, " he explains.

Since 1982, this cowboy has leased the old Garcia Ranch in Milligan Canyon on N.M. 107. He's on his horse just about every day, tending to more than 100 cows on his cow/calf operation. Robert even finds time to tend a neighbor's herd. Like so many of the old, traditional cowboys and ranchers, Robert sees changes in the way things are done now and how ranches are operated.

"Most of the cowboys nowadays don't have as many good horses like in the old days," he shrugs. "There's more motorized vehicles. Too much work is done by vehicle." He vividly remembers when he had to carry his ax on his horse just to break ice. "We couldn't get around in pickups."

Now in his early 60s, Robert stands straight with a muscular body and his hands display a lifetime of hard work. He says, "A lot of ranchers get horseshoers to do their horses. When I grew up we did our own horses. I've done them all my life."

For fun, Zamora, like most cowboys of his era, competed in amateur rodeo. He rode bulls and broncs, roped calves and even played on a cowboy polo team based in Datil. His contemporaries will tell you that he was a pretty good rodeo hand. Before he started running his own outfit in 1982, Robert cowboyed for some of the biggest ranches in the Magdalena area; ranches like the Double H, the Major Cattle Co. and the old Muleshoe were glad to hire his cowboy services. A few times during the 1950s, he was a drover on the Magdalena Cattle Highway, bringing large herds to the trailhead in that old cowtown.

Robert married his wife Bennie in 1962 and she's now a Magdalena Village councilor. Her father also was a miner and her grandfather came from Madrid, Spain. Their daughter Grace is a worthy "cowboy," who can shoe, rope and handle cattle with the best of them. She hung around with her dad while growing up and obviously had a fine teacher.

Robert Zamora is a throwback to an era when cowboys did all of their work on horseback. He embodies many of the old cowboy virtues and understands what a good life on the range is all about.

**– Joel H. Bernstein**

OPPOSITE – ROBERT ZAMORA AND HIS YOUNG GRANDSON ROBERT.

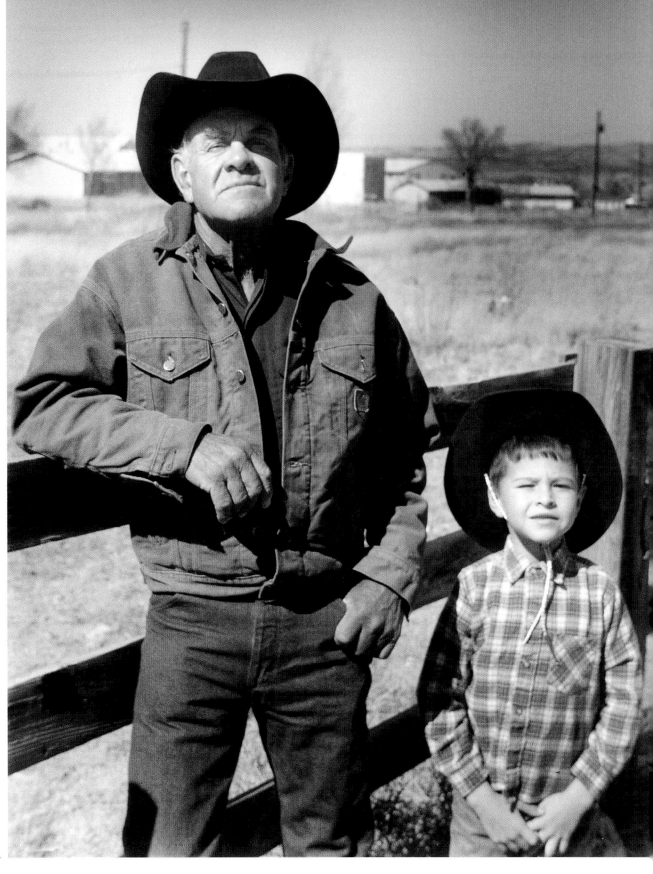

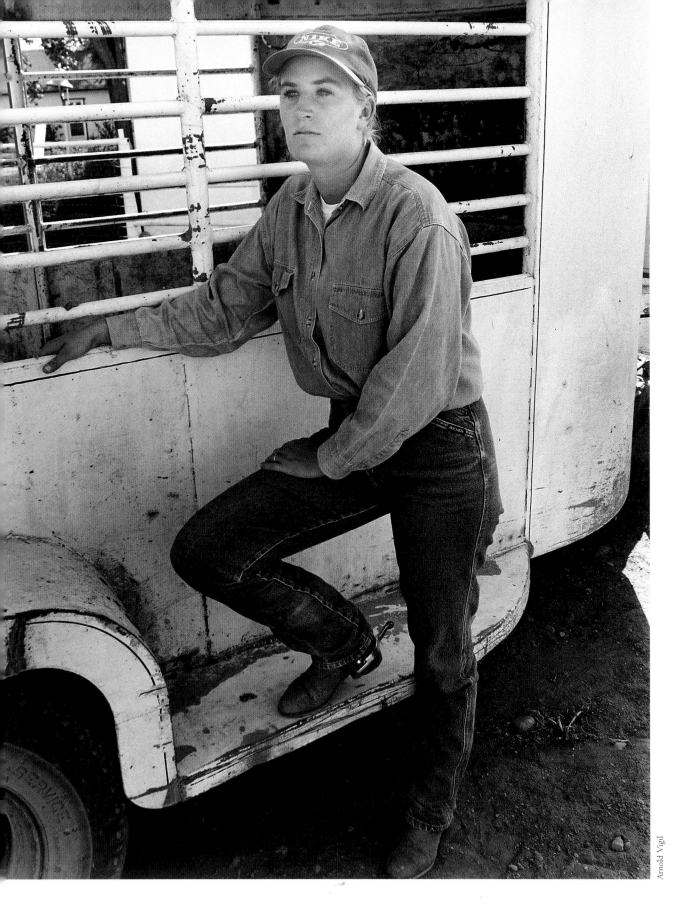

Arnold Vigil

# JULIE GATES

Don't let the ball cap fool you, Julie Gates is as cowgirl as they come. Although she owns several wide-brim, traditional cowboy hats, she prefers the ball cap on the range because "it's not as hot."

Julie hails from Socorro where her family has worked the Pound Ranch for at least five generations. Cowboying runs thick in her blood just as it does in her two younger sisters, Cori, 20, and Ashley, 10, both avid horse-ridin' gals who love the ranch.

She currently lives in San Jon near Tucumcari with her newlywed husband Randal Gates, a 7-foot-tall day-working cowboy she met while attending Clarendon College in Texas. When she's not in class, Julie can be spotted on horseback, riding side-by-side with Randal, rounding up cattle, branding or any other type of ranching day work they can find in the Tucumcari area.

This rugged, pretty 22-year-old wants exactly what her husband wants — children and a ranch of their own. But she realizes that ranch-ing more than likely won't provide all the income they'll need to make a living. That's why she continues to study for her master's degree in agricultural business and economics at West Texas State, which she expects to earn by 1999.

Julie says she and Randal have an agreement that she will work full time in town while he continues to cowboy on other ranches until they can get their own spread. After Julie earns her degree, she says she'd like to work for the county extension service or teach at Mesa Tech College in Tucumcari – "Something that pays better than ranching," she says.

But giving up the cowboy way of life never will be considered an option in Julie and Randal's future.

"If we have children later on, that's how we want to raise them," she says. "That's how we were raised."

**– Arnold Vigil**

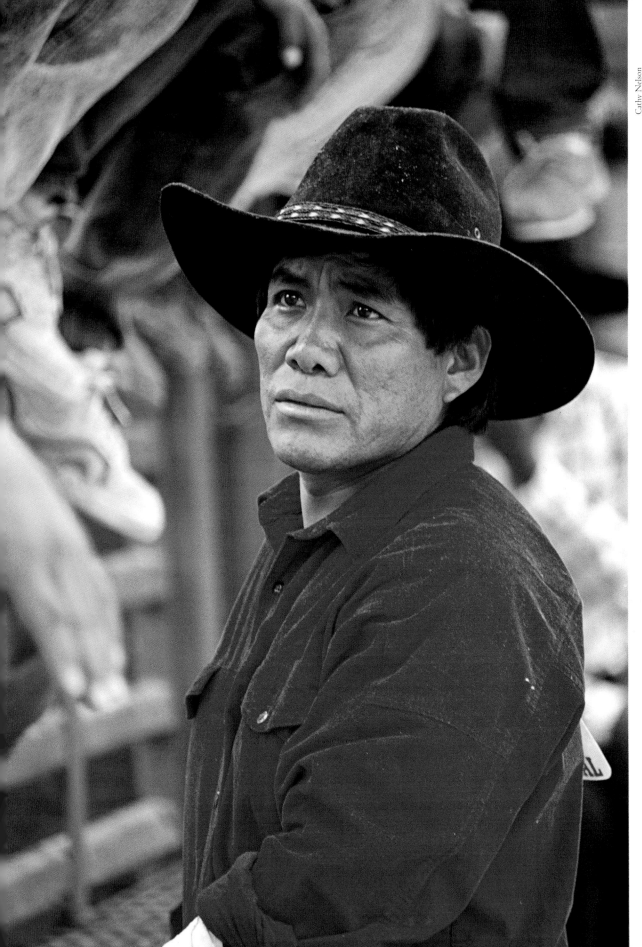

LEFT — AN UNIDENTIFIED NATIVE AMERICAN COW-
BOY MENTALLY PREPARES HIMSELF BEFORE HIS
UPCOMING EVENT DURING AN ALL-INDIAN RODEO
COMPETITION AT THE GALLUP INTER-TRIBAL INDIAN
CEREMONIAL. ALTHOUGH MAINSTREAM SOCIETY
RARELY FATHOMS INDIANS AS BEING COWBOYS, THE
COMBINATION IS QUITE COMMON IN NEW MEXICO.

N ANY GIVEN SATURDAY MORNING, HORSE TRAILERS ARE HITCHED UP TO GMC, FORD AND CHEVY PICKUP TRUCKS ACROSS MANY RESERVATIONS IN NEW MEXICO BY INDIAN COWBOYS WHO USUALLY HAVE FULL-TIME JOBS ELSEWHERE, BUT SPEND THE WEEKENDS TENDING TO THEIR LIVESTOCK. THEY LOAD SADDLES, BRIDLES, ROPES, EAR TAGS AND BALES OF HAY INTO THEIR PICKUP BEDS, ALONG WITH COOLERS OF FOOD AND WATER.

Horses — roan-colored, a paint or possibly a prized Appaloosa — are eased into the trailer for the long trip across dusty, two-rut roads to sections on the reservation considered grazing areas. Fathers and sons, still sleepy-eyed, will cram into the front of the pickup for a day's worth of hard work, or spread it out over two days if calves have to be earmarked and branded, or if the herd needs to be dipped and medicated.

Weekends will sometimes turn into weekdays if the herd has to be moved from one area of the reservation to another, depending on the time of the year. Once out there in the mountains, the hills or the flat open valleys, Indian cowboys gather, work, laugh, tease and kid around. All share a common attitude toward their livestock. They seriously care about them and revere them, not only because they are a source of food or a symbol of wealth, but also because they are living beings.

### ACOMA INDIAN COWBOYS

He loosened the rope around the cow's thick neck with one hand

# Cowboys As Indians

by Conroy Chino

and gripped the knife firmly with the other. The large brow and white Hereford bellowed loudly, as it was held against its will on its side. The animal's eyes, wide with fear, sensed danger from the man kneeling just behind its head. Frank Cerno instructed his grandsons to keep their ropes securely tied around the animal's front and back legs. Together, the two teens, one on horseback and the other on the ground, did as they were told. One wrapped his rope firmly around the saddle horn, and steadied his horse, while the other held a cotton fiber rope tightly against the leg of his chaps, digging the heels of his boots into the loose dirt, and pulled. Their grandfather pushed up his cowboy hat, then pushed the cow's head back with his left hand and made the sign of the cross on the cow's throat with the blade of the knife. He said a short prayer in Acoma, asking the cow's spirit to leave happily and to return, bringing only prosperity to his family and the remainder of his herd. Then he slit the cow's throat.

Other families did the same with their animals near the stockyards located in Acoma Valley. It was part of the annual ritual in preparation for All Soul's Day in early November. This is the way it went: Families would butcher one of their cows on the weekend before, and days later would prepare a huge meal. Toward sunset, the families would gather inside their sunbaked adobe homes, and set out roasts, fried meat, chile stew, tamales, oven bread, coffee and desserts on a kitchen table — foods that the souls of those departed, now returning, might spiritually enjoy. That's how Acomas remember and celebrate the return of the ancient ones, by combining traditional beliefs with Christianity.

Early Spanish settlers not only introduced a new religion to the Pueblos, they also brought the first cattle and horses to New Mexico, along with new terms that were quickly absorbed into the native language. *Vaquero* (cowboy) became *Waa-gue-rra*. *Caballo* (horse) turned into *Ka-wa-yu*. Acomas also learned that the domesticated animal with horns, *Waa-ka-shi*, was an easy source of food, trade and barter. But the idea of raising cattle as an economic endeavor didn't occur until the late 1800s and tribes have practiced ranching ever since.

The federal government helped many New Mexico tribes, including Acoma, assimilate into the ranching lifestyle. In 1885, Indian agents for the government reported that Acoma applied animal husbandry in an effort to improve conditions on the reservation made difficult by periodic droughts. According to government records, the tribe had 550 cattle, 9,500 sheep, 400 horses and 500 *burros*. At the turn of the century, the government sent an Indian agency farmer to assist the tribe in increasing and managing its herds. When tribal members noticed a beneficial change in their herds and personal incomes, they gradually adopted the cowboy lifestyle and added cattle to the list of animals prayed for and revered.

## Navajo Indian Cowboys

The U.S. government also was responsible for introducing the cowboy lifestyle to families on the Navajo reservation. That's what Stanley Kedelty of Crystal, N.M., remembers. He says it started with a simple pair of blue jeans. At clothing distribution time, the tribe, with the help of the federal government, gave out Wrangler jeans. Attached to the new stiff-legged, western-style jeans were little booklets with pictures of rodeo stars, like Jimmy Shoulders and Casey Tibbs. The small glossy pictures planted lasting images in the minds of young Navajo boys, including Stanley. Now, years later, Stanley wears his cowboy hat, even inside the Village Inn Pancake House where he was interviewed. He says according to Navajo legend, the *Diné* always had horses. He mentions the story of the twin boys and how one of them climbed onto the back of a bronc and rode away.

"That legend has always been a part of us," Stanley reveals, as he sips on a cup of coffee, adding, "I guess there's always been rodeos among my people."

When the world wars and later the railroad took men to faraway places off the reservation, they remembered the legend as they watched bucking broncs come busting out of the chutes at rodeos. When the Navajo men returned to the reservation, they brought back the western sport and started up rodeos. Out of necessity and popularity came the cowboy attire; besides, that was the only kind of clothing sold in reservation trading posts. First came the Levi's, then the Wranglers, followed by Stetson hats and Tony Lama boots.

Stanley and his wife Theresa Kedelty say their families always had livestock, cattle, horses and sheep. Both of them are principals at schools along the eastern edge of the Arizona border. They return on weekends to their home on the New Mexico side of the Navajo Reservation in the sage- and piñon-covered hills just below the Chuska Mountains. The Navajo couple consider themselves part-time ranchers. Relatives care for the livestock when they're away working their other jobs. They say they aren't in it for the profit, but have the herd for subsistence, and sell a cow whenever they need the extra cash. They reminisce about riding horses as children, hauling wood and water with a horse-drawn wagon and caring for their family's animals.

Theresa remembers the cattle drives in May and June. She says her brothers would take the herd from the flatlands near Naschitti up to the mountains for the summer. "We'd get up to the mountains and you'd hear the bulls. It was such a neat sound echoing through there. I remember climbing up onto a tree and watching them brand and castrate."

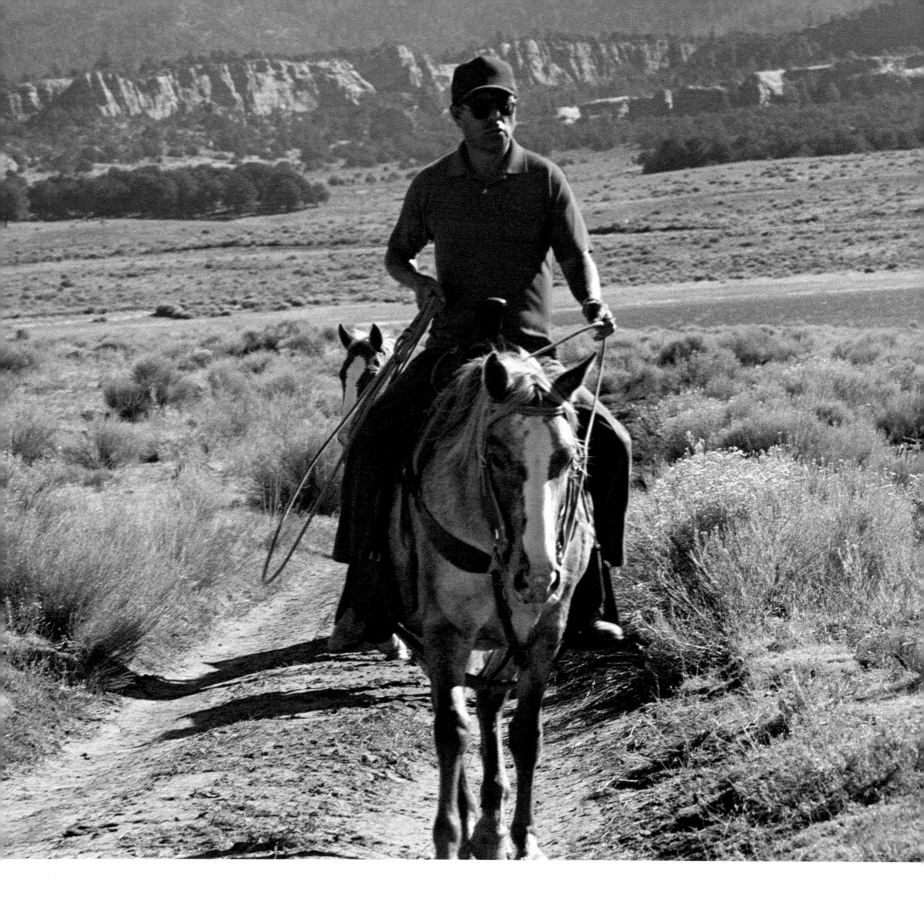

Arnold Vigil

Theresa repeats what she remembers hearing from her grandmother, "If you don't have livestock, you don't have anything." She also recites a common belief and practice shared by many Native American livestock owners, "Horses and cattle, all livestock are revered," she says. "They are in the prayers, they are in the songs, special songs. We treat them with respect." The couple's serious nature changes when they think about Indians as cowboys. They both laugh and smile. They remember growing up, watching movies where cowboys, white guys in grade B Westerns, would always win, despite incredible odds. Now, they say, that's turned around and everybody is rooting for the Indians.

"We didn't know the difference until the '60s when they started protesting," Theresa declares. No doubt, she remembers the protests against federal government demands and societal efforts to have Indians assimilate and conform to the rest of mainstream America. She also remembers young Indian men and women protesting against America's legacy of racial injustice, and the historically harsh treatment of Indians by the U.S. government. Ironically, the attire of many long-haired young Indian activists in the '60s civil rights movement was jeans, boots, a Levi jacket and a cowboy hat with an eagle feather tucked alongside.

Al Charlie of Shiprock remembers 1960. That's when he knew he wanted to be a professional bull rider. Charlie would flip through the pages of *Rodeo Sport News* and zero-in on the black-and-white action photos of rodeo stars. When he graduated from his reservation high school, he immediately headed for Dallas, Texas, the heart of rodeo-cowboy country.

Charlie said it wasn't easy breaking into the dangerous sport of rodeo riding and he had to pay his dues. Fate saw the greenhorn competitor having to get on feisty 1,500-pound bulls that never had been ridden before. But he was determined to prove himself and impress the non-Indian crowd, especially non-Indian judges.

"I was the only Indian guy," he says with a reservation accent heavy with pride, "but I made a lot of friends and they treated me real nice."

The ones who especially didn't care about the rider's skin color were the bulls. They only wanted

LEFT – STANLEY KEDELTY RIDES HIS HORSE ON THE NAVAJO RESERVATION IN CRYSTAL, N.M. HE WAS RAISED NEARBY ON THE ARIZONA SIDE OF THE RESERVATION BUT LEFT HIS HOME TO LIVE WITH HIS WIFE THERESA'S FAMILY. ACCORDING TO CUSTOMS OF THE DINÉ (THE TRADITIONAL WORD FOR NAVAJO PEOPLE), A MAN GOES TO LIVE WITH HIS WIFE'S FAMILY AFTER MARRIAGE. KEDELTY SAYS THAT BESIDES BEING TAUGHT THE NAVAJO TRADITIONS OF HIS ANCESTORS, HIS FATHER ALSO SHOWED HIM HOW TO BE A COWBOY AND RANCHER. BOTH STANLEY AND THERESA WORK AS PRINCIPALS IN EASTERN ARIZONA, BUT THEIR FREE TIME IS SPENT ON THE CRYSTAL RANCH, WHICH THERESA'S FAMILY HAS BEEN WORKING FOR MORE THAN A CENTURY.

whoever, or whatever, off their back. Charlie stoically remembers breaking bones, once shattering his shoulder in 16 places after being thrown and stomped on by a bull. Thoughts of old injuries fade when he proudly displays his Professional Rodeo Cowboy's Association (PRCA) card, which he won in Waco, Texas, three years into pursuing his dream. The card, like a license, allowed him to enter rodeos and ride professionally on the rodeo circuit. Charlie says he'd drive across the Southwest with his young wife, entering rodeos while always intending to walk away with first place.

"I was there to win a ride. That's the way I always thought about it, " he says. "I didn't think about getting hurt. I was just there to win."

During his first year, the young Indian cowboy won $3,000 and some of his winnings went to pay his wife's hospital bill after she gave birth to their first son. "I paid for it with my first-place cash," he fondly remembers. "I won the bull riding."

Charlie's wife, Martha, stands in her kitchen kneading tortilla dough. She vividly remembers her rodeo husband's loyal fans. "He was known all over the reservation," she says. "When they heard Al Charlie, boy, everybody would come. Friends from Oklahoma, Haskell, the Dakotas. They all came to watch Al ride."

As his wife pauses to remove a slightly burnt tortilla, Charlie quickly interjects that he had fans off the reservation, as well. "A lot of white kids would come around. They wanted me to sing Indian songs. They cheered me on, too."

Over the course of three decades, Charlie figures that he rode 1,500 bulls professionally plus another 700 broncs, a part of rodeo riding he says he didn't try right away. The now-aging Indian cowboy sits at a kitchen table, flipping through several stacks of photo albums and newspaper clippings. He boasts he was the bull-riding champion six years in a row on the Senior Pro Rodeo Association tour.

"I'm proud of myself. I tried and done it. Any Indian cowboy can do it, if they put their minds to it," he says, adding quite proudly, "I did pretty good." In a corner of his Shiprock home stands a large bookshelf loaded with trophies, ribbons and framed pictures of a young Al Charlie. One picture shows him digging his heels into the side of a bucking Brahma bull, his face grimacing as he grips a rope heavily coated

RIGHT – THERESA KEDELTY AND HER YOUNGER BROTHER ROSS BEGAY JR. BUILD UP A FIRE ON AN EARLY AUTUMN MORNING IN CRYSTAL, N.M., A SMALL VILLAGE ON THE NAVAJO RESERVATION NORTH OF GALLUP. THE FIRE, ONCE ROARING, WILL HEAT UP BRANDING IRONS WITH VARIOUS IDENTIFIABLE SYMBOLS THAT WILL BE BURNED ONTO THE SIDES OF CALVES BELONGING TO THE TWO, AS WELL AS NUMEROUS OTHER RELATIVES WHO ALL RAISE CATTLE ON THE FAMILY'S RESERVATION-ASSIGNED RANCHING ALLOTMENT. MANY GENERATIONS OF THE BEGAY FAMILY HAVE PERFORMED THIS RITUAL FOR MORE THAN 100 YEARS.

Arnold Vigil

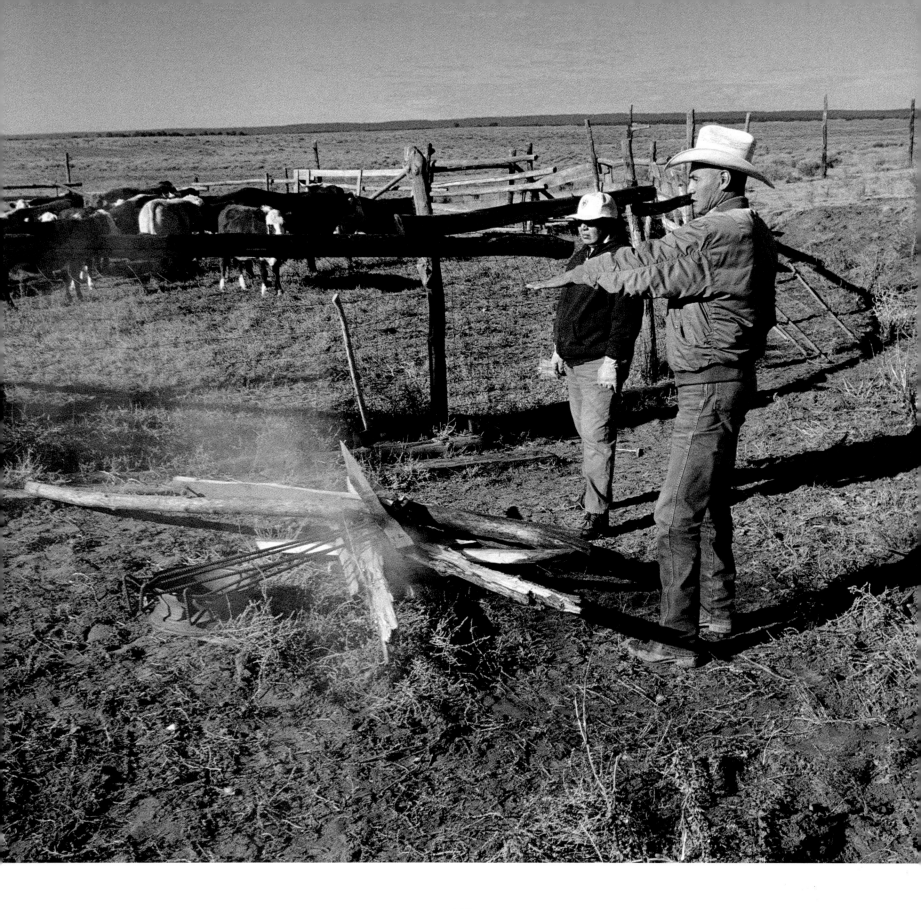

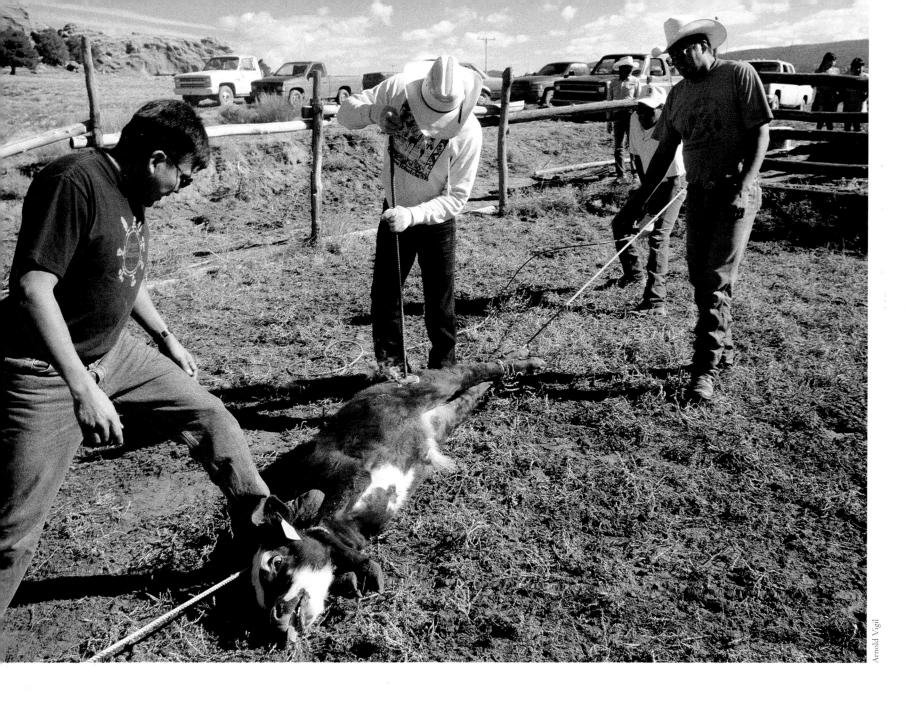

with resin, the other hand waving free for the grueling eight-second ride. Al Charlie now shares his years of experience, teaching young bull riders the art of staying on and jumping off a bucking bull. He gives paid lessons to both Indian and non-Indians alike and uses the large dirt arena and wooden chutes next to his home as part of his outdoor classroom. Despite the fading glory of those prolific rodeo days, what doesn't seem to wane is the sense of pride and accomplishment easily detected in Al Charlie's voice:

"I was in there for the Indians because all you would see is those white people. Among all those white people, it made me feel great."

## APACHE INDIAN COWBOYS

Wainwright Velarde, acting general manager of the Jicarilla Apache Tribe's casino, remembers his family raising cattle for a living. From an office at the Apache Nugget Casino in Dulce, he says his days off and vacations are spent "out in the wild with the deer and the elk," and away from the smoke-filled casino and the constant clinking chatter of slot machines. He calls it going back to the old ways, the old days when there was no electricity and no running water.

"I stayed out there one year," Velarde adds. "I had tears, it was the most enjoyable time of my life." This Apache cowboy spent the whole year fixing fences and taking care of sick cows. "It's a whole different world on that side of the fence," he says.

Long before the tribe considered wagering on a gambling enterprise, the Jicarilla Apache tribe bought up cattle during the 1940s and '50s, mainly as a tribal investment. Wainwright says the tribe initially sold timber and later purchased livestock, first sheep then cattle. The Jicarilla, once a nomadic tribe, suddenly became sheepherders and shipped off their herds and wool to be sold in Kansas City. The period between the Great Depression and World War II was a desperate time for the tribe and raising sheep was not very profitable. So, after the war, the tribe turned to cattle. Individual families also decided to invest in their own time and effort, and purchased cattle for themselves as a source of food and financial gain.

Wainwright kiddingly remarks, "Herding cattle was one step up from being nomads."

OPPOSITE — AN UNSUSPECTING CALF DIDN'T KNOW WHAT HIT HIM AFTER THIS INVOLUNTARY ENCOUNTER IN A CORRAL WITH THE BRANDING BEGAY BROTHERS ON THEIR FAMILY'S RANCH IN CRYSTAL, N.M., ON THE NAVAJO RESERVATION. JOHN, ONE OF 18 BROTHERS AND SISTERS, APPLIES THE SEARING-HOT IRON WHILE RICHARD, LEFT, AND FRANK, IN THE BACKGROUND, RESTRAIN THE BELLOWING ANIMAL. MIKE, IN THE BLUE, WATCHES HIS BROTHERS AND RESTS AFTER SUCCESSFULLY CHASING DOWN THE CALF THEN BULLDOGGING IT TO THE GROUND, A TASK HE WILL REPEAT SEVERAL MORE TIMES DURING THE DAY.

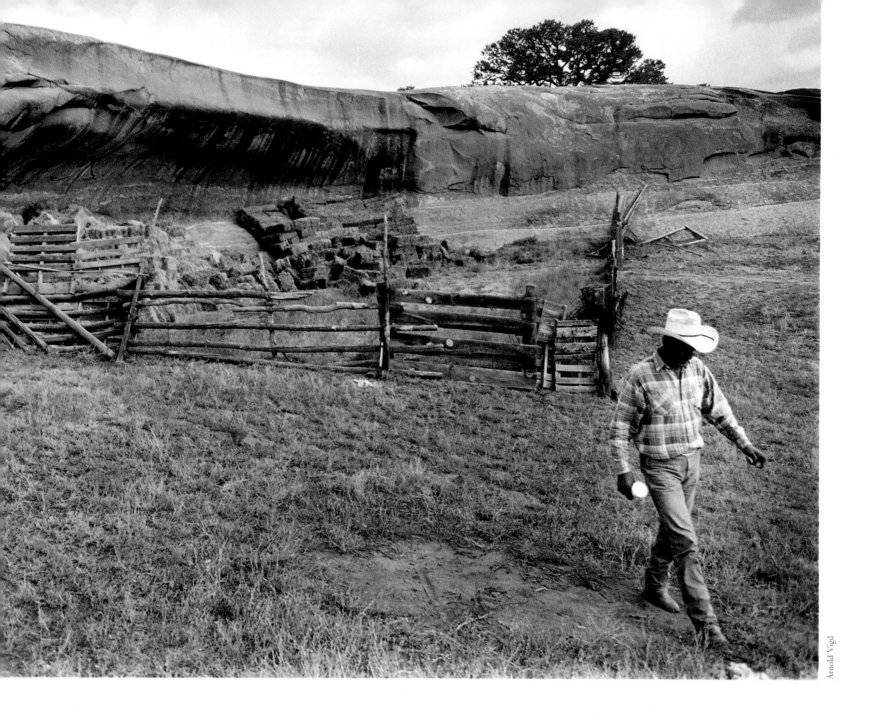

Arnold Vigil

ABOVE – ROSS BEGAY JR. WALKS AWAY FROM HIS FAMILY'S "BARN," A NATURAL AMPHITHEATER THAT KEEPS HAY SHELTERED FROM THE ELEMENTS ON THEIR RANCHING ALLOTMENT IN CRYSTAL, N.M. BEGAY SAYS THAT SOME UNKNOWN CHILDREN FROM THE AREA KNOCKED OVER THE BALES, WHICH HAD BEEN NEATLY STACKED. SUCH INCIDENTS OF VANDALISM AND THEFT, COMMON IN MAINSTREAM SOCIETY, ALSO OCCUR ON THE RESERVATION BECAUSE THE TRIBAL LAWS OF THE NAVAJO NATION PROHIBIT THE BEGAYS AND OTHER RANCHING AND FARMING FAMILIES FROM RESTRICTING ACCESS TO THEIR ASSIGNED PROPERTIES. RECENTLY, SOMEONE STOLE NUMEROUS SECTIONS OF METAL CORRAL FENCING WHILE THE LAND WAS UNATTENDED AND THE BEGAY FAMILY REBUILT MUCH OF THE STOCK FACILITY WITH FRESHLY CUT ASPEN STANDS FROM THE NEARBY CHUSKA MOUNTAINS.

Some 45 families on the Jicarilla Reservation still "run" cattle. But now there is another change under foot. The price of cattle has dropped considerably, and horses are the new "stock" for investment. Wainwright says he's personally made the switch.

Other Apache tribes like the Mescalero in southeastern New Mexico allow tribal members to become shareholders. They buy into the Cattle Growers Association and hope for a dividend at the end of the year. It's a concept introduced to help keep a fleeting tribal cattle-ranching enterprise from totally disappearing. Councilman Christy La Paz says tribal members can now buy and sell shares. The Mescalero, like many tribes with livestock, subsidize ranchers by either setting aside large sections of the reservation for grazing at little or no cost, or setting aside tribal funds for fencing and windmill repair. But despite the opportunity to carry on an acquired tribal tradition, La Paz says most young people on the reservation shun the livestock business.

"Most kids work, they don't have time for cattle and horses. It's a dying livelihood," he says, adding that it might change. La Paz says that the ranching lifestyle is simply too hard, demands much knowledge and requires much sacrifice. Most young people prefer to spend their weekends watching the Dallas Cowboys or the Denver Broncos on TV, he says.

## The Future

While the allure of ranching might be waning on the reservations, the widespread appeal of rodeos is gaining popularity. The appeal seems to cut across generations and across genders. Young men, young women, whole families participate in rodeos. Barrel racing is a popular event for a new breed of female riders who often compete at the ever-growing Navajo Nation Fair Rodeo.

Despite the attraction, thrill and excitement of rodeos, families with livestock, even the weekend ranchers, understand and appreciate the special relationship between man and animal — a relationship that engenders a respect for all living things. Many Indian cowboys believe that's what makes them just a little bit different.

SOURCES AND SUGGESTED READING
*Acoma* by Ward Alan Minge
*When Indians Became Cowboys* by Peter Iverson

# ROSS BEGAY SR.

Ross Begay Sr. remembers herding upwards of 1,200 sheep as a 12-year-old boy riding horseback with his family through the Navajo Reservation near Crystal, N.M., north of Gallup. But ever since the U.S. government began a stock-reduction program to regenerate land damaged by drought in the 1930s, the herds are required to stay smaller even through the terrain has long since recovered, he says.

Today, the 78-year-old is not the avid horseman of his past because doctors amputated part of his foot due to a diabetic condition that afflicts so many of his fellow Navajo people.

"*Aoo', akałii nishłį́įgo ádaa nitséskees, háálá shilį́į́ dóó shibéégashii hólǫ́* (Yes, I consider myself a cowboy/rancher, but I'm not doing much of that now)," says the soft-spoken Ross Sr., who speaks no English but gets his message across through his daughter, Theresa Kedelty, who translates from his native Navajo tongue. "*Łį́į́ shił naazhdloozh yéegóó. Łahda baa nitséskees łeh* (I always think about riding a horse)."

Ross Sr. says that when he was born, the Navajo people didn't officially record births, so when U.S. Census workers began tabulating the native populations of his homeland, they guessed the ages of the children and assigned them birthdays. They recorded the toddler Ross Sr.'s age as 2, but he believes he was actually about two years older.

The patriarch of a large family, including his own 18 children, their spouses, plus scores of grandchildren and great-grandchildren, this Navajo cowboy gets a lot of help ranching a large section of land in Crystal. Ross Sr. has worked the same land all his life and his forebears stewarded the allotment long before he was born.

"We're all responsible about how we take care of the land," Ross Sr. says, adding that it bothers him to see land lie fallow. "I often think of what it would be like if everyone took care of their land."

Technology has made the ranch life somewhat easier, he says, especially in the winter. He remembers the snow being much deeper in the days of his youth, making it much harder to check on the cattle during that time of the year. There were no roads when he was young, only horse paths, he says. Today, with the availability of pickups and horse trailers, it takes only hours to do what used to require days on horseback, he says.

The cultural values of the Navajo people are very important to Ross Sr. and he constantly teaches them to his children and grandchildren, who are on the verge of being the next generation to inherit the land. Ross says he has high hopes for the younger kids.

"I have confidence that the kids can do more than we can," Ross Sr. says. "They have a lot of energy and can continue as long as they are taught."

– **Arnold Vigil**

Arnold Vigil

Arnold Vigil

# ROB CHAPPELL

If there's such a thing as a most likely/unlikely cowboy, Rob Chappell would fit the description. Rob's father, Frank, took advantage of the breakup of the sprawling Bell Ranch and bought the now-40,000-acre Chappell-Spade Ranch in 1947, two years before Rob was born. The elder Chappell also operates other larger ranches in Texas and leases another south of Tucumcari.

With ranching all around him and in his blood, a betting man probably would ante money that Rob would be a true, die-hard cowboy from the git-go. Not so fast thah, pardner!

Rob says he didn't start working on any of the family ranches until he was a teenager and then, so, only during the summers. Instead of horse fever, Rob caught snow fever. He left the range to work as a ski instructor for seven years at the Santa Fe Ski Area and for 10 years at Taos Ski Valley before he immersed himself back into the cowboy lifestyle full time in the mid 1990s.

Most cowboys will swear to you that skiing is much more dangerous than ranching or even rodeo, but don't tell Rob that. Shortly after he returned to his rightful place in the saddle, his horse bucked him off and he broke his left hand.

"I've been skiing all these years and I come out here (to the ranch) and break my hand," shrugs Rob, who at first glance looks nothing other than a salty cowboy.

Today, Rob lives in San Jon near Tucumcari with his daughter Amanda, 16, and 13-year-old son Jesse. He says the jury's still out whether Amanda and Jesse will choose the horse and saddle over skis and mittens before it's all said and done. Given their unique opportunity, there's probably a good chance they'll pick both.

Although Rob has totally applied himself to the cowboy life today, he says he's not so sure he'll ride the country lifestyle out into his sunset years. With land in the Taos area awaiting this skiing cowboy's discretion, one can be sure the steep mountain slopes of Taos Ski Valley might be beckoning him away from the rolling hills and plains of eastern New Mexico.

– **Arnold Vigil**

# CHARLES GOOD

The Good Family has ranched in southeastern New Mexico ever since New Mexico became a state – 1912. That fact is proudly proclaimed on a large wrought-iron sign along U.S. 70 between Roswell and Portales.

Charles Good, who was born in 1934 just a few miles from his current home in Elida, recalls riding horseback to school in Kenna, where as many as 40 to 50 children once attended classes. Back then Kenna was a thriving community, he says, but now it's just a blip to passing motorists.

In many ways, cowboying is the same today as when Charles was young: branding in the spring, riding fence in the summer, breaking ice on frigid winter days so the cattle don't die of thirst, and – always – good neighbors helping one another. But some things have changed over the years.

"My granddad and father fed from a team and wagon," Charles says. "When I came along, it was a pickup truck." Frank, the patriarch of the family, never did learn how to drive. He always rode a horse.

"I started riding, I imagine, before I learned how to walk," Charles points out. "A horse is just a part of me." The 65-year-old still saddles a horse every morning, well before daybreak.

The engraved saddles, belts and spurs hanging in his home reveal many successes on the prestigious Pro Rodeo Cowboy Association (PRCA) circuit – world champion steer roper in 1976 and three-time senior world champion steer roper in 1991, '96 and '97, among other honors. He and his son, Gary, are one of four winning father/son combinations in the PRCA.

Like any rancher in it for the long haul, Charles has seen both good times and bad. Born during the Great Depression, he says, "The '50s were the hardest for me. We would go to the banks and borrow money. If it hadn't been for the Kenna store extending us credit, we wouldn't have made it."

The worst winter storm, however, was just back in 1997, when the snow came right before Christmas and stayed on the ground for two weeks, Charles says. While this cowboy has few regrets about the life he's lived, he nevertheless hopes his descendants will choose another line of work.

"It used to be everybody's desire that their kids and grandkids would be ranchers," he says. "Now it's their desire that they not be." Of his four grandchildren, he notes, "I thank the Lord three will do something else. But there's still one in every generation who wants to be a cowboy."

And then he adds, "If the small ranchers go out of business, who's going to take over?"

– Cathy Nelson

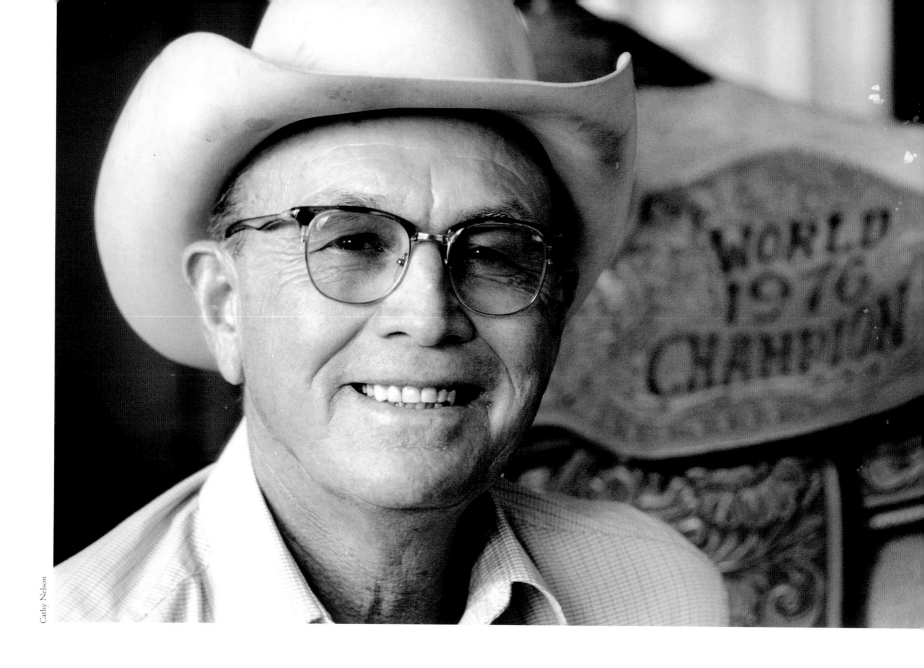

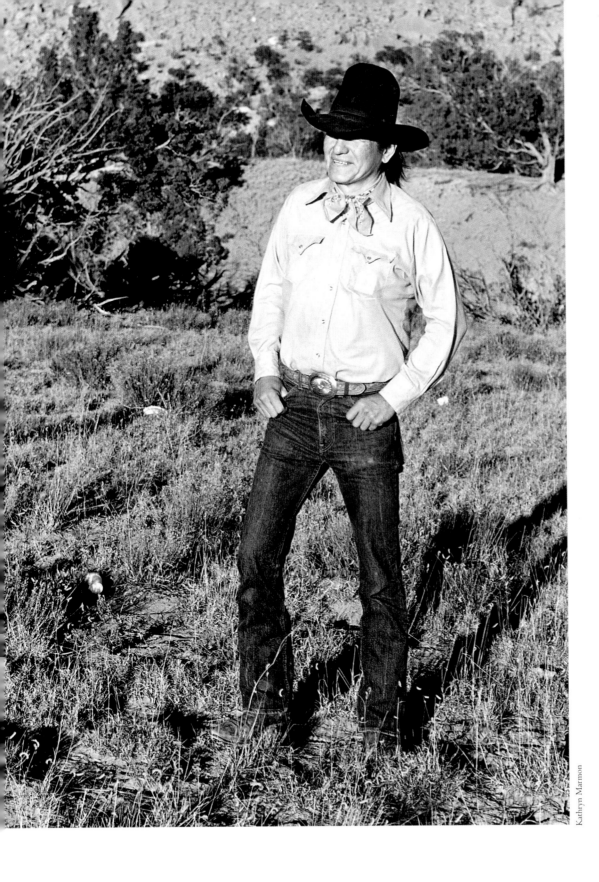

# BRONCO MARTINEZ

In many circles around the Gallup area, David "Bronco" Martinez is synonymous with "friend." A natural-born wrangler raised punching cows and sheep on the Navajo Reservation near Thoreau, this cowboy competed on the rodeo circuit during his youth.

David quickly picked up the nickname "Bronco," winning first-place trophies for bronc and bareback riding. But the coveted title of "World Champion" bronc rider eluded him due to a weakness for alcohol, a constant battle he struggles with and is winning today.

Bronco and acquaintance, J.B. Tanner, who also overcame problems with alcohol, joined together for a radio talk show in the Gallup area. Their message, broadcast in the Navajo language on KTNN-AM out of Window Rock, Ariz., is one of helping by example. The two share their personal experiences with liquor and Alcoholics Anonymous. Bronco offers words of encouragement to all who need and welcome his revelation that "after he sobered up, he could do anything."

The men emphasize the importance of family support and prayer. "Rely on God and the old Navajo ways," Tanner, of the area's Tanner Trading Co. family, states emphatically.

Bronco has stayed sober for more than 15 years and he satisfies his lifelong love of rodeo by organizing the Annual Old-Timers Rodeo for older buckaroos throughout the state. The 58-year-old also sponsors a Navajo rodeo near his hometown of Thoreau in western New Mexico. By remaining involved with the sport, Bronco has another solid forum to warn cowboys and young people about the detrimental effects of alcohol and the advantages of staying sober. Also utilizing other God-given talents, Bronco sings on the weekends, plays guitar with a country-western band and recites original poetry at a local establishment. He also serves as auctioneer when called upon.

Like many native New Mexicans, Bronco's family has a long history with the state. His late grandfather, Paddy Martinez, was a well-known cowboy in the area, having worked for a local Spanish ranching family. He spoke three languages, Spanish, Navajo and English, which helped him become a competent trader.

Paddy was credited with the discovery of uranium in Thoreau in 1950. The find changed the course of New Mexican economics for several decades — and international politics for all time.

Paddy's discovery stirred controversy because many ranchers had purchased uranium-rich land along the routes of the Santa Fe Railway, which sold the property to them but retained mineral rights to most of the area. Although the ranchers were secretly speculating on the area's ore samples at the same time, Paddy, knowing he had uranium, went public with his "rock" instead.

For his "discovery" and honesty, Paddy received a lifelong pension from the Santa Fe Railway. The site where Paddy found the ore sample was named Todilto, because it was a part of a limestone formation dating from the early Jurassic Age.

The Martinez cowboys are, indeed, a breed of their own.

– **Kathryn Marmon**

# RANDALL JONES

Randall Jones has never owned the LE Ranch east of Roswell, and he probably never will, but it's been his home since he was 10 years old.

His father ran the LE from 1961 to 1979 after a stint in the Army. Randall, who recalls learning how to ride horses at age 2 or 3 on a makeshift saddle his dad built, took over the job of foreman after studying animal science and range management on a football scholarship at Oklahoma State University.

The ranch today flanks U.S. 380, stretching farther than the eye can see – 200 square miles – but Randall knows every turn in the road, sometimes from hard experience, although he says he rarely gets lost.

"One winter day when my son was a few months old, my wife, Brenda, and I broke down nine miles north of the highway," Randall remembers. "It was a nice day, and we didn't have any coats. I had to walk three hours to get help. That's happened several times."

Of course, that was before modern conveniences made it possible for cowboys to do business out in the middle of nowhere. Nowadays, Randall can hardly escape the ringing of the cellular phone and static of the two-way radio in his pickup truck. Also, water is piped through the desert, chemical sprays control the brush and new medicines have improved the quality of the herd. But modern conveniences aside, it still takes a special kind of person to be a cowboy, Randall says. The hours are long, the work is often dangerous, and the weather can turn in an instant. But the best part of ranching in New Mexico is "being kind of free, in a way your own boss."

"I think it's just the enjoyment of it, to love horses and to love to work the cattle," he says. "It takes a lifetime of learning."

The ranch life is also the best life for his family, Randall believes. While his children, John and Laura, attend school in Roswell, living off the land has made them more responsible and self-reliant, Randall says. They know how to work, and they respect authority.

Ranch families also spend more time together than "town" families, Randall believes. He and his wife and kids enjoy sleeping under the stars just like the pioneers, even though there's no real need to be away from home overnight.

"Anymore, we just do it for fun."

– Cathy Nelson

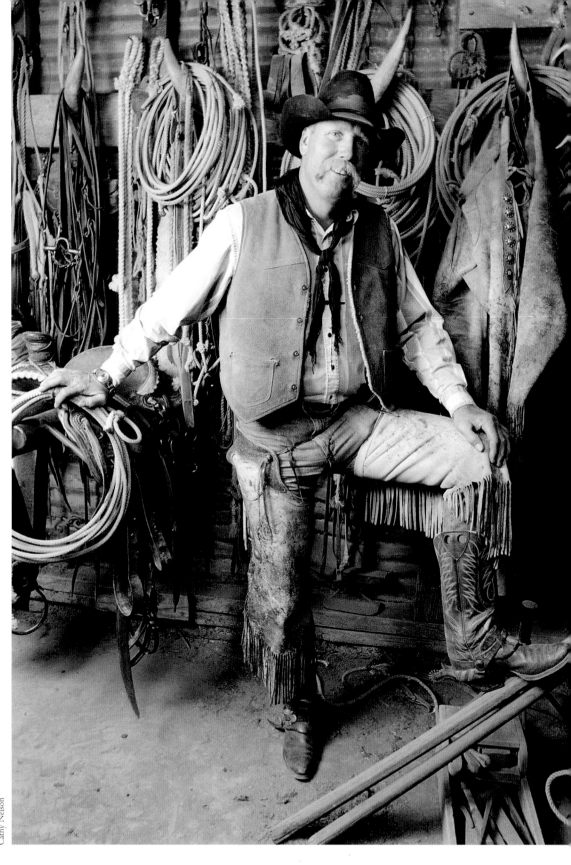

127

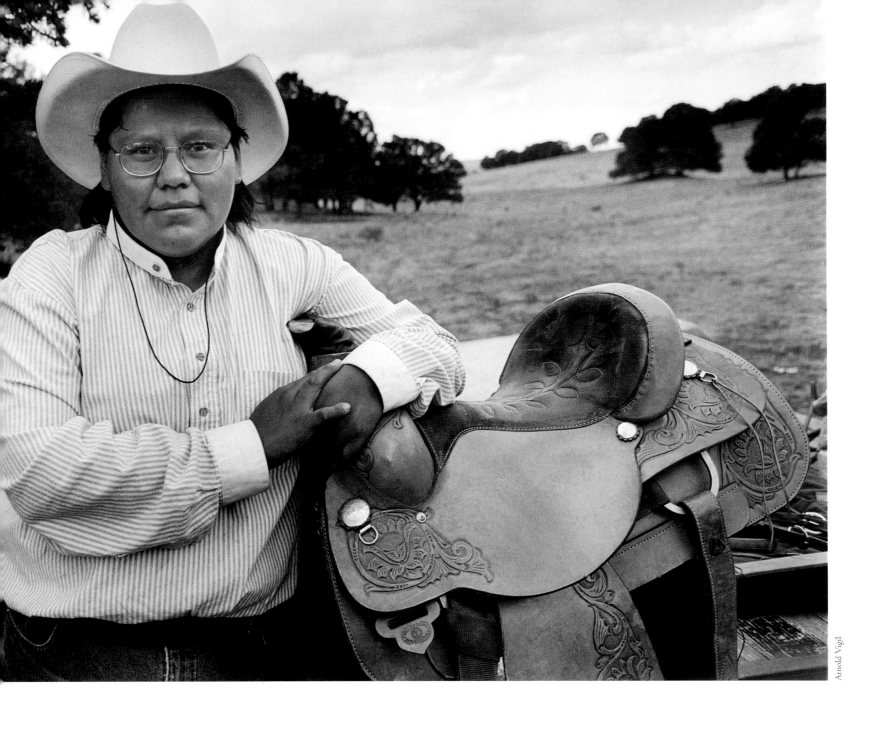

# MICHELLE KEDELTY

Riding horses ever since she was just 6 years old, or perhaps even younger, Michelle Kedelty has mingled with cows and sheep all her life while growing up on the Navajo Reservation in Crystal, N.M., a small community about an hour's drive north of Gallup.

During the week the 27-year-old cowgirl dons an official uniform on her job as a ranger for the Navajo Environmental Protection Agency in Window Rock, Ariz. But come weekends it's always back to the family's New Mexico ranch, and she wears the familiar cowboy attire with wholehearted conviction.

"I wear a uniform every day, but on my days off the boots and jeans come on," Michelle laughs. "I have several cowboy hats and quite a few ball caps."

Even when she attended high school in Farmington, she always wore cowboy boots and a Western hat. She says she took some ribbing from other students at first about her dress, but eventually her sneaker-wearing peers accepted her cowgirl ways even though they appeared to be contrary to the image of a traditional Native American. Michelle minces no words when asked if she sees any paradox in being a Navajo Indian as well as a cowgirl, a combination almost never portrayed in popular literature and Hollywood movies. "I consider myself a working cowpoke," she says without hesitation.

But the fact is that Kedelty and her family are also steeped in meaningful Navajo tradition as well. She speaks fluent Navajo as the primary language with her many young and old family members, and English is spoken only when necessary. A traditional hogan, which is used for praying and many of their life's momentous occasions, also sits on their allotted ranching section on the reservation that her family has worked for more than 100 years.

"Once I get my own place I want to start a herd of my own," Michelle says. "I want my own cattle ranch."

Although currently single, Michelle says that she will never give up her ranching ways, even if her lucky fella isn't the cowboy type. "He can always learn," she says with determination.

– **Arnold Vigil**

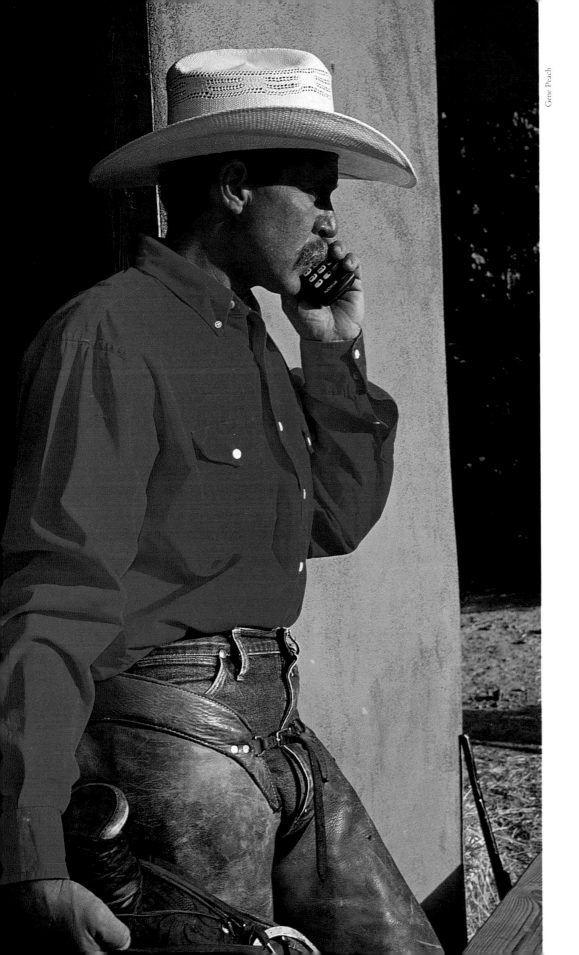

Gene Peach

The Techno Cowboy

Nowadays it's almost conventional wisdom that in a few years there won't be any more family ranches as we know them — only big corporate outfits. And, of course, it only follows that there'll be no more cowboys. Surprisingly, you not only hear these sorts of comments in the East or Midwest, but they're also uttered in cowboy country, from Montana all the way down to Texas and New Mexico.

It seems the modern world of 20th-century technology is impacting one of the most American of institutions — our own romantic past of ranches and cowboys. The theory is that modern technology will put them all out of business and that is that. But is this true? Is this really going to happen? Has modern technology had such a dramatic impact on this uniquely American lifestyle that it'll not only change it, but actually make it disappear?

Of course, none of us can predict the future, but there doesn't seem to be any evidence that technology has dramatically impacted ranching as it has so many other American institutions. In fact, over the past 100 years, cowboys still essentially do the same thing that they've always done — they work cattle from the back of a horse. And as long as people want to eat their hamburgers and steaks, there will be ranches and cowboys working on them.

Certainly there will continue to be changes that have a significant effect on how ranches and the cattle industry operate. It's rare now to see the classic cattle drives with the chuckwagons out on the open range and cowboys gathered around a big fire, eating beans and drink-

# The
# Techno
# Cowboy

by Joel H. Bernstein

ing their Arbuckle's coffee. Modern technology has made these activities unnecessary or, maybe, in business terms, uneconomical for the ranchers. The fact is, however, that ranching is a business as well as a wonderful lifestyle.

But as the noted artist of the West, Tom Ryan, observes, nostalgia is creating a demand for the return of chuckwagons and many of the bigger ranches are sending them out again. For the same reason, a wide variety of advertisements exist for cattle drives that enable city people to get at least a touch of what the "Old West" might have been like.

There are many technological advances that set ranching today apart from what it was 50 or a 100 years ago. When you drive up to the headquarters of a modern ranch, it's apt to look more like a motorpool with pickups, cars, horse trailers, stock trailers, automatic cattle feeders atop flatbed trucks, tractors and other heavy duty equipment. Gone are the wooden horse-drawn wagons, although there are still horses in the corral. Motorized vehicles have changed ranching as much as anything. Now a cowboy can cover so much more ground with his pickup and horse trailer than he could just riding a horse. No longer does he have to spend a night or more at a line camp and be away from headquarters for days at a time. This one advance in efficiency means that ranches need fewer cowboys. Pickups and cowboys cover more of the range and actually can do more work in an average day.

There is less need to have cowboys stationed at faraway camps because they can move from one location to another so quickly. The hands can now make it back to headquarters for meals, to sleep in their own beds and be back on the range early the next morning. A short drive by trailer and pickup used to mean several hours in the saddle to cover the same amount of ground.

One of the most identifiable images of the Old West is the cattle drive, often going from Texas to Montana or the railheads in Kansas or Nebraska. We all saw that imagery in the wonderful television mini-series, *Lonesome Dove*. Today, the big stock trucks can go directly to the ranch, load the cattle with buyers standing right there, and drive off to the auctions or the feedlots. There just isn't any need for the big cattle drives.

OPPOSITE – DURING AN AUTUMN 1998 CATTLE SALE ON THE CHAPPELL-SPADE RANCH NEAR TUCUMCARI, COWBOYS HERD COWS OUT OF A HOLDING PEN INTO AN ADJOINING "ALLEYWAY," WHERE OTHER HORSEBACKED COWBOYS CUT OUT SEVEN ANIMALS AT A TIME. EACH GROUP OF SEVEN IS "BOOGERED" INTO AN ENCLOSED SCALE AREA, WHERE THEY ARE WEIGHED THEN RELEASED INTO ANOTHER PEN AND CHECKED BY A STATE LIVESTOCK INSPECTOR WHO ENSURES THEY ARE PROPERLY BRANDED. IN THIS SYSTEMATIC FASHION, THE COWBOYS LOADED 500 COWS INTO SEMI-TRAILER TRUCKS BOUND FOR A BUYER IN TEXAS.

And we shouldn't overlook the use of light planes and helicopters to locate scattered cattle in rugged country. In fact, helicopters are sometimes used to herd cattle away from dense brush country, which causes trouble for cowboys working on horses or even with dogs.

As ranches became increasingly mechanized, the use of welding technology grew at the same time. Welding came into its own after World War II, when ranchers were able to buy good Army surplus equipment at a reasonable price. This meant that pipe corrals and gates could supplant old wire and poles, and it became much easier to keep some of the motorized equipment in good repair. Metal pipe, usually steel, could be used for gates, corrals, barn construction, culverts, cattle guards, fence posts and rails, and a variety of other uses. Implements could be built and maintained right on the ranch.

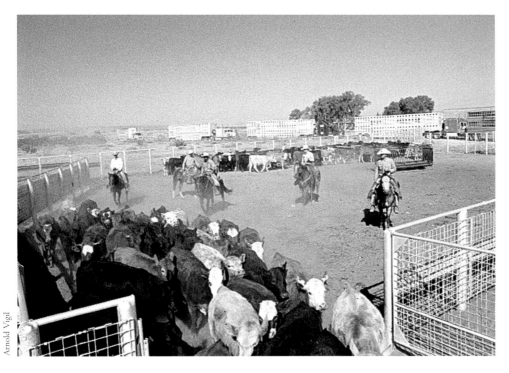

Arnold Vigil

The lifeblood of any ranch, particularly in the semi-arid country of New Mexico, is water. Art Evans, a third-generation rancher who for years was manager of the vast Ladder Ranch in southwestern New Mexico, says that one of the biggest technological changes has been the ability to supply water throughout a large ranch.

In the old days, he remembers, wells were dug by hand and pumped with windmills. They were rarely more than 50 or 75 feet deep. When the Rural Electrification Administration (REA) brought electric power to rural Americans and ranches in the 1930s, ranchers were able to use electric submersible pumps and other similar-powered pumps to disperse water to drinkers and tanks on even the driest part of the range.

Jim Kelly, whose family has been ranching in the scenic Water Canyon area east of Magdalena for three generations, says the impact plastic pipe has had on water distribution is tremendous. Plastic pipe, used almost exclusively these days, is economical, simpler to use, and easier to move and repair.

No matter how you cut it, the water on a ranch determines the land's carrying capacity and outlines the entire economics of an operation. Moving water is absolutely essential and modern technology has made it a more feasible option. There are ranches in the Land of Enchantment that have of tens of miles of underground pipe. This relatively simple development enables livestock to be spread out farther and has

resulted in far better range conditions in the very driest of climates.

Cattle can be moved around without the worry of a particular well or dirt tank being dry. Even in drought situations, deep wells can provide water over a vast area. On some ranches during the hot summer months, one cowboy, usually in a pickup, can spend more than two hours each morning just checking wells, pumps and tanks. Without water there is no cattle operation. More recently, some ranchers have utilized stock-tank systems that use solar panels, solar controllers and solar submersible pumps. We'll probably see more of these systems on more ranches in the future as the prices become more affordable.

On most ranches, particularly the larger ones, modern communications really helps. It enables cow bosses, foremen, managers and even owners to keep in constant touch with the cowboys out on the range or at some faraway permanent camp. When Lonnie Moore was manager of the immense Gray Ranch in southwestern New Mexico's Hidalgo County in the 1980s, he kept in touch with various camps on the ranch by telephone. He said that he could give new orders to the cowboys each day, get information or just keep in touch. In turn, the cowboys could reach headquarters if they needed something, if there was trouble like a medical emergency or if they just needed directions to solve a problem. This saved time and made it unnecessary for people on the ranch to travel great distances to get information. Today, cell phones make it possible to keep in touch, whether a cowboy's at headquarters, in the saddle, at one of the camps, in a vehicle heading for town or returning with news. Even fax machines play a role in today's complex ranching. Ranchers can fax orders to feed stores for medicines, equipment and even personal items for the family. It is, indeed, a faster world out there. It wasn't too long ago that the majority of ranches didn't even have regular mail delivery.

Wanda Evans, Art's wife, remembers days on the sprawling Ladder Ranch when her husband was gone for long periods of time. "That's when we got communicators," she says. "Motorola two-way radios." It might not seem like much, but on a ranch where there are so many potential accidents waiting to happen, being able to keep in touch has made life a lot easier for everyone concerned. If there's an accident, help is much closer and can arrive much faster. Being able to call and get a helicopter or an ambulance to a specific spot has prevented many potentially bad situations from becoming disastrous.

Today most ranchers, and especially the larger corporate outfits, use computers. The machines are used to keep track of everything from daily operating expenses, bills and salaries, paperwork on registered livestock, and precise feed requirements and weight gains. And, of course, to keep up with the latest cattle and feed prices, and even to get the most current weather information. Computers are used to keep informa-

tion that needs to be regularly updated. Ranchers use computers just like anyone else who knows how to "log on." They use them to order goods and to help educate their children. Cowboys can "surf the Net," looking for helpful information about changes or improvements in the livestock industry. Computers and all other modern communications have put ranchers living miles from the nearest town in touch with their neighbors and the world. They've made cowboy life a little less lonely.

An important area that modern society often takes for granted is the new materials scientifically created in the 20th century. Plastic and fiberglass are used extensively on ranches because they are lightweight, non-corrosive and require far less maintenance than the older products they replace. For example, heavy duty plastic and fiberglass stock tanks that don't rust are replacing the older metal tanks. Simple but important time savers for the cowboys. Even buckets, halters, feeders and some gear are made from these modern materials. With all the standardization of the cowboy's gear — and most of it has changed very little over the years — switching from leather to nylon, even for simple things like latigos, was a very hard sell. Although hats, boots, spurs and chaps remain relatively unchanged, a dramatic shift is evident in the ropes. From the old braided rawhide lariats used by the *vaqueros* in Mexico to the manila hemp ropes that had a growing popularity after the Civil War, it is the new nylon ropes that we mostly see in use today because they have great strength and durability.

A very, very significant development that affects all areas of society, not only ranching, is the improvement in health, medical services and supplies. In fact, the strides in veterinary medicine, it could be argued, compare with those made in human medicine. Both in feeds and pharmaceuticals, the improvements have come at a dizzying pace. It is no longer necessary to just put your livestock out on the grass and wait for them to fatten up. Today, horses, sheep and cattle all have additives in their feed that raise conception rates, increase growth and weight, help them overcome nutrient deficiencies and generally improve their conditions. Very often grass alone won't do the job as ranges just plain wear out. But with the additives, pastures that once were considered useless can now be somewhat productive.

Improvements in veterinary medicine happen so fast today that ranchers have to be on their toes just to keep informed. Vaccines, antibiotics, wormers, vitamins and insecticides are all crucial to ranching and are constantly being improved. New drugs that have been developed throughout the last half-century have made cattle raising safer and more profitable. Diseases like anthrax, "black leg," and foot and mouth could wipe out an entire herd. In the Southwest, the elimination of the screw-worm fly made a tremendous difference.

"It was a big job for us in the summer to doctor for screw worms," Art Evans recalls. "Everybody carried an empty pint whiskey bottle now filled with 'Peerless Screw Worm Killer,' and another one filled with pine tar that they would smear over the wound."

The medicine they used in the past was mostly chloroform. Today when calves are branded, part of the routine is to give them shots, usually a seven-way vaccine that prevents a wide variety of diseases. In retrospect, ranching has remained remarkably the same throughout the last century. Cowboys still ride horses and work cattle the same as they did in the past. Not too long ago I was doing day work at a good-sized local cattle outfit and about a dozen cowboys unloaded their horses from their trailers. When we rode to the range to make a big gather, I realized there was very little difference from what we were doing than what cowboys did in former days. The nature of the work is the same.

Max Evans, the legendary New Mexico writer whose novel, *The Hi-Lo Country*, was recently made into a movie, commented to a Santa Fe audience at the film's premiere about what many feel are the dwindling number of cowboys. Quoted in the *Albuquerque Journal*, he said, "They're still out there bustin' their butts. You just don't see 'em from a jet airplane or ridin' down the road in a van. But they're there, ridin' through the brush and breakin' those horses."

Evans knows, too, that technology hasn't drastically changed the daily life of a cowboy. That's about it. Cowboys are still doing cowboy work on ranches that still raise some of the best beef in the world. All that's changed is that there are a few more modern conveniences that make the work only marginally easier and safer.

OPPOSITE – THE INVENTION OF THE GOOSENECK TRAILER REVOLUTIONIZED THE WORLD OF COWBOYS. THIS VERSATILE TOOL ENABLED COWBOYS TO TRUCK THEIR HORSES MILES UPON MILES INTO TERRAIN THAT IN THE PAST HAD TO BE RIDDEN HORSEBACK. ALTHOUGH THE HORSE IS PROBABLY THE MOST IDENTIFIABLE TOOL OF THE CLASSIC COWBOY, THE TRUCK AND TRAILER, TO THE CHAGRIN OF THE NOSTALGIC, HAVE BECOME SYNONYMOUS WITH THE CONTEMPORARY COWBOY.

Cathy Nelson

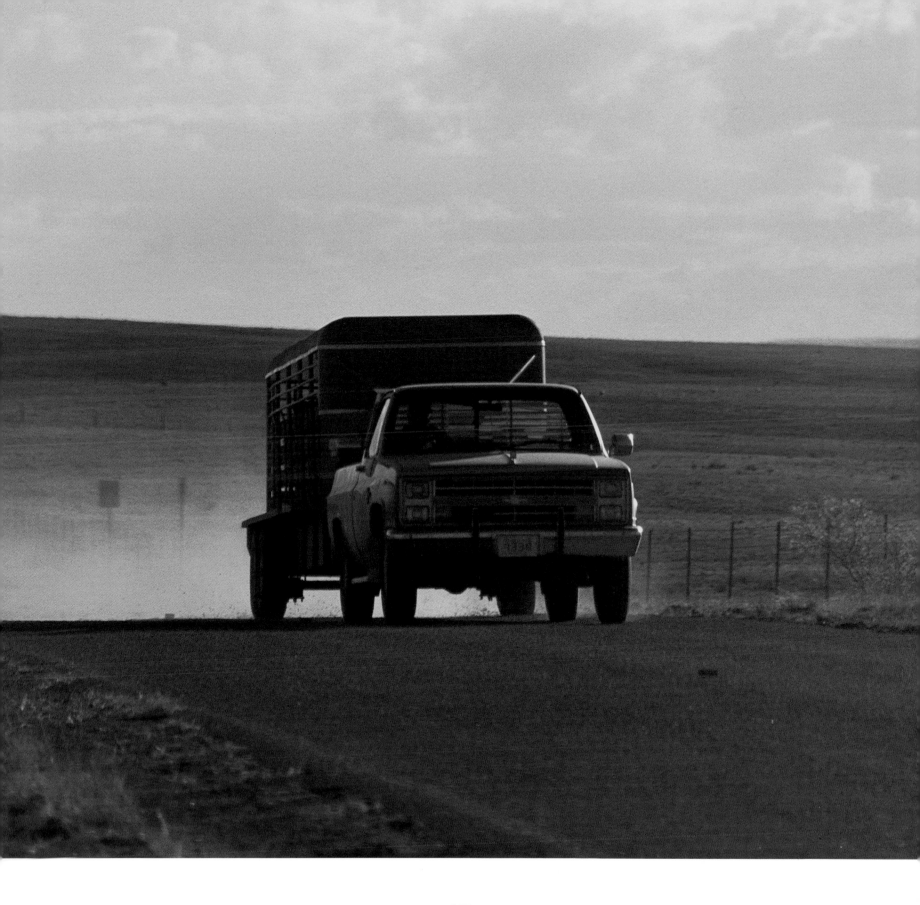

# PEG PFINGSTEN

Peg Pfingsten doesn't need to study the illustrious history of Lincoln County. He's been living it for more than 80 years and remembers it line by line.

Born Fred Wells Pfingsten in 1913 in Angus, Peg got his nickname from a popular song in his youth. His grandfather, a stowaway from Germany on a steamer to New York, was offered citizenship papers to serve in the Union army for "the duration" of the Civil War.

Peg spent the first 30 years of his life five miles down from the historic town of Lincoln, followed by 22 years on the Mesa Ranch near Nogal. He ran the G Bar F Ranch for 14 years before moving in 1979 to the house where he lives comfortably today, just up from the Río Bonito.

Along the way, he's plowed fields with his father, and hauled hay and hogs. Peg learned to drive a coal truck at 14 and later a Caterpillar tractor, or "Cat," as he casually calls it, for the U.S. Forest Service. Working in a logging camp, Peg used to earn $2 for a grueling 16-hour day.

But there were always horses and cattle in the background. "I traded horses, broke horses, got rid of horses," Peg says. "I left a little bit of skin on every tree for miles around."

He recalls driving horses to Roswell in the 1930s, moving a hundred head once and 65 another time. From there the animals were shipped all the way to Oklahoma.

"We went right into town past the old airport to NMMI (New Mexico Military Institute)," he remembers. "We went through a fella's yard and caught the clothesline. It jerked a board right off the house. Boy, was that owner mad!"

The man who once wanted to be a veterinarian tells how he once pulled a calf from a cow in difficult labor and was happy to see it take its first breath. The mother died that night and as the calf grew, Peg noticed that he had one bowed leg.

"I put PVC pipe on it to straighten it out," he explains. The soft brown bull now follows him around like a pet. Even now, at an age when he should be retired, Peg still cares for some 60 head of livestock.

Another time, mountain lions attacked five of his calves. "They would git ahold of the nose and break the jaw," Peg says of one injured calf. "I used a half-gallon milk jug to hold up the jaw, and pour milk down it for five days."

Although he gets up at 5:30 a.m. to feed and work his cattle, Peg admits he "doesn't hit it as hard" as in his younger days. "I ride when I need to," he says, adding with a wry grin, "why, sometimes I even take a little *siesta* after lunch."

– Cathy Nelson

Steve Larese

# ALCARIO MARQUEZ

Alcario Marquez always knew his fate in life was to be a cowboy, the only lifestyle he's ever really aspired to since he was a toddler. In fact, this 66-year-old *vaquero* says he only maintained successful careers as a surveyor, mechanical technician and engineer as a means to acquire land and cattle. Then he could retire with a healthy pension to work full time at his profession of choice – ranching.

"I went to work in Los Alamos, just so I could have (my ranch)," Alcario says. "That's the only reason I went up there every day to put up with all that bullshit. But I had some good bosses. Hell, they're still treating me good – I still get a good check every month."

Alcario was raised in the border area of northern New Mexico and southern Colorado near Antonito, where his father Antonio Marquez taught him the necessary skills to be a *vaquero*. The Marquez family is typical of hundreds of other Hispanic ranchers in northern New Mexico and southern Colorado still living the way their ancestors did many centuries ago.

Today, Alcario has passed along much of that tradition to his son Pedro, who operates his own ranch across the road and helps his father out, too.

"My dad was one of the most authentic *vaqueros*," Alcario says with pride. "He passed the lifestyle on. I used to tend camp for him as a boy and I would come down back and forth from the mountains to get supplies."

Alcario remains very humble about the land he's accumulated for himself and his family. Both he and his son Pedro have built up hundreds of acres of ranch land even though he never inherited any from his father Antonio. He is quick to clarify that the many other sections of public grazing land that he and Pedro lease for their cattle are not their own.

"It's not our land, it belongs to both me and you," he says. "I'm not like other ranchers who say that (public) land is theirs."

Realizing that the current environmental issues might heavily impact his use of the public allotments, Alcario says he has resolved not to get too emotional about the cattle-on-public lands debate.

"You don't get anywhere by fighting," he says of the controversy. "I try to get along with my neighbors.

"We take better care of it than the hunters. You've gotta take care of the place. We're kind of like the stewards. You should see the bags of trash I haul out of there."

– **Arnold Vigil**

# JAMES WOOLLEY

The long and winding road that leads to James Woolley's house is full of cattle guards and bumps, and darn near impassable after a good rain.

James, who manages both the Rockhouse and Bosque Grande ranches for the Cooper Cattle Co., can see the lights of Roswell shining in the distance to the west, but most days it seems as if he is 100 miles — and 100 years — from modern civilization, the computer in his living room notwithstanding.

As swimmers and picnickers frolic at Bottomless Lakes State Park nearby, James and his wife ride the range, keeping an eye on 300-plus cows, often with baby Jaymee Lenee tucked into Lana's backpack. Their 12-year-old daughter Kelby, who is home-schooled, helps with the chores, while son Shane, 17, works in Muleshoe, Texas.

In the barn sleeps a Vietnamese pot-bellied pig named Sparky, and a tiny six-day-old orphan calf, Baldy, is penned in the corner, waiting to be fed. While one of six horses sticks its nose over the fence to check for snacks, Molly the mule wanders up out of curiosity. A wild cat ducks into the ruins of a building, and a timid Australian shepherd dog named Lizzie skulks in the shadows, keeping a steady cautious eye on the infrequent visitors. It's the perfect life for the Woolley family, says Lana, who, like her husband, was born in 1960.

The couple has worked together in Crane, Texas, where once just a half-inch of rain fell in 18 months, and Johnston, Kan., where they struggled through an unusual autumn blizzard in 1997, losing 4,000 head of cattle. Crane, population 3,533, was a big town to them and they slept with the radio on "to block the noise from the traffic."

But they're happy on the Rockhouse, with few visitors and no neighbors to speak of. "We love it," say the Woolleys. "Out here, if you see someone coming, they're either coming to see you, or they're lost."

Born in Portales, James once turned cattle out of the chute during practice for world-champion steer- and calf-roper Sonny Davis. A former rodeo man himself, he's more interested these days in cutting horses.

James returned to school at age 35, earning an associate's degree in ranch and feedlot management in just 18 months from Clarendon College. "I put myself through school shoeing horses," he says, a skill he learned from his father, Harold Thomas.

Prior to that, James also tended house and cared for the children after Lana contracted encephalitis in November 1990, causing her to sleep 23 of 24 hours a day for five years.

Now, James is on the road three or four days a week, heading up to the 15-section Bosque Grande. It's 17 miles north of the landmark known as the "old schoolhouse" on U.S. 70, and there's no place to spend the night at the ranch. He estimates he'll put 40,000 miles on his truck this year.

Rain, snow, drought, coyotes — it might not be the perfect life for everyone, but as the Woolleys look up into a nighttime sky full of glistening stars, it's obvious they couldn't be more content.

– **Cathy Nelson**

143

# FLETCHER HALL JR.

Fletcher Hall Jr. is lucky. That's probably why he always seems to be grinning. As a boy on a horse, he raced his friends for fun. Today, his horses race for cash prizes. The plaques, trophies and saddle towels in his home reveal his many successes, while mountain lion and bear skins on his wall tell of an exciting life.

Born just north of Capitán about seven miles from where he lives today, Fletcher comes from hardy stock. Three years before his birth, Fletcher's family was traveling near Hobbs in 1912 and their covered wagon caught fire and burned. The senior Hall left his daughter and pregnant wife on the plains with their destroyed belongings while he rode to town to trade a spare horse and $25 for supplies.

Fletcher's father later traded his homestead near Capitán for a drugstore, which he ran for 40 years along with a mail route. Fletcher proudly notes that his father missed only one mail stop all those years because of a bad snowstorm.

Raised in the days of pioneer independence, Fletcher claims that when he was a 5-year-old, he rode 35 miles from Ancho to Capitán on a horse with no saddle. Luckily, the horse knew the way, he chuckles.

Looking out at the burgeoning town of Capitán, he recalls, "There wasn't one single house here when I was a kid," just a thousand head of cattle.

Fletcher says he's always been a cowboy, winning five Independence Day calf-roping events in Fort Stanton, Capitán and Mescalero in the 1930s and '40s, and running wild horses on the national forest.

"We'd catch these mustangs and if they didn't buck, you'd make them buck," he recalls. Then, glancing at his wife, Emma Gene, he adds, "Of course, that's poor horsemanship."

Fletcher laughs at how he won a wild cow-milking contest as a youngster. "My horse was small. I got a loop over the cow's leg. She was bawlin' and barely pullin' my horse. I milked that cow and beat everybody bad."

But it took brains to train a horse to spin on a dime just to make a point, or win a bet. "I started training my horse, Toby, to run down and turn back," he says. "He left me right on the line a few times. The horse would be standing there waggling his ears, someone would yell, 'Go,' and he'd take off."

But the most dramatic race Fletcher ever saw was in 1991, when his horse, Mount Capitán, came back from 18 lengths to win the 1 1/16-mile New Mexico-bred Thoroughbred Derby in Albuquerque.

Fletcher and his wife still get a thrill from watching the videotape of that race. He estimates he's trained some two-dozen racehorses since the early 1960s, and still breaks his own prospects today.

As the century closes, Fletcher gets sad when he passes abandoned ranch houses where families he knew long ago once lived. "We used to ride up and have dinner with them," he recalls. "We used to bring the cattle right through town.

"The days of ranch life, they're gone."

— **Cathy Nelson**

# LORENZO VIGIL

Born into a historic *vaquero* ancestry that traces back to the Spanish reconquest of New Mexico in the late 1600s, Lorenzo Vigil of Nambé established his own prominent legacy in the cowboy world during his productive 91-year lifetime. Lorenzo died in 1987, but while he was in his 20s he earned a lasting reputation as a skilled *vaquero* by driving large herds of wild horses hundreds of miles through unfenced country from Wyoming to northern New Mexico in the 1910s.

Lorenzo worked as a wrangler for a large ranch in Wyoming at the time and would save his earnings to buy horses, according to one of his sons, Gilbert Vigil of Rodarte. When he would accumulate enough money to make a large buy, Lorenzo and his older brother Esquipula "Pula" Vigil, who died in 1997 at the age of 105, would drive the herds on horseback south to New Mexico.

On two of their adventurous drives, the brothers started out with 80 to 90 horses and another time, accompanied by their cousin Juan Vigil, they herded close to 200 horses of all shapes and sizes, and maybe even a *burro* or two, Gilbert says. Both born and raised in the village of Cundiyó in the Sangre de Cristo Mountains, Lorenzo and Pula would sell and barter the animals on their way back to New Mexico. Their journeys would take months to complete, Gilbert says.

"Dad was a good cowboy," Gilbert says. "He only liked spirited horses. If he got a gentle horse, he'd get rid of it because they wouldn't work all day for him. Gentle horses would give up by the time the day was over."

In fact, Gilbert and his brothers Longino, Benito and Lorenzo Jr. had no choice but to learn how to handle spirited horses while they worked the family's Nambé ranch in the 1930s and '40s. "When he'd saddle the horses, he'd mount them, they'd buck, and after they'd settle down he would put the boys on them," Gilbert recalls of the many early mornings of his childhood.

The indefatigable Lorenzo learned how to cowboy while growing up in Cundiyó, where, according to local lore, only Vigil families have lived since the 1700s. Gilbert says that when Lorenzo was a boy herding cattle high up in what is now the Pecos Wilderness, an *americano* stranger rode up. The man, who Lorenzo later learned was a forest ranger, handed the boy a paper that officially entitled the family to graze cattle on the newly established federal land, which the Vigils had already been using as common lands for generations before New Mexico became a state or even a U.S. territory.

The rough-and-ready Lorenzo also befriended the Native Americans of nearby Nambé Pueblo, whose elders and leaders routinely referred to him as "*pariente*," meaning relative in Spanish. The Indians believed he was of *mestizo* lineage because of his facial features and background, Gilbert says. Whereas other non-Indians were always required to detour around pueblo boundaries, Lorenzo and his sons were allowed to cut across Indian lands with his cattle en route to the family's grazing section in the high mountains east of Nambé.

– **Arnold Vigil**

# BRUCE KING

A book about New Mexico cowboys wouldn't be complete without including former three-time governor Bruce King, arguably the state's most famous contemporary cowboy. Bruce is best known as a humble-speaking politician whose public-service career spans more than 40 years. Throughout the decades while serving in Santa Fe as a county commissioner, state representative, speaker of the house, president of the constitutional convention, chairman of the state Democratic Party and stints as governor, Bruce says he usually commuted 50 miles back to his family ranch in Stanley to do what he enjoys most — working as a cowboy.

He started wrangling in the Estancia Valley as an 11-year-old in 1935, when his father Bill left him alone on a horse to watch over a hundred grazing cows. The unfenced country was his only world until he attended the University of New Mexico, where he played football in the early 1940s. In 1945 he served in an Army field artillery unit, and later was stationed in Japan just after World II ended.

"All I knew how to do was ride a horse," Bruce jokes about his pre-military experience. "Basically, I was just a cowboy." After he returned, Bruce went to a local gathering and met Alice Martin, who lived on a ranch down the road from the King family. They married in 1947.

Bruce says his father was a "true old-time cowboy" who started out in Texas, and homesteaded in Stanley in 1918 because "he always heard about these wide-open spaces." The elder King traded a Model T Ford to a burned-out homesteader for 160 acres and a dugout house.

Bill then worked as a "mechanic or anything else to get by" and his homestead soon grew into the W.S. King and Sons Ranch. After his death in 1949, the spread became what is now King Brothers Ranch Inc. Bruce's brothers Sam and Don, his son Bill, and a multitude of cowhands ran the outfit while he was away shakin' hands, slappin' backs and kissin' babies in Santa Fe or other parts of the state. At one time the Kings ranched about a half-million acres around the state, including what is now El Malpais National Monument in western New Mexico.

Bruce says that he's encountered many cowboys and three of the best he's worked with over the years were *vaqueros* Leonardo Trujillo of San Ysidro, Orlando Alarid, who worked for the Bell Ranch, and Pete Otero, who cowboyed for both the expansive King and Bond ranches.

"We're fast runnin' out of cowboys," Bruce says of his current dillema of finding labor for the ranch. "It's hard to get anybody to take a cowboy job. It's too lonely and too far out.

"The lack of cowboys is just going to get worse. It's a dying breed."

Bruce recently suffered a heart attack and doctors implanted a defibrillator in his chest. A newspaper reported that after he was released from the hospital, Bruce immediately pulled into a fast-food joint and ordered a hamburger. This is the typical Bruce King country style that endears him to cowboys, meat eaters, voters and just about anyone.

"They (doctors) told me I had to quit ridin' the horse in 1997," Bruce says. "I'm ready to git back (in the saddle), but I gotta git their permission. I'm feelin' good."

– **Arnold Vigil**

# CONTRIBUTORS

## About the Contributors
(In Alphabetical Order)

**Joel H. Bernstein** is a free-lance writer living on a small ranch in Magdalena who specializes in cowboys, ranching and the West. He's cowboyed in Wyoming and Montana, where he coached a rodeo team and was on the faculty of the state university. He's written for *New Mexico Magazine* and is the author of three books.

**Bette Brodsky** is a graphic artist and illustrator, who has designed many books for *New Mexico Magazine*. Her illustrations have appeared in many other books and publications, most recently *1863: The Rebirth of a Nation* by Joseph E. Stevens, Bantam Books, 1999.

**Conroy Chino** spends his days as an award-winning anchorman and investigative reporter for KOB-TV in Albuquerque. The Acoma Pueblo-born broadcast journalist also contributed another insightful essay to the *New Mexico Magazine* coffee-table book, *Mark Nohl: Photographs of New Mexico.*

**Steve Larese** is *New Mexico Magazine*'s associate editor and his stories and photos also appear in publications such as *National Geographic Traveler* and *American Angler*. He lives in Albuquerque with his wife, dog and "too many damned cats."

**Kathryn Marmon** is a student of photography and English major who first arrived in New Mexico in 1983, and has written many feature stories around the state. She lives in Laguna Pueblo with photographer husband Lee and this is the first time they've been published together.

**Lee Marmon** is a lifelong resident of Laguna Pueblo and most of his celebrated photography documents the lives of his fellow tribal members. His culturally distinct photographs are collected worlwide and have appeared in *New Mexico Magazine*.

**Michael Miller** is a writer from northern New Mexico and is the former state historian whose stories have appeared in *New Mexico Magazine*. He has authored several books about New Mexico and the Southwest, including his most recent for children, *NEW MEXICO: Celebrating 400 Years of History*, Cobblestone Publications, 1998.

**Gary Morton** started painting in 1969 while working as a cowboy on the Bell Ranch in northeastern New Mexico. His *The Simple Pleasures of New Mexico* hangs opposite the governor's office in the state Capitol. He believes good cowboy art entails artistic ability, passion for the subject and first-hand knowledge of cowboy life.

**Cathy Nelson**'s photos appear in *New Mexico Magazine* and she currently attends Eastern New Mexico University in Portales. She studies digital imaging, web design and multimedia, things she says that were invented after she received a photojournalism degree in 1982.

**Jane O'Cain** is the oral historian at the New Mexico Farm & Ranch Heritage Museum in Las Cruces, where she records stories remembered by many of the state's rural "old-timers." The books *Homes on the Range* and *School Days* were based on some of her previous interviews with displaced White Sands ranchers.

**Gene Peach** is an advertising and editorial photographer who lives near Santa Fe. His New Mexico images are published throughout the world. Although originally attracted to the Hollywood persona of cowboys, Peach quickly discovered a world of real working ranch families committed to preserving their way of life.

**Glenda Price** is a free-lance writer and photographer living in southern New Mexico's Mesilla Park. Her work has appeared in *New Mexico Magazine* and she is a contributing editor for the *New Mexico Stockman*.

**John L. Sinclair** first began writing for *New Mexico Magazine* in 1937 and he contributed regularly until his last prolific story in 1993, the same year he passed away. Hailing from Scotland, Sinclair first came to New Mexico in 1923, when he began working as a cowboy. His first novel, *In Time of Harvest*, was published in 1945.

**Steve Terrell** is a staff writer for the *Santa Fe New Mexican* and contributes to such publications as *New Mexico Magazine* and *No Depression* (a national music magazine). He hosts two music shows (KSFR-FM, Santa Fe Public Radio) and maintains his own website: (**http://members.aol.com/bluespud/**).

**Arnold Vigil** is a native of Santa Fe and has edited many other book titles for *New Mexico Magazine*. The former newspaper reporter is the author of *Backtracks: Time Travels through New Mexico* and his feature stories and photographs have appeared in the *Albuquerque Journal, Santa Fe New Mexican, La Herencia del Norte* as well as *New Mexico Magazine*.